Social Concern and Left Politics in Jewish American Art

Judaic Traditions in Literature, Music, and Art
Harold Bloom and Ken Frieden, *Series Editors*

Social Concern
and Left Politics in
Jewish American Art

1880-1940

Matthew Baigell

SYRACUSE UNIVERSITY PRESS

∞ The paper used in this publication meets the minimum requirements
of the American National Standard for Information Sciences—Permanence of Paper
for Printed Library Materials, ANSI Z39.48-1992.

For a listing of books published and distributed by Syracuse University Press,
visit www.SyracuseUniversityPress.syr.edu.

ISBN: 978-0-8156-3396-9 (cloth) 978-0-8156-5321-9 (e-book)

Library of Congress Cataloging-in-Publication Data
Baigell, Matthew.
Social concern and left politics in Jewish American art 1880–1940 / Matthew Baigell. — First edition.
pages cm. — (Judaic traditions in literature, music, and art)
Includes bibliographical references and index.
ISBN 978-0-8156-3396-9 (cloth : alk. paper) — ISBN 978-0-8156-5321-9 (e-book)
1. Jewish art—United States. 2. Social problems in art. 3. Art—Political aspects—United States.
4. Art, American—19th century. 5. Art, American—20th century. I. Title.
N6538.J4B358 2015
704.03'924073—dc23 2014046340

Manufactured in the United States of America

For Maria Chamberlin-Hellman and Gerard Hellman

Matthew Baigell is emeritus professor of art history at Rutgers University. Since the mid-1960s, he has written widely on nineteenth- and twentieth-century American art. He has authored fourteen books, including *Jewish American Artists and the Holocaust* (1997), *Artist and Identity in Twentieth Century America* (2001), *Jewish Artists in New York: The Holocaust Years* (2002), *Jewish Artists, American Images* (2006), and *Jewish Art in America: An Introduction* (2007), and has edited, coedited, or coauthored seven other books.

Contents

Illustrations

Acknowledgments

FIRST AND FOREMOST, I owe a special debt of gratitude to Renee Baigell for her translations from the Yiddish and for sharing her knowledge of religious rituals with me. Needless to say, this book could not have been contemplated, let alone written, without her constant support and insightful observations.

I also thank Sharon Liberman Mintz, curator of Jewish Art at the Jewish Theological Seminary, as well as Anne-Marie Belinfante, Shoshana Kanowitz, and Eleanor Yadin of the Dorot Jewish Room, New York Public Library, for their professional expertise and good cheer in making materials available from their respective collections.

I owe debts of gratitude to Donald Kuspit for calling my attention to Karl Menninger's essay "The Genius of the Jew in Psychiatry"; Seth Wolitz for discussing William Gropper's print *Hoirst* with me; and Nancy Heller for arranging the photographing of Joseph Hirsch's murals in the Sidney Hillman Apartments in Philadelphia.

I also owe profound thanks to Jennika Baines and Kelly L. Balenske of Syracuse University Press for their gracious and patient support of my project and for guiding the manuscript through all phases of its production. I must acknowledge the brilliant copyediting of Annie Barva, who caught and corrected several grammatical infelicities and who found far too many inconsistencies in the text. And I need to thank the anonymous readers for their very helpful suggestions for improving the text. Of course, I am responsible for all errors that might appear in it.

English translations of the titles of Yiddish-language newspapers and journals as well as specific Yiddish words or phrases are included in the glossary. The newspaper *Frayhayt* (Freedom), was also known as *Morgan*

Frayhayt (Morning freedom). Depending on the source, both titles are used interchangeably in the text. So, too, *Forward* also appears as *Forvetz* depending on the source. And other names, such as "Birobidzhan," the Soviet Autonomous Jewish Republic, are spelled variously, depending on the particular source.

All illustrations from *Der Groyser Kundes*, *Yiddisher Imigrant*, and the *Arbayter Ring* pamphlet are included through the courtesy of the YIVO Institute for Jewish Research, New York.

A word about the quality of some illustrations. Some were downloaded from microfilm copies of old journals and newspapers, a few more than one hundred years old. The poor quality of some microfilms and the downloading and digitizing processes compromised some images. And those illustrations photographed directly from journals and newspapers were sometimes marred by creased and yellowed pages. On occasion, printers ink had spread beyond borders. Furthermore, some librarians, ever protective and rightly so, would not let me photograph near a window for fear sunlight might further ruin some images. Nor was I always allowed to open a bound volume completely because the binding might crack, and loosened pages could then fall out. As a result, some prints I would have enjoyed showing here were simply beyond recovery. Such important artifacts of Jewish American political and cultural history await the development of more advanced technology for reproduction in future books and articles.

The discussion in chapter 6 of Ben Shahn's painting *Ram's Horn and Menorah* appeared in more elaborate form in my book *American Artists, Jewish Images* (Syracuse, NY: Syracuse Univ. Press, 2006), 102–4. My remarks about Clement Greenberg's and Harold Rosenberg's writings, also in chapter 6, are based on my article "Clement Greenberg, Harold Rosenberg, and Their Jewish Issues," *Prospects* 30 (2005): 651–64. And some observations scattered through chapters 1–5 appeared in very abbreviated form in "Social Concern and *Tikkun Olam* in Jewish American Art," *Ars Judaica* 8 (2012): 55–80.

I have made every reasonable effort to locate the estate representatives of the artists and owners of all the works here illustrated. To those I could not find, I offer my apologies and hope to add your names at the earliest opportunity.

Social Concern
and Left Politics in
Jewish American Art

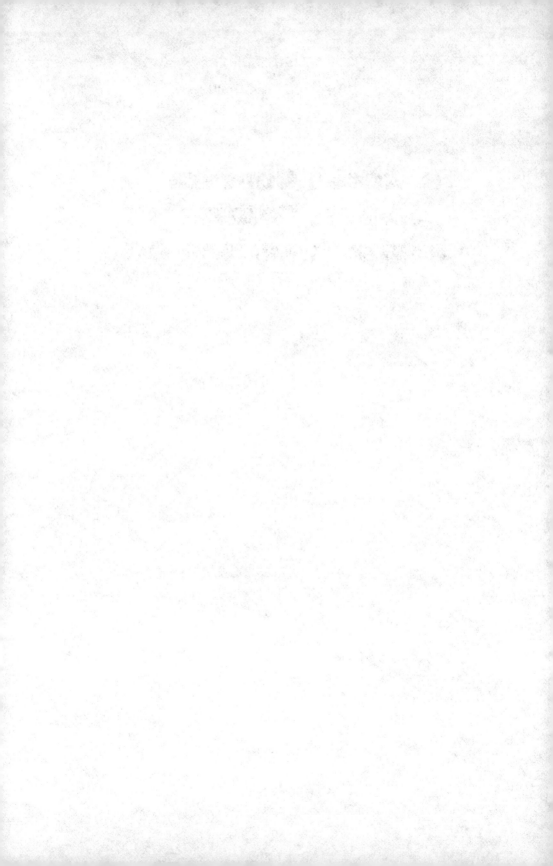

Introduction

AN ARTICLE by Milton Hindus in a 1927 issue of the *Menorah Journal* describing the connections between Jewish radicalism and religious heritage set in motion research for this book. Its author suggested in a simple but detailed argument that Jews in eastern Europe became radicalized only after being exposed to books, articles, and pamphlets by non-Jewish authors. He qualified this statement by adding:

> It must be owned that the heritage [the Jewish radical] brought with him from his Jewish world facilitated his process of acclimatization and his rise to prominence and leadership [in radical causes]. Many of his Hebraic beliefs and practices which had greatly influenced his thinking, many old Jewish traditions which had become part of his everyday psychology, fitted splendidly into the theoretical framework of the radical causes. . . . Both exalt the underdog. Both scorn the wrongdoer. (1927, 372)

As labor sociologist Moses Rischin succinctly summarized Hindus's thoughts decades later, "For most Jewish socialists, although unaware of it, socialism was Judaism secularized" (1962, 166). The present study is meant to fill some of the gaps in what will always remain a complicated story detailing the connections between religious heritage, social concern, and political radicalism in the Jewish American art world from the time of the Great Migration from eastern Europe in the 1880s to the start of World War II in the early 1940s.

In recent years, very few art historians have touched on the connections between religious heritage and radicalism even though it would seem logical to do so because the former would help explain the latter

1

(those that do include Baskind 2004, chap. 3; Mendelsohn 2003, 173–84, and 2004, 99–127). Although the artists' religion has been acknowledged, most art historians have barely recognized the importance of connecting cultural and religious backgrounds with radical politics. For example, Bram Djikstra at least acknowledges in *American Expressionism: Art and Social Change, 1920–1970* that the majority of artists he discusses were Jewish, but he does not consider why so many were involved in social causes (2003, 12). Andrew Hemingway in *Artists on the Left: American Artists and the Communist Movement, 1926–1956* (2002) and Helen Langa in *Radical Art: Printmaking and the Left in the 1930s* (2004) do not even say that much. Hemingway illustrates the works of about ninety artists, of whom roughly forty-six (about half) were Jewish, and Langa reproduces the works of forty-seven artists, of whom about nineteen (roughly 40 percent) were Jewish. Hemingway even mentions in the introduction to his book that he did not consult Yiddish-language material or, evidently, English-language Jewish publications (2002, 4). For whatever reasons, these authors neither explain nor comment on the amazing differences between the percentage of Jewish artists among the artists they discuss and the percentage of Jews in America, about one and a half percent in the early and mid–twentieth century.

A brief description by Langa of the lithograph *Primary Accumulation* (1933) by Hugo Gellert (1892–1985), who emigrated from Hungary in 1905, provides a way to begin to think about this matter (fig. 1). In Gellert's print, the impassioned, larger-than-life orator, his interracial American audience behind him, seems to be bellowing at us, the viewers, to do something at a difficult time during the Great Depression—perhaps go on strike, demand higher wages, join a union. Of this print, Langa writes: "This dramatic image of an impassioned worker exhorting an interracial audience visualized ideals derived from contemporary Communist theory" (2004, 15).

She probably did not plan to have that sentence parsed when she wrote it, but it was most likely not just Communist theory that influenced Gellert. He and other Jewish artists were not a bunch of blank tabulae rasae sitting around waiting to have their minds filled with Communist theory. There must have been other reasons for finding left-wing causes so attractive. A partial list of those who contributed their time and energies to

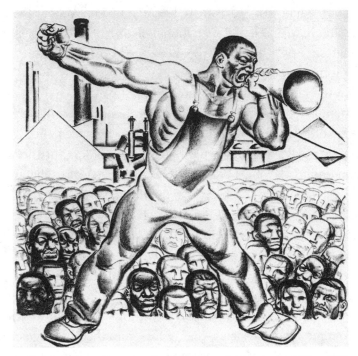

1. Hugo Gellert, *Primary Accumulation*. Lithograph, 13⅝ × 13⅞ in. From the portfolio *Karl Marx' "Capital" in Pictures*, published in 1933 in an edition of 133 (New York: Ray Long and Richard R. Smith). Courtesy of Mary Ryan Galley, New York.

left-wing causes during the 1930s includes Phil Bard (1912–66), president of the Artists' Union in 1935; Jacob Burck (1907–82), an art editor of *New Masses*; Hugo Gellert (1892–1985), an art editor of *New Masses*, director of the first John Reed Club art school located in New York, organizer of the Municipal Artists' Guild of the United Scenic Painters, and leader of the Artists' Committee of Action and the Artists' Coordination Committee; Boris Gorelick (1912–84), a founder of the Artists' Union in 1934 and its president for three years; Harry Gottlieb (1895–1992), president of the Artists' Union in 1936–37 and an editor of *Art Front*, the newspaper of the Artists' Union: William Gropper (1897–1977), a founder of the John Reed Clubs in 1929; Louis Lozowick (1892–1973), a founder and an art editor of *New Masses* and a secretary of the John Reed Clubs; Joseph Solmon

(1909–2008), editor of *Art Front* in 1936; and Max Weber (1881–1961), national chairman and honorary national chairman of the American Artists' Congress (AAC) from 1936 to 1940. (See "Artists' Biographies" for further information.)

Given the facts that only a relatively small percentage of Jews in the general population became politically radical and that a relatively small percentage of artists in general were Jewish, why, given their relatively small numbers, did so many Jewish artists and writers turn to the left? The reasons ultimately lie, I believe, in two separate factors that were conjoined by the events of the 1930s: first, the influence of their religious and cultural heritage or, to say it differently, what they brought with them to their art before they became artists; and, second, the ever-present anti-Semitism in America that grew especially virulent during the 1920s and 1930s with the increasingly terrifying policies of Hitler's Germany. Like it or not, artists understood that in the eyes of many, including themselves, they were Jews first, last, and always and thus vulnerable whether they wanted to repress or disassociate themselves from their heritage or not. As the 1930s progressed and the dire circumstances of Europe's Jews grew increasingly evident, many on the left looked to the Soviet Union for leadership to combat anti-Semitism despite Stalin's dictatorial excesses. The Soviet Constitution unequivocally stated equality for all, and by 1935 the Soviet Union was the only country that openly condemned Nazi anti-Semitic activities.

This book is about those artists, illustrators, and writers whose intentions were to help the poor, the needy, and the downtrodden. My premise is that their sense of social concern and communal responsibility that they absorbed as youngsters influenced their political choices. They were born in eastern European communities or heavily Jewish neighborhoods in America, where they learned about and absorbed community and religious values while growing up. They knew who they were and where they came from. They read articles and books and spoke to each other in various eastern European languages, and, if the many letters collected in the Smithsonian Institution's Archives of American Art (AAA) are any indication, they often communicated with each other in Yiddish and even sent each other Jewish New Year's greeting cards, regardless of their political affiliations.

In that sense, they never left home. Their Jewish particularism and their universalist intentions, to greater or lesser extent, reinforced each other. The link between biblical Judaism and radicalism in the art world varied from individual to individual, but even during the heyday of Communist influence during the 1930s religious heritage remained evident (see chapter 5). As historian Ezra Mendelsohn explains,

> The subsuming of Jewish particularism within a discourse of universalism is to be expected by anti-nationalists, Jewish leftists in general, and of Communism particular. At the same time, one might argue that this very attitude—this universalism—was itself a hallmark of secularized Judaism, so that even if the "text" does not usually reveal a link between Jewishness and radicalism, a Jewish subtext may nevertheless be postulated, if not proven. (2004, 101)

Sometimes the link was pretty obvious. Artists raised in Jewish neighborhoods, whether or not in Orthodox households, would have absorbed community values concerning responsibility for those in need even if as adults they chose to suppress their heritage and ignore religious rituals. They would have been familiar with the thoughts and perhaps the actual words of verses 14:27 to 15:11 in Deuteronomy that summarize as clearly as possible the Jewish vision of justice (Jacobs 2009, 34–40). Passages in Leviticus 19 also provide instances of social justice by condemning theft, deceit, fraud, and the favoring of the rich and by reminding landowners to allow the poor to gather fallen fruit and the gleanings of the harvest. One historian wrote several decades ago that in the Book of Ezekiel "the Hebraic doctrine of human equality reached its highest expression" (Finkelstein 1936, 29; see also Isaacs and Olitzky 1995, 156–77). In addition, treating others fairly and honestly and helpfully is especially emphasized in Ezekiel 18:7–9. The Talmud states flat out, "All Jews are responsible for each other" (Babylonian Talmud, qtd. in Dorff 2005, 131; Jerusalem Talmud, qtd. in Konvitz 1978, 43; see also Vorspan and Lipman 1959, 6, 23).

Several passages found in Prophets also speak to and invoke the idea of helping to create a better world. In Isaiah, for example, we read: "Learn

to do good. Devote yourselves to justice. Aid the wronged. Uphold the rights of the orphan. Defend the cause of the widow" (1:17), and "Stored wealth shall become as tow [a chain?], And he who amassed it a spark. And the two shall burn together, with none to quench" (1:31). In modern times, these passages elicit a reference to monopolies, trusts, and business moguls. One might also point to such passages as Micah 6:8, Jeremiah 22:11–17, Zechariah 9:9–10, Amos 5:14 and 8:1–10, and Proverbs 31:9, which condemn the rapacious, the avaricious, and those who defraud the poor and rob the needy. Other passages virtually demand that one should seek good and not evil and accept responsibility for the less fortunate, and still others allude to messianic times.

Furthermore, of the 613 commandments a Jew is supposed to follow in his or her lifetime (a literally impossible task in the modern world), some are quite applicable to the notion of social concern. Numbers 13, 22, 76, 77, and 489, respectively, tell you to love your neighbor as yourself; to teach Torah to your children; to recite the central prayers twice daily and always study Torah wherever you are; to serve God with prayer; and, especially important for those concerned with union organizing in early-twentieth-century America, to prevent industrial accidents, to aid the impoverished, and not to stand idly by if somebody's life is in danger. Several other commandments are concerned with promptly paying salaries as well as alleviating oppressive work conditions.

Modern theologians, whom the artists probably did not read but whose writings reflected community values, also considered the moral aspects of social concern, thus indicating how pervasive the concept of responsibility is in Judaism. For example, Rabbi Abraham Isaac Kook (1865–1935), a Torah scholar and the first Ashkenazic chief rabbi of Palestine, thought it important to integrate Judaism into the general culture and to introduce Jewish values from the private to the public sector. Rabbi Joseph B. Soleveichick (1903–93), head of the Rabbi Isaac Elchanan Theological Seminary of Yeshiva University, felt that Jews were duty bound to "stand shoulder to shoulder with the rest of civilized society over against an order which defies us all. . . . We must protect human rights and aid the needy" (qtd. in Shatz, Waxman, and Dramert 1990, 2, 4). And Abraham Joshua Heschel (1907–72), who taught at Hebrew Union College and the Jewish

Theological Seminary, stated much the same thing when he wrote, "Who is a Jew? A person whose integrity decays when unmoved by the knowledge of wrong done to other people," and "[Judaism] leads us to regard injustice as a metaphysical calamity" (1996, 32, 7).

Clearly, conflating religiously based thoughts with universal responsibilities has been an integral part of Jewish culture for millennia. As one observer has suggested, "In the most general sense, [social concern] is associated with the thesis that Jews bear responsibility not only for their own moral, spiritual, and material welfare, but for the moral, spiritual, and material welfare of society at large" (Shatz 1990, 1).

It has been generally understood that most radical Jews of the pre–World War II era never really abandoned their culture. For example, Sorin has pointed out that such a break, generally speaking, "did not necessarily mean a break with ethnic culture rooted in traditions of religious consciousness, which prevailed in the Jewish community" (1992, 174). And literary critic and cultural observer Irving Howe states that however ambivalent Jewish Communists were to everything Jewish, they could not escape their heritage (1976, 330). This is important to keep in mind because, as literary historian Daniel Aaron points out, an artist's Jewish political beliefs that "promised justice, the elimination of national frontiers, and the brotherhood of man [were] only a secular blueprint of an old Jewish dream" (1969, 264; see also Lautner 1996, 43, 46).

To make this point crystal clear, many social historians of Jewish life in America have understood this connection and have written many books and essays about it. In fact, Sorin premises his book *The Prophetic Minority: American Jewish Immigrant Radicals, 1880–1920* on the assumption that even the most politically oriented, secular-minded Jewish socialists never forgot their heritage and often invoked it in their speeches and writings—and therefore in their thoughts: "Without the cultural dimension, without Jewish religious values, proletarianization and exploitation by themselves will not explain Jewish socialism" (1985, 3). Literary critic David Daiches, who grew up in Edinburgh, the son of an Orthodox rabbi and a student of the Bible, writes of his own radicalization that "modern Socialist teaching seemed to round out those ancient utterances, and my turn to the Left was due as much to the Hebrew prophets as to Marx"

(1944, 29). And author Louis Kronenberger believed that "a social conscience is today a distinguishing mark of American Jewish writers; and partly, no one can doubt, because they are Jews" (1944, 22).

Another way to come at the conflation of religion and politics and the turn to radicalism is to call attention to Eric Hobsbawm's concept of invented tradition. As Jewish artists abandoned their religious heritage for newly developing radical secular positions in mainstream culture, they nevertheless called upon that heritage to support their current activities. Invented tradition, Hobsbawm notes, seeks "to inculcate certain values and norms of behavior by repetition, which automatically [implies] continuity with the past. In fact, where possible, they normally attempt to establish continuity with a suitable historic past." Because America offered Jewish artists the kinds of freedoms they had never before experienced in eastern Europe, and because there was no radical Jewish art tradition to fall back on, there was an "attempt to structure at least some parts of social life within it as unchanging and invariant" (1983, 1, 2).

As if in answer to Hobsbawm, historian Arthur A. Goren notes that because the majority of immigrants came from traditional societies, "the communal thrust of Judaism—the sense of being a community of fate, the discipline imposed by *halacha*, and the obligation to brethren in distress— was still at the heart of their religio-ethnic outlook" (1980, 11). In this light, we can say that religious heritage still mattered, so that artists constructed their present based on aspects of their past (see Heyd and Mendelsohn 1993–94, 202; Michels 2001, 25; Wald 2004, 137; Zucker 1994, 175).

Other background factors might also help us understand the turn to left-wing politics. These factors cannot be quantified but are nevertheless interesting to consider for their effects on all Jews, not just those in the art world. Maurice Hindus suggested in the late 1920s that radicalism provided a way for Jews to fight anti-Semitism and compensated for Jewish sensitivity to discrimination and to a socially constructed sense of inferiority and self-hatred. "There is no other movement in existence, not even religion," he offered, "which so audaciously attacks racial ill-feelings as does modern radicalism" (1927, 377).

Psychiatrist Karl Menninger (1893–1990) advanced a similar theory when explaining the attraction of Jews to the practice of psychiatry. His

insights are suggestive when applied to socially concerned artists of the period covered here (Menninger [1937] 1959). Menninger's thesis, like Hindus's, was not based on the racist canard regarding Jews' "biological predisposition" to radicalism, but on social and psychological factors. He held that Jews especially understood spiritual anguish because of their experiences of suffering during childhood. Simply stated, as children, they had been secondarily victimized because of their responses to their parents' reactions to anti-Semitism. Through strong family bonds, they found dangers of any sort magnified, and as they matured, they did not necessarily lose their sense of fear and distrust of Gentiles but also paradoxically wanted to be like Gentiles.

As a result, Jewish children grew up with a greater desire to help others because of their own desire to be saved from pain. The result was that Jews in both their youthful and adult years might obsequiously befriend Gentiles by wanting to become like them, or, contrarily, they could defy danger by turning aggressive and try to neutralize that danger. In my context here, the latter would mean political activity as adults. They could be both sensitive to anti-Semitic bias and aggressive in order to address those slights. In this sense, memories of Jewish suffering and socially induced self-hatred could be turned into a universalist ethics through socialism—a socialism that lessened the stigma of rejection.

Hindus's and Menninger's theses, therefore, might help explain the relatively large number of Jewish artists involved in left art movements and organizations as well as the leadership roles they assumed in the John Reed Clubs, the AAC, the Artists' Union, and the latter's newspaper *Art Front*.

This book offers a collection of related essays about the conflation of Jewish memories, religious customs, and practices with left-wing politics as these relate to Jews from 1880 to 1940. Chapter 1 includes considerations of religious and political images that show the presence of social concern and that suggest correlations between Judaism and Americanism in the late nineteenth and early twentieth centuries. Chapter 2 discusses ideas by figures such as Karl Marx and John Ruskin, among others, who considered the place and function of art in society, as well as some articles in the Jewish press that reflected those ideas. Chapter 3 focuses on the attraction of communism. In chapter 4, the Communist-controlled press

policies toward art are discussed as well as anti-Semitism in Europe and America. And chapter 5 considers the relevance (or irrelevance) of those policies for artists and illustrators. The concluding chapter charts the growing disenchantment with communism and reflects on Jewish art, art criticism, and the politics of social concern after 1940.

I chose to illustrate the text primarily with cartoons and prints for a variety of reasons. In these media, artists found ways to provoke discussion, to engage with and relate directly to mass audiences through their explorations of society in general and of human-interest subjects in particular, and to overlay their works with religious and political content (Meyers 2003, 47). Ordinary people with whom the public could easily identify were often the centers of attention. As historian Edward Portnoy has observed about cartoons, "More than anything, they are a form of commentary, a type of visual editorial that offers comic or acerbic interpretations of current events or situations. [They] lie at the intersection of art, literature, politics, and culture." And, important from my point of view, Yiddish cartoons often rely on "traditional Jewish religious motifs and textural references used to comment on current issues" (2008, 5, 10–11).

The artists also appreciated the value of cartoons. For example, William Gropper stated, "Cartoons are a medium of expression that has a wide audience and an immediate effect; [this medium] interprets the situations of our life [sic] in the simplest forms so that many people can understand them at a glance" (qtd. in Epshteyn 1927, 139–40). Maurice Becker (1892–?) believed that "the one who loves to paint everyday people and who has the ability as [a] cartoonist, should speak up for them in his cartoons" (qtd. in Fitzgerald 1973, 199). Becker's contemporary Anton Refregier (1905–79), who was not Jewish, said: "Doing cartoons was not a separate activity from our painting or from our lives" (qtd. in Hemingway 2002, 48). And this observation was made about the cartoons of Louis Ribak (1902–79): "He felt that the only kind of work which would harness his ability as an artist to his emotional desire to make this a better world and give him, in return, a living wage was that of cartooning" (Salpeter 1942, 154).

But there are other reasons today to look at these old cartoons and prints. First, because of Jewish communality based on immigrant experiences at

the turn of the twentieth century; second, because of the political affilia-
tions of the midcentury period; and third, because of the disappearance
of cohesive Jewish neighborhoods after World War II except in Orthodox
enclaves, it is quite possible that these old and largely forgotten images will
become a form of primary documentation, "identificatory texts," for Jews
in America (Leavitt 2000, 65; see also Heilman 1998, 78; Keniston 1965,
178). The cartoons and prints as well as the various comments by artists
and critics provide a way to maintain a connection both to the past and to
the Jewish heritage of social concern. Quite probably, they will become
mementos and artifacts of Jewish communality and perhaps provide a
sense of Jewish continuity and Jewish identity formation in what is now an
increasingly fragmented Jewish space.

Selecting illustrations posed certain challenges. My choices were tem-
pered by an uneasy feeling that some very discolored or torn magazine
and newspaper illustrations as well as very poor quality, scratchy microfilm
images might have been more appropriate to reproduce if they had been
in better condition. I should also mention here that lighting conditions
for photographing images were usually terrible; I was not allowed to fully
open some bound volumes for fear of cracking their spines; and many
individual pages had yellowed with age.

As I turned pages in several magazines and newspapers dating back to
the 1880s, it became clear to me that illustrators varied their subject mat-
ter to accord with each journal's nature or bent (cultural, humorous, and
political in any combination) and with their own or their editors' political
positions of the moment. As a result, I chose to keep a certain distance
from incredibly complex and convoluted political and social developments
reported on and debated in the magazines and newspapers. There are, for
instance, no illustrations here concerned with national, local, and union
politics of the moment; of the endless disagreements between different
left-wing political groups; of the vitriolic attacks on individuals whose
politics were considered unacceptable to various journals' policies; of the
ongoing debates between those wanting to assimilate into the American
mainstream and those who preferred to maintain a separate, secular Yid-
dish culture in America; and, finally, of those Zionists and anti-Zionists
(both religious and secular) who were for or against settlement in Palestine.

Nor did I find any reason to rehearse once again the histories of those who at one time or another might have been members or disillusioned former members of the American Communist Party or of splinter parties, followers or critics of Stalin, those friendly or hostile to Leon Trotsky, socialists of one stripe or another, or well-intentioned humanitarian liberals (for more on these groups, see A. Liebman 1979, 458–59, 502–7).

All of these matters are important parts of Jewish history in America, and the prints they engendered are certainly worth serious interest, but they were not pertinent to this study and would have resulted in a book seemingly without end. In short, I selected the images that fit most comfortably within the narrative presented here. Finally, to prevent sprawl, I have kept illustrations to a reasonable minimum. Adding more would not have altered the book's overall theme.

Two important caveats should be mentioned here. First, social concern is obviously not an exclusively Jewish trait. People of other faiths and racial and ethnic backgrounds are also concerned with the plight of the downtrodden and disenfranchised. In fact, the epigraph from Edmund Burke (1729–97) for a book about Harry Sternberg (1904–2002), whose work is discussed in chapter 5, makes this point quite clear: "All that is necessary for the forces of evil to win the world is for enough good men to do nothing" (book epigraph in Moore 1975, 4). Second, I do not and cannot argue that social concern is a general characteristic of all Jewish art. Nor do I believe that a specifically Jewish art exists, especially if one takes into account art made over the thousands of years of Jewish history, the differences between Jewish cultures around the world and the variations in styles and subject matter (abstract or representational, expressionist or analytical), between rich and poor, male and female, urban and rural, as well as religious and nonreligious artists (Baigell 2005). But I do claim that social concern can be considered an aspect of the cultural and religious heritage of Jewish American artists who trace their roots to eastern Europe. That heritage, the one with which I am most familiar, lies at the base of this study.

Religious Images
and Political Concerns

DOZENS UPON DOZENS of authors have described and ana-
lyzed social, economic, and political reasons for the Great Migration of
eastern European Jews to America around the turn of the twentieth cen-
tury. Very briefly, the immigrants began to leave Russia and other east-
ern European lands especially after the assassination of Czar Alexander
III in 1881 because of job discrimination, rising industrialization that
hampered their small-business economy, and the economic and physical
threats of pogroms (more than nine hundred of them recorded by 1905)
(Bloom 1960; Klier and Lambroza 1992; Levin c. 1987; Mendelsohn 1970;
Michels 2005; Vital 1999, 283–570). Most immigrants were not radicals or
involved in radical activities, but some had taken part in demonstrations
and worker organizations in their native lands. At least two artists who
established careers in America, Saul Baizerman (1889–1957) and Frank
C. Kirk (1889–1963), had to flee Russia after the failed 1905 revolution
(Strauss 2004, 15–16). One contemporary explanation stated simply that
the "spirit of radicalism [was] nothing but the reaction against autocracy"
("Retrospect" 1905, 741). The words "nothing but" are easy to pass over,
but they obviously encompassed desires to counter the czars' virtually
unlimited powers as well as to improve working and living conditions and
to alleviate discrimination and poverty.

After arriving in America, some were attracted to radical causes
because of low wages, unbearable working conditions, especially in the
textile industry, and crowded and unsanitary housing facilities in New
York's Lower East Side. Although some returned to their homelands,

the great majority, whether politically radical or traditionally religious, whether desperately poor or well off, found America to be a country in which they could finally live free and without fear of systematic economic repression and organized or spontaneous outbursts of anti-Semitism on the street or in the workplace. For many, America took on the aura of a golden land, a land where Jews no longer felt that they lived in exile or in the Diaspora. Of the various comments that might be quoted here, one by Abbo Ostrowsky (1889–1975), the long-time director of the Educational Alliance Art School, will suffice: "The fact [that] anyone who desired to take advantage of the educational opportunities would not be barred because of his religion seemed the most wonderful thing in the world" (AAA, Ostrowsky, roll 1394, frame 678), a statement about the possibilities of freedom of expression reflected in the works of many artists.

The cover illustration for the January 1909 issue of the *Yiddisher Imigrant* (Yiddish immigrant) (fig. 2), published by the Hebrew Immigrant Aid Society, illuminates unambiguously the place that America held in the immigrants' imaginations (see Lederhendler 1994, 117–19). Under the newspaper's title, a passage from Psalm 17:8, "Shelter us in the shadow of thy wing," is printed on a banner held in the eagle's beak. In the center, the figure of Liberty opens the gate to welcome an immigrant. To the left of the gate, the phrase "Open the gates and let a righteous nation enter" is taken from Isaiah 26:2. The passage "Open the gate of righteousness for me," which appears beneath the gate to the right, is taken from Psalm 118:19 and is traditionally chanted more than once by congregations during the concluding service on Yom Kippur when imploring God to sustain life, to keep the gates of life open for another year, and to open the gates of heaven for the sake of salvation. In this illustration, it clearly refers to salvation in America.

The composition of this print was based on the kinds of illustrations found in contemporary magazines in which images disparate in size, perspective, and even subject matter were placed next to each other in a kind of montage pattern. The figure of Liberty, the largest figure in this print, symbolizes the benefits of life in America. She opens the gates for the Wandering Jew, who, in traditional fashion, carries his possessions in a cloth bundle. On either side of the central image, a line of male

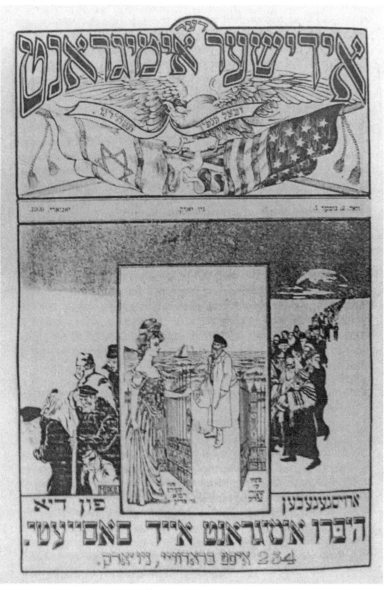

2. Cover illustration, *Yiddisher Imigrant*, January 1909.

immigrants stretches to the horizon as if to indicate that there is room for everybody in America (at least for men—there are no women in the line). At the head of the line on the right, there appears another version of the Wandering Jew. No longer the fearful wanderer fleeing from bodily harm, he holds his Torah scroll and wears his prayer shawl openly and without fear, literally carrying his religious traditions with him to America (Amishai-Maisels 1990, 112).

The figures in this print also represent the majority of immigrants who came to America. Ghetto Jews were welcomed and would find the gates opened for them as they entered a kind of heaven on earth they had never experienced in the Old Country. In America, they would find the freedom denied to them in eastern Europe. For them, America became the land in which they could live with dignity and worship in their own way without fear of prejudice, pogroms, or restrictions of any sort. By living moral, ethical lives as religious Jews and as American citizens who would conduct themselves according to the highest ideals of their religion, they could be both Jews and Americans, as reflected in the Jewish and American flags as well as in the passage from Psalms held in the American eagle's beak at the top of the illustration. Their new country, America, would become for them the new homeland in which they no longer felt alienated and made to feel distinct from other population groups.

The illustration in the *Yiddisher Imigrant* conveys, then, a few messages. First, to remain a Jew with a ghetto mentality, to exist as if still oppressed, meant that one would not become, even if remaining religious, an Americanized Jew living according to American and Jewish ideals of dignity and freedom. Second, after arriving in America, a Jew no longer considered himself or herself to be living in exile, but rather in a free country that guaranteed freedom of opportunity. As Simon Wolf (1836–1928), a leader of the B'nai Brith organization, founded in 1843, said in 1888, America "[is] our Home, our Palestine, we have no other ambition than to prosper in this land of our adoption to whose growth—material, social, and intellectual—we have contributed our share" (from S. Wolf [1888] 1926, qtd. in Mendelsohn 1993, 6).

At the same time, it was felt that a person should not entirely cut off the past by completely reinventing himself or herself as an American.

One should instead retain past traditions while looking forward to future possibilities. As Israel Friedlaender, a professor of the Bible at the Jewish Theological Seminary of America in New York, wrote in 1917, "The Jewish immigrant, like other human beings, cannot be made a new man. The human soul is not a *tabula rasa*. The impress of centuries is indelibly stamped upon it" (from Friedlander [1917] 1961, qtd. in Lederhendler 1994, 119). Therefore, Friedlander held, tradition helped maintain one's psychological balance, a balance essential for encouraging one's self-esteem and good citizenship in the new country. His phrase "the impress of centuries" was, of course, a code phrase for European anti-Semitism.

No doubt, tradition did help maintain one's psychological balance, but living in America allowed artists and illustrators the freedom to express themselves in ways unimaginable in eastern Europe. They no longer had to act like ghetto Jews worrying about defying authorities, possibly being incarcerated, or "keeping their place." Through the decades in America, as their sense of freedom became increasingly internalized and externalized, artists created paintings and illustrations that, by turns, might be aggressive, explosive, adversarial, and challenging and that could trumpet both the virtues and shortcomings of American social, political, and economic systems and policies. America provided them with a sense of incredible creative release, which many took advantage of without much fear of official retribution.

There is no question, however, that by the 1930s criticism of mainstream policies had become more dominant than praise. The initial optimistic hope for the triumph of some sort of socialist governing system in an open society was shattered by the Great Depression and by the powerful influence of communism's intention to impose its economic system on society. But, even then, artists might and often did soften their attacks on capitalism by favoring a Jewish sense of sympathy for the underdogs rather than adhering to aggressive, but not always effective, Communist Party pronouncements.

For many in the immigrant generations and after, there were distinctions between Jewish particularism and political universalism. Nevertheless, many thought that one blended invisibly into the other in that the tenets of Judaism and the belief in American ideals were quite similar if

not identical and could not be disentangled. That is, one could or should be patriotic because American ideals were similar to those found in the Torah as well as in socialism. In the decades just before and after 1900, immigrants, because of their memories of humiliating experiences in the Old Country, tended to glorify America as a nation in which they could pursue their goals openly and freely for the first time within collective memory (Lieven 2004, 135), as suggested in the cover illustration for the *Yiddish Imigrant*.

This attitude contributed to the long-lasting Jewish construction, dating back to the mid–nineteenth century, of a mythic America in which Jewish and American moral and ethical ideals were considered to be one and the same. It was thought then that being a good Jew meant being a responsible American. Thus, Jews could rapidly become good Americans by fulfilling the beautiful statements and sentiments they found in the Declaration of Independence and the Constitution, but that had already been articulated in the Hebrew Bible.

As early as 1854, Rabbi Isaac Meyer Wise (1819–1900) asserted in a Fourth of July oration that "the principles of the Constitution of the United States are copied from the words of Moses and the Prophets" (qtd. in Wenger 2010, 66). In the twentieth century, figures such as Kaufman Kohler (1843–1926), a president of Hebrew Union College, equated justice, liberty, and peace with the essence of both America and Judaism. Supreme Court justice Louis D. Brandeis (1856–1941) wrote in 1915: "The twentieth-century ideals of America have been the ideals of the Jew for more than twenty centuries" (15). Philosopher and social observer Horace Kallen (1882–1974) included in his arguments for cultural pluralism in America the thought that such pluralism is Jews' "duty to America, inspired by the Hebraic tradition—our service to the world in whatever occupation—both these [*sic*] are conditioned, in so far as we are Jews, upon conservation of our Jewish nationality. . . . Let us serve mankind; as Jews, aware of our great heritage, through it and in it strong to live and labor for manhood's good" (qtd. in Lederhendler 1994, 122, 127). And Chaim Zhitlowsky (1865–1943), a prominent socialist and Yiddishist, felt that America's freedom allowed one to remain Jewish (Kallen 1915, 86).

In the mid–twentieth century, Henry A. Wallace, Franklin Roosevelt's vice president from 1940 to 1944, stated in 1940 in the all-embracing language not unlike that of the Communist Party's Popular Front: "The Jewish tradition, the Christian tradition, the democratic tradition, and the American tradition are all one" (1940, 127). And just about the time that World War II ended, then radical author Ben Field evoked the language of the earlier figures when he stated: "The keystone of my ideology, which is a devotion to the cause of the common man, is in the spirit of true Americanism and Judaism. This devotion is proclaimed in the Declaration of Independence and in the prayer of the Jews who asked the Lord to raise the needy from the dunghill" (from the prayer of Hannah in I Samuel 2:8, "He raises the poor from the dust, Lifts up the needy from the dunghill") (1944, 20).

Among authors, Milton Konvitz asserted as his basic premise in *Judaism and the American Idea* that the American ideal of inalienable rights, equal opportunity, and justice was basically Hebraic in spirit. Konvitz, therefore, saw himself as indissolubly American *and* Jewish and was prompted to write: "The ideal of Judaism is a kingdom of Heaven on this earth" where people can live free from fear, want, and with justice and freedom (1978, 15, 21, 193). And Sam B. Girgus, commenting on Konvitz's thesis, notes that "American Jews can be most Jewish by being totally devoted to the ideals of the American Way, since Jewish concepts of human dignity and freedom provide the foundation for the American Idea in the first place" (1983, 328). The historian Abraham J. Karp focuses this thought more specifically when he writes: "Building a house of worship in America was not so much an act of piety as an expression of good citizenship; maintaining it was bearing witness to America as a land of freedom and opportunity" (1998, 4).

The former executive editor of the *New York Times*, Max Frankel (b. 1930), who had to flee Hitler's Germany as a child of eight, has also commented on the connection between Jewish and American values. "Jews codified a set of values and laws synthesized in the Ten Commandments that form the roots of our culture as I see it. There is ultimately no way of explaining the American Declaration of Independence, the Bill of Rights, and the concept of the Constitution—no way of divorcing that from the

ethical precepts that are embodied in ancient Jewish religion" (in Pogrebin 2005, 232).

Among artists, Max Weber most clearly embodied these patriotic thoughts on at least two recorded occasions. In a letter to the editor of the *New York Tribune* published on October 31, 1917, he responded to a previous letter in which its author attacked Jews for their lack of patriotism. Weber stated that Jews were at that very time in fact serving in the United States Army. Then, combining patriotic sentiment with socialist concerns, he wrote that as an American citizen born in Russia and as a Jew, he loved and revered America and prayed for "greater justice, peace, and happiness, for better understanding and harmony among classes, races, and nations. And if it is socialism that might bring this about, then let it be socialism" (AAA, Weber, roll 69-86, frame 471).

And thirty years later, on April 14, 1949, Weber wrote a letter to a member of Alabama University Art Department, accusing him of racism because the professor had told African American students at the traditionally segregated Talladega College not to attend a conference and exhibition at his university. Weber continued: "As an artist with implicit faith in democracy and in the humanitarian tenets of the Declaration of Independence, I am impelled to ask you why you persist in profaning the sacred heritage and name of our great emancipator, Abraham Lincoln." Weber then added that by doing so the professor evoked the name of "the most vile, most evil and hated name in the history of civilization—that of Adolph Hitler" (AAA, Weber, roll 69-86, frame 536).

To bring these thoughts down to street-level reality in the Lower East Side of the early twentieth century, that America really was the golden land where it was possible to thrive without fear of officially sanctioned anti-Semitic thuggery, we need to turn to cartoons in the Yiddish press. There, one can find several images that illustrate government actions of social concern directed at the Jewish community. For example, a cartoon by Leon Israel (1887–1955), who used the pseudonym "LOLA" for his cartoons (Strauss 2008, 28), in the April 1, 1910, issue of *Der Groyser Kundes* (The big stick), a seriocomic magazine with socialist leanings, praised then mayor William Jay Gaynor for protecting Jewish peddlers on the Lower East Side (fig. 3). The caption at the top reads: "When the Messiah Will

Come." The caption below reads: "Mayor Gaynor's Ideals Have Material-ized. A Policeman Is the Protector Angel of the Poor Jewish Peddler." (Wil-liam Jay Gaynor [1840–1913] was mayor of New York from 1910 to 1913.) In this work, Israel depicted a gentle, pot-bellied, angelic policeman whose nightstick hangs seemingly harmless by a strap from his left middle finger and whose outstretched hands almost enfold the Jewish pushcart peddler, a stereotypically bent, skinny, perhaps malnourished man clearly in need of protection. The exaggerated image of the police officer might have been nothing more than an observation but might also have been intended as a joke in that peddlers, who had learned to defend themselves because of circumstances on the street, were not always protected, let alone loved, by the possibly anti-Semitic police, despite Mayor Gaynor's policies.

Most immigrants who arrived in America before and after 1900 were, like the peddler in the cartoon, products of traditional eastern European Jewish culture, especially those who came from small towns and villages.

3. *When the Messiah Will Come*, from *Der Groyser Kundes*, April 1, 1910.

They brought with them traditions of communal life and deep-rooted habits concerning responsibility to others. For example, by 1883 the Jewish community of a large city such as Odessa spent nearly one-half of its communal outlay on charity, and in Vilna around 1912 about 34 percent of the community's welfare budget supported the local poorhouse and soup kitchen. Further, various artisan groups and associations, regardless of their political positions, had their own Torahs for synagogue worship, suggesting that during the years of the Great Migration to America, modern politics, social responsibility, and traditional religious practices were intertwined one with the other (Lederhendler 2009, 8–9, 32–35). As one historian states, "The civil Jewish message of solidarity and mutual responsibility, its insistence that [Jews] have obligations to one another, to the Jewish community, and to society as a whole expressed an authentic Jewish religious conviction" (Woocher 2005, 294).

As early as 1905, the editors devoted an issue of the *American Hebrew and Jewish Messenger* to an assessment of the history of Jews in America and were pleased to state:

> The life of the Jew in America, no matter what the religious complexion of the community, has been a continual social service. It has been a monument of glory to the Jewish people that at no time have we had to turn to others to relieve the distress of our own. We have fulfilled our pledge; we have done our best to be grateful to the country which is our own, our very own. [Russian immigrants] bid fair to do their entire duty toward the less fortunate among them who have been victims of later and fresher outrages. ("Retrospect" 1905, 740–41)

But this observation had been previously validated several years earlier in a lengthy article in the mainstream *Century Magazine*: "None of the older world-religions surpasses Judaism in the merciful provision made by law for the relief of the poor. One of its proudest boasts is that there are so few Jewish beggars in the streets and paupers in the almshouses" (Wheatley 1892, 527).

These remarks are borne out by the great number of charitable and communal organizations formed to help the overwhelming number of

new arrivals adjust to and become integrated into American society (Goren 1970; Konvitz 1978; Michels 2005; Nusan and Dreier 1973; Sorin 1985, 1992; Soyer 1997). A partial listing would include the Hebrew Immigrant Aid Society, founded in 1881; several settlement houses, the most famous in New York being the Educational Alliance, founded in 1891, and the Henry Street Settlement, founded in 1893; in addition to hospitals, orphanages, and mutual aid societies (landsmanshaftn) organized by former residents of Old Country communities to administer burial rites, provide insurance policies, and support synagogue worship among other functions. By 1910, there were around two thousand such societies. As early as 1904, the United Hebrew Charities received 10,334 requests for aid from its own funds in addition to overseeing other support groups. And between 1908 and 1922, the New York Kehillah, a loose-knit, self-governing body of many organizations, helped recent arrivals adjust to a new life in a new land.

Jews contributed to or were entirely responsible for the formation of several unions, including the Jewish Workingman's Association, founded in 1883; the United Hebrew Trades, formed in 1888 from more than twenty previously organized Jewish worker unions that by 1914 included 104 affiliated unions with 250,000 members; the Jewish Socialist Federation, founded in 1912, which emphasized worker education; the Arbayter Ring (Workmen's Circle), founded in 1892, which sponsored general education and art programs, including trips to museums, as well as summer camps for youngsters and provided its members with health insurance, tuberculosis sanitariums, as well as medical and burial assistance programs; the International Ladies Garment Workers Union in 1900; and the Amalgamated Clothing Workers of America in 1914. And, finally, in 1906, the American Jewish Committee was founded to defend civil and religious rights as well as to secure equal economic, social, and educational opportunities initially for Jews and later for the public at large, the idea being that "what was hurtful or degrading to American Jews was hurtful or degrading to Americans" (Konvitz 1978, 174).

It should be noted here that unions such as the International Ladies Garment Workers Union and the Amalgamated Clothing Workers of America were especially important to the immigrants because—unlike labor organizations in eastern Europe, which were not very effective owing

to local- and state-supported religious prejudice—they provided a means to enter into and become upwardly mobile in the American industrial system. (See discussion of murals in chapter 5.) As historian Eli Lederhendler (2009) makes clear throughout his study of Jewish immigrants and American capitalism, intertwined political, religious, and economic reasons consequently prompted support for unions because immigrants found them essential vehicles for improving their economic and social circumstances in America.

Joining these organizations also served another purpose. Most of the east European Jews who came to the United States between 1880 and 1920 identified in some way with Orthodox Judaism. As they abandoned synagogue membership and old-fashioned religious rituals, they turned to organizational life outside the synagogue, thus in an odd way maintaining their separate religious distinctiveness even as they developed new cultural and political associations. Irving Howe points out that Jewish trade unions—and he emphasizes the word *Jewish*—were the most important secular institutions created by immigrants, and the *landsmanshaftn* were the most innovative. In his opinion, the garment unions "were an essential part of immigrant life, helping to ease its hardships and giving our people a fragment of dignity," a position articulated throughout the early decades of the twentieth century (1982a, 149, see also 8; and see C. Liebman 1974, 278–79).

As difficult as the adjustment process might have been culturally and financially, recently arrived immigrants, now proud, newly minted Americans, did not forget those they had left behind in eastern Europe who still suffered from pogroms, the dislocations brought on by World War I, the Russian Revolution, and the civil war that followed. Magazines such as the *American Hebrew* provided monthly reports of one horrible event after another and of the various organizations raising funds to help refugees who shuttled between small towns and large cities to avoid murder squads ("Among Our Brethren Abroad" 1917, 148). One comes on passages attesting to the feeling of responsibility for both the most recently arrived immigrants and those still living in the Old Country. In an article in an issue of the *Jewish American* published in Detroit in 1901, the author, noting the arrival of so many Russian Jewish immigrants, called on those who had

already become financially successful to help "their struggling brethren." Each individual Russian Jew, the author wrote, "is our brother and as Jews we must receive him as such" (qtd. in Sacher 1992, 150). In an article published in 1905, another anonymous author stated: "What is true of New York Jews is true of their coreligionists everywhere. The Jew has always cared for his own poor" (qtd. in Wenger 1996, 136).

Artists were also quite aware of Jewish tradition as well as of the many organizations helping recent arrivals. For example, Abbo Ostrowsky, who immigrated in 1908, when commenting on the aid provided to him by the Hebrew Immigrant Aid Society and other groups, stated that the "time honored tradition, commended by religion to give shelter to the wayfarer, was warmly extended to the newcomer by the community." He went on to say: "Throughout the centuries the practice of *Gemilath Khesed* was hallowed as one of the three precepts that sustains the spiritual life of the Jewish community: the Torah, worship of God, and *Gemilath Khesed* [or] acts of loving kindness. Specifically it means in Hebrew, a free loan" (AAA, Ostrowsky, roll 1394, frames 636, 641). (The concept of free loans expressed in Exodus 22:24 ultimately lay behind the creation of the Hebrew Free Loan Society in 1892.)

With so much emphasis on helping others, what kinds of contemporary images illustrated communal responsibilities? Unfortunately, too few works from the turn of the twentieth century survive. Settlement houses apparently did not keep records of exhibitions or of art classes. Magazines and newspapers emphasized economic and political matters; few included illustrations of any sort. But one major and surprising source of information for the modern scholar has come down to us in the form of postcards. Many thousands were produced during the so-called golden age of postcards that lasted from roughly 1898 to 1918, although some were printed before and after these dates (Morgan and Promey 2000; Smith 2001, 229–44; Weiner 1997). The precise history of the postcard craze is somewhat murky. Most American card companies were located in New York, but many cards were printed in Germany. Perhaps local companies such as the Hebrew Publishing Company, founded in 1883, the Williamsburg Art Company, and the Bloch Publishing Company were only or primarily the American distributors. Artists known to have designed

cards were Europeans and included Moritz Daniel Oppenheim (1800–1882), Alphonse Lévy (1843–1918), Ephraim Moses Lilien (1874–1925), Hermann Stuck (1876–1944) Samuel Hirszenberg (1865–1908), Leopold Pilchovski (1869–1933), and Lazar Krestin (1868–1938).

Despite the popularity of the postcards, the European artists' influence on the course of political art in America appears to have been minimal because so many of their works emphasized Jewish suffering and portrayed shtetl scenes rather than aggressive political actions. In fact, it has been pointed out that because of the freedom political cartoonists enjoyed in America, they had greater influence on their counterparts in Warsaw, the major center for this kind of art in eastern Europe, than the other way around (Portnoy 2008, 274).

The postcards discussed here were aimed at Jewish audiences and cataloged under the following headings: "biblical," "religious," "Zionist," "general," and "comic." The most relevant were those intended to be sent to friends and relatives on Rosh Hashanah, which marks the Jewish New Year, and other holy days associated with it. Some postcard images emphasized communal responsibility; others emphasized religious continuity. Of the former, one of the most revealing of the mindset that created immigrant communal organizations shows the American-based community responding to the needs of those about to emigrate from the Old Country (fig. 4). This postcard is virtually a graphic illustration of the following sentences from an article in the January 1892 issue of *Century Magazine*: "[Those] in New York write to friends left behind. These hasten to follow, and come in tens of thousands. On arrival they are met by more fortunate co-religionists proud of common origin and history, who welcome them to 'home' where they receive food and shelter" (Wheatley 1892, 324). It is also a perfect example of the notion that "beyond the daily devotionals, religion bound its ethical prescriptions into the social fabric, making charity an obligation" (Rischin 1962, 37).

If one were looking for biblical precedent, it would appear in Leviticus 15:31. "If your kinsman under you continues in straits, comes under your authority, and you hold him as though a resident alien, let him live by your side: do not exact from him advance or accrued interest. . . . Let him live by your side as your kinsman."

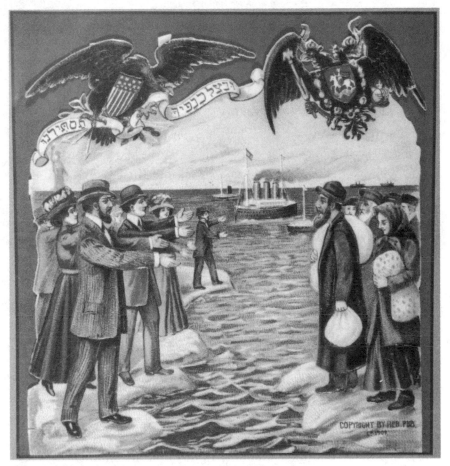

4. *Shelter Us under the Shadow of Thy Wings*, 1909. Print Collection. Courtesy of the Library of the Jewish Theological Seminary.

On the left side of this postcard, those dressed in modern, well-tailored clothing and standing erect have already begun the process of successfully reinventing themselves as Americans, but they have not forgotten those left behind. They reach across the Atlantic Ocean and the ship that will carry future immigrants to welcome their brethren still garbed in the old-fashioned clothing of eastern European villages and towns and whose postures and facial expressions reflect their ghetto mentality. Clearly, the message is that the new Americans will welcome and at least initially take care of relatives, friends, and strangers until they can find jobs, begin their

own transformation into Americans, and then in turn offer help to the yet newer arrivals. The Yiddish words written on the banner held by the eagle hovering above the welcoming immigrants emphasizes that point: "Shelter us in the shadow of Your wings" (Psalm 17:8).

Leaving the Old Country did not mean abandoning long-held traditions of community responsibility. Depending on the needs of the moment, the community was constantly reminded of its obligations to others, as it still is to this day. For example, an illustration in the February 5, 1915, issue of *Der Groyser Kundes* reminded viewers to help those dislocated by the outbreak of World War I (fig. 5). The caption at the top reads: "In Our Times." In the center, the Statue of Liberty stands behind a bearded man who represents both an American Jew and Uncle Sam, weighed down by the guilt provoked by the disembodied, quasi-surrealistic, all-seeing eyes of his fellow Jews in Europe. His posture indicates that he is overwhelmed by the plight of his fellow Jews. The scroll in the man's left hand, suggesting an opened Torah scroll, contains plans to help Jews abroad. But the eyes, watching and waiting for relief that cannot come too soon, fill the man's own vision as he looks out across the water to Europe. The name of a European country is written above each tear-filled eye, as if pleading for immediate help. The caption under each eye reads: "Belgian Jew" or "Polish Jew" or something similar. The caption at the bottom reads: "The eyes of all Jews are staring at him."

It is possible that the cartoonist, LOLA, had in mind two passages from the second chapter of the Pirke Avot, verses 1 and 5. The first passage states that a person, to prevent committing a sin, should know what is above: "A watchful Eye, an attentive Ear and all your deeds are recorded in a Book" (*Complete Art Scroll Siddur* 1984, 551). The usual interpretations of these three aspects are: man's deeds are observed, his words are heard, and he cannot escape the consequences of his behavior. The eyes in the print probably refer to European Jews watching, hearing, and judging the actions of Jews in America. In the second passage, Hillel, a religious leader and teacher who lived in the first century BCE and the first century CE, instructs the reader: "Do not separate yourself from the community." This passage indicates that one must share in the community's woes and do nothing to undermine community solidarity. Whatever his source, LOLA

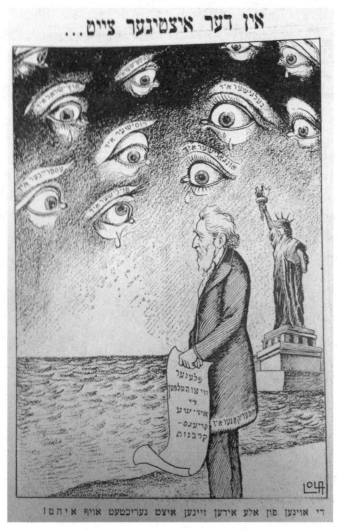

5. Leon Israel (LOLA), *In Our Times*, from *Der Groyser Kundes*, February 5, 1915.

could not be more obvious in pointing out with this nightmarish scene the bearded man's communal and religious obligations to his brethren in Europe even from faraway America.

The image of the Statue of Liberty, which figured in many prints and paintings over the decades, was a constant reminder of how lucky immigrants were to live in an America free from pogroms and the devastations of

warfare. Designed by Frédéric-Auguste Bartholdi (1834–1904), the statue was officially unveiled on October 28, 1886, and soon became a worldwide symbol of freedom. As early as 1892, an article in the English magazine the *Graphic* stated: "Entering a New World: Bartholdi's great statue of liberty in New York harbor has a serious meaning for many shiploads of expatriated Russian Jews to whom it seems to offer a welcoming hand." And in our own time, the meaning of the statue still resonates with immigrants. One very old person recalled in 1984: "When you see that Liberty Statue, when you see that open hand, it is the greatest feeling. It's like going to heaven and God accepts you" (both quotes from Dillon and Kotler 1994, 41).

Many of the images on the postcards emphasized the importance of maintaining and celebrating religious traditions and passing them on to succeeding generations. For Jews then, as now, fulfilling religious obligations was considered an aspect of social concern in the sense of maintaining a degree of psychological stability (as mentioned earlier) as well as the community's viability and continuity. Although one might argue that showing people in old-fashioned garb engaged in old-fashioned rituals impeded Americanization, the cards' popularity also indicated how popular those rituals, traditions, and obligations were, how central they were to the community as a way to maintain itself in face of easy assimilation.

A significant number of the cards illustrate religious rituals and activities that might take place in a synagogue or at home. One card shows people engaged in the ritual of *shlogn kaporet*, a ritual of repentance completed before the start of Yom Kippur in which certain prayers are said to ensure the transfer of one's sins to a rooster (for a man) or a chicken (for a woman) as it is swung around one's head (fig. 6). The bird would then be given as charity to the poor. The few lines seen in the postcard state: "Arise, arise, it's time for the atonement ceremony. Either with a hen or with a coin. Look to the East, day is dawning. A new sun illumines the world" (translated in Weiner 1997, 25 n.). The words at the bottom of the table cloth translate as "Happy New Year." That the people are dressed in eastern European garb might simply be a reminder to honor religious tradition on the holiest day in the Jewish calendar.

The ceremony of *shlogn kaporet* also lent itself to secular attacks on one's enemies. Because the bird will be killed and eaten after prayers

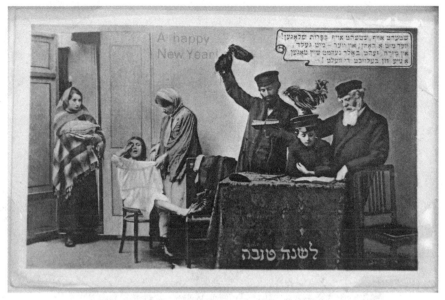

6. *Ceremony of Kaporet*, c. 1915, showing a Yom Kippur ritual. Postcard Collection. Courtesy of the Library of the Jewish Theological Seminary.

are said, one cartoonist in 1889 replaced its head with that of the hated Czar Aleksander III (Portnoy 2008, 78), and in 1943 William Gropper substituted Hitler's head (see illus. 35 in chapter 4)—both works revealing how easily artists could extrapolate political meaning from a religious ceremony.

Other cards portrayed more solemn aspects of Yom Kippur. One depicted young boys and older men deep in prayer, no doubt atoning for their sins on that sacred day, hoping, according to the ritual, that God will grant them another year of life (fig. 7). The elimination of all extraneous elements and the intensity of the individuals at prayer call attention to the profound meaning of that day for Jews. The men cover their heads with their prayer shawls to invoke the holiness of the occasion. The boys do not wear prayer shawls because they have not reached their thirteenth birthdays, when, after the ceremony of their bar mitzvah, they accept adult responsibilities. Nevertheless, the taller boy, like the man in the foreground, indicates that he is already practicing the habit of gently smacking a table or lectern for emphasis as he intones or sings his prayers.

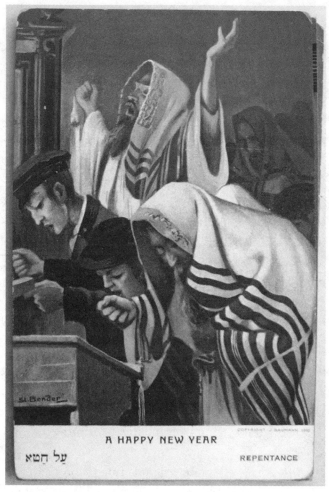

A HAPPY NEW YEAR

עַל חֵטְא

REPENTANCE

7. *Repentance,* undated. Postcard Collection. Courtesy of
the Library of the Jewish Theological Seminary.

Some cards were intended for women (fig. 8). One of them shows
young ladies at prayer and includes the following lines: "The tear of a Jew-
ish girl / Her prayer, her pleading glance / They will not be lost in the abyss
/ They will not go unanswered" (translated in Smith 2001, 244).

One subgroup of cards showed several generations of individual fami-
lies about to enter a synagogue at the start of the Sabbath on Friday eve-
ning for worship services. In the postcard of this type included here (fig.

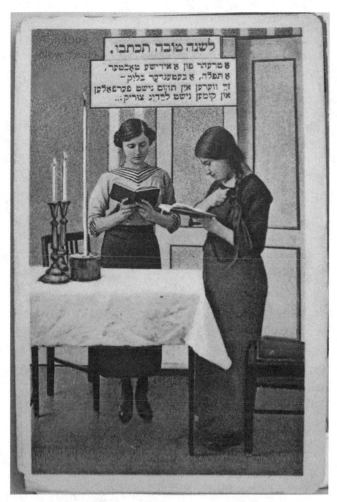

לשנה טובה תכתבו.

8. *Young Girls in Prayer,* c. 1915. Postcard Collection. Courtesy of the Library of the Jewish Theological Seminary.

9), the friezelike arrangement reveals the grandparents still dressed in eastern European garb and the middle and younger generations dressed in both old-style and modern clothing. The grandfather and one of his sons or a young male relative still wear old-style clothing and carry their prayer shawls under the arms, whereas the men in modern dress have either stored their shawls in the synagogue or, more probably, are meant to illustrate their newly minted American character by no longer wearing

their shawls during religious services. (Carrying anything on the Sabbath is prohibited.) The grandmother, bringing up the rear, carries a prayer book as if to remind her brood of their religious obligations as well as to maintain her traditional importance in and responsibilities to a family that is fast Americanizing itself. (For an account of dressing American style, see Schoener 1967, 120–22.)

The postcard also indicates that it is possible to maintain traditional practices and become financially successful in America. The synagogue, undoubtedly built with congregational funds, is set well back from the street; the building itself sports a columnar front, and the family is impeccably dressed. This card and similar cards in this subgroup present two continuing arguments among both religious and political leaders: Should the community assimilate entirely into the American mainstream or maintain a semblance of traditional religious Yiddish culture? And should those who want to maintain a strong sense of Yiddish culture remain religious or turn secular?

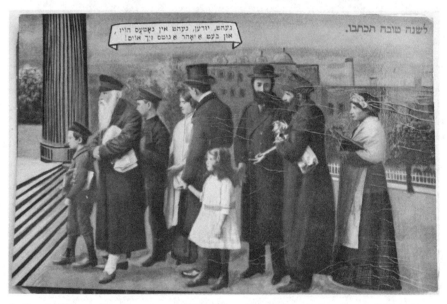

9. *On the Way to Synagogue*, c. 1910. Postcard Collection. Courtesy of the Library of the Jewish Theological Seminary.

The popularity of the postcards suggests that they played an important role in the adjustment to life in America rather than just being an easy and lazy way to send New Years' greetings to friends and relatives. The cards reminded people of traditions difficult to sustain in the new world. Rabbis could provide little guidance because they, too, were recent arrivals, and around the year 1900 there were too few of them in America to do much good. Traditional spiritual life as lived in Europe could and often did collapse. Children might be lost to the religion. Therefore, communal and religious activities were stressed as a way to keep the community in tact (Sarna 2004, 159–66). This is not to say that the postcards could save or prop up the community, but in retrospect they might be considered as reminders of community and religious obligations.

Jewish rituals must have seemed exotic to Christians because we can find illustrations of various practices in mainstream magazines of the period. For example, in an illustration of the havdalah service marking the end of the Sabbath, the father lowers the lit candle into a bowl of wine, and his wife smells the spices in the spice container (fig. 10). Dressed in their finest clothes in honor of the Sabbath, the family is presented in a very dignified manner. The same might be said for the well-dressed individuals attending service in one of the illustrations made by Jacob Epstein (1880–1959) for Hutchins Hapgood's *The Spirit of the Ghetto* (1902) (fig. 11), the point being that one could remain Jewish, aspire to be an American, and attain a reasonable degree of wealth. Perhaps such images were also published to attest to the immigrants' religiosity and to show that they were not, after all, revolutionaries or anarchists or diseased, unkempt degenerates or whatever else others described them as (Baigell 2009b; Schoener 1967, 26, 57).

There are at least two famous images by Jacob Riis (1849–1914), the photojournalist and anti-Semite who in documenting the lives of immigrants and the poor alluded to the filth and unhealthy living and working conditions that Jews were thought to enjoy. His photograph *Ludlow Street Hebrew Making Ready for Sabbath Eve* shows a recently arrived immigrant who lived in a coal chute, his clothing hung on hooks and the table covered by a dirty cloth. He is seated alone for his Sabbath meal, consisting only

10. *Havdalah Ceremony*, from the *Century Magazine*, January 1892.

of a loaf of challah bread (fig. 12). No doubt, it was intended to reveal the filthy conditions in which Jewish immigrants lived, but it also perhaps has an unintended countermessage here, well summarized in a speech given by Rabbi Judah L. Magnes (1877–1948) in 1909, who said, "Strong roots in one's ethnic heritage would avoid the social disorganization caused by immigration and assure a sound integration into American society" (paraphrased in Goren 1970, 67). So perhaps one should read Riis's photograph as showing a person of considerable inner strength who found solace in traditional religious rituals despite terrible living and working conditions and the inevitable disruptions caused by immigration to a new country. The man in the photograph reveals the kind of determination exhibited by immigrants who came to America with their Torah scrolls and prayer shawls in search of a better life, who ultimately succeeded in finding it, and who, as the contemporary Jewish press might have mentioned, would become good, law-abiding Americans.

The second famous Riis photograph shows the airless, unkempt, and crowded conditions of a heder, religious school, that Riis probably thought

11. Jacob Epstein, a synagogue interior, from Hutchins Hapgood, *Spirit of the Ghetto* (New York: Funk and Wagnalls, 1902).

was deleterious to the children's health and well-being (fig. 13). It might very well have been, but the very fact of the school's existence, the determined look of the teacher at the far end of the room, and the placement of the children in the foreground revealed the community's continued obligation to provide a religious education for the next generation despite poverty and lack of decent facilities. In their different ways, the subjects in these two photographs called attention to the community's continued

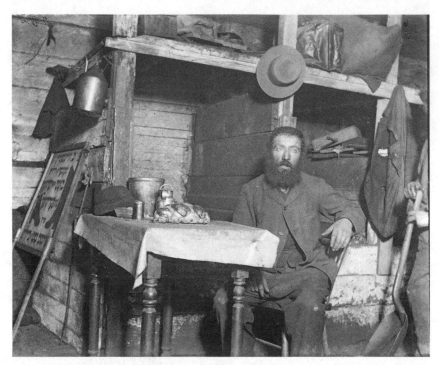

12. Jacob Riis, *Ludlow Street Hebrew Making Ready for Sabbath Eve in His Coal Cellar—Bread on His Table*, c. 1890. Photographic print, 90.13.4.291. Courtesy of the Museum of the City of New York. The Jacob A. Riis Collection.

desire for religious observation and instruction as a way to ensure its survival and vitality.

The religious postcards and other works shown here might possibly be read as nothing more than ephemeral illustrative material, but this would be missing the point that they are also really important markers in the history of the Jewish immigration before and after 1900. They cataloged religious practices, served as a kind of community glue by reminding people of the importance of those practices, reflected the religious freedom that America promised, and suggested that religious observation and American ideals were one and the same and that one could be both a proud Jew and a proud American. Even if these notions were not articulated precisely in this way, the very fact of the postcards' great popularity implies as much.

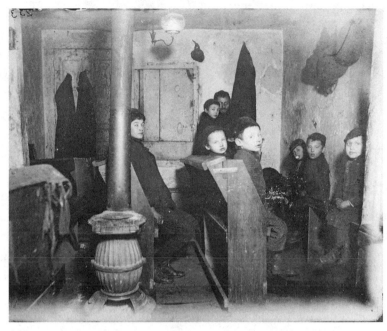

13. Jacob Riis, *Talmud School in a Hester Street Tenement*, c. 1890. Photographic print, 90.13.4.257. Courtesy of the Museum of the City of New York. The Jacob A. Riis Collection.

After World War I, the postcards and illustrations of religious practice in the popular press all but disappeared. Perhaps the public had grown accustomed, at least in New York, to the presence of eastern European Jews. They were no longer a novelty. In any event, children of immigrants, according to all reports, became both less religiously observant and less open about their religious activities. They attended synagogue and engaged in specific religious rituals less frequently. In addition, the growth of anti-Semitism in the 1920s and 1930s probably inhibited many people as well as magazine editors from revealing religious activities so overtly. Jewish New Year greetings sent discreetly in sealed envelopes attracted less attention. It should also be noted here, though, that cards of one sort or another did not entirely disappear. In the papers of politically radical artists such as Max Weber housed in the Smithsonian Institution's Archives of American Art are many saved New Years' cards.

For the next several decades, some artists continued to explore religious themes even though traditional Orthodox practices were increasingly ignored and forgotten. Some artists, such as Jennings Tofel (1891–1959) and Ben-Zion (1897–1987) often created works that illustrated biblical scenes (Baigell 2006, 45–62; Granick 1976). Their works represent those who chose not to abandon the insular world of eastern European Jewish culture even if they did not adhere to religious rituals (for more on Tofel and Ben-Zion, see the conclusion). Other artists, fearing the demise of that culture in America, created works often elegiac in tone that idealized eastern European religious traditions and customs that had been passed on from generation to generation. By the 1940s, perhaps some artists, overwhelmed by the loss of community through assimilation and the ultimate destruction through government-sponsored murder of Jewish communities in Europe, chose to record their own memories before they, too, would vanish from Jewish history.

We can reconstruct the idealized past developed by these artists especially from works collected by Sigmund R. Balka, now housed at Hebrew Union College–Institute of Religion in New York (Rosensaft 2006). For example, in *Men and Boys Seated at a Table* Yussel Dershowitz (dates unknown) re-created a scene common in a small towns in which elders included children in their rituals (fig. 14). The men wear *straymls*, the fur-brimmed hats denoting that they are hasids. One of them brings to the simple plank table what appear to be cups, probably for the wine in the carafe. Their rebbe, or leader, cuts the challah. The scene probably depicts what is known as the "rebbe's *tish*," or "rebbe's table," which takes place after the havdalah ceremony marking the end of the Sabbath. At that time, a religious discussion takes place, and the rebbe's followers will eat the bread or bread crumbs he leaves on the table.

The custom became less common during the 1930s and 1940s because of the attrition of the Orthodox community, but it was revived after the immigration to America by hasidic and ultra-Orthodox Jews from eastern Europe who survived the Holocaust. The ultimate source for this activity might derive from chapter 3, verse 4, of the Pirke Avot: "If three have eaten at the same table and have spoken words of Torah there, it is as if they have eaten from the table of the Omnipresent, as it is said: 'And

14. Yussel Dershowitz, *Men and Boys Seated at a Table,* undated. Drawing, 24¼ × 20¼ in. Sigmund R. Balka Collection at Hebrew Union College Museum, Hebrew Union College–Institute of Religion, New York.

he said to me, This is the table that is before *Hashem* [God]" (*Complete Art Scroll Siddur* 1984, 559).

Such works are not just picturesque fiddler-on-the-roof accounts of a community's customs but rather serve the purpose of recording activities that ensured the continuity of traditional Jewish culture in the second half

of the twentieth century and after. In this context, the artists created these works with a sense of obligation and responsibility to their community. They are of a piece with the postcard illustrations and as such are documents intended to sustain the community's religious rituals as well as its sense of moral and ethical behavior. We might consider them the reverse side of the same coin as left-wing artists' secular-themed works.

It is entirely possible that artists, writers, union organizers, and political radicals might have mailed religiously oriented picture postcards to friends and relatives and perhaps even collected prints such as the one in figure 2 through the early decades of the twentieth century. As Arnold Jacob Wolf notes, "In the case of Judaism, . . . a bifurcation of spiritual and socio-political concerns is hardly possible. Anyone who tries to undertake it ultimately has to deal with the prophets of ancient Israel, still the strongest and most uncompromising advocates for social justice our world has known" (2001, 480; see also Michels 2001, 25, and Rischin 1963, 236).

Yiddish-language socialist newspapers published in New York began to appear in the 1880s, but the following decade was evidently the take-off decade for Jewish radicalism in America (Michels 2005, 3–4; Sanders 1987, chaps. 2–5). Karl Marx's name often appeared in print, but studying his writings and those of other radical thinkers did not mean abandoning one's roots. Balancing secular knowledge and religious heritage was always tricky, and Ronald Sanders's observation regarding a statement made by Abraham Cahan (1860–1951), the noted editor of the socialist newspaper *Forward*, speaks to that very point. Cahan discussed raising his own particularistic views to a universal level in the March 3, 1895, issue of *Di Arbayter Tsaytung* (Workers' newspaper): "Humanity is my people, the wide world is my fatherland, and helping everyone advance toward happiness is my religion!" (qtd. in Sanders 1987, 38). But Sanders cautions that "in spite of Cahan's protestations of universalism, there seemed to be a delicate line, impossible to avoid, between being a good revolutionary and being more aware of one's own Jewishness than revolutionary principles could easily allow" (38).

Cahan and others were well aware of radical European figures. In its first issue published in 1892, the journal *Di Tsukunft* (The future) included

a photograph of Karl Marx (1818–83) as well as articles on Marx and the evolution of the American proletariat. Feature articles about heroes of the left appeared regularly. But in the early years of the new century, *Di Tsukunft* and other left journals tended to avoid calling attention to Jews as a separate people, preferring to stress universal social democratic issues that revolved around all exploited workers, the organization of labor unions, and the amelioration of workplace conditions (Cassedy 2001, 2, 10–14). Nevertheless, they also covered events such as the notorious pogrom in 1903 in Kishinev, Bessarabia, then part of the Russian Empire. It was only when Abraham Liessin became *Di Tsukunft's* editor in 1913 that articles on specific Jewish concerns were added, including articles on the Mendel Beilis blood-libel case in Russia in 1913 (Beilis 1992) and the lynching of Leo Frank in Georgia in 1915, who had been accused of rape (discussed more fully in chapter 5). African Americans were also singled out as a separate people at that time because of racial discrimination.

The contents of many articles on both Jewish and non-Jewish subjects might have prompted Moses Rischin to observe that Yiddish newspapers and public forums "framed universal issues in terms of a morally intense Judaic heritage" (1963, 235). Other cultural observers have also commented on the interconnections between religious heritage and social concern at the turn of the century. In fact, two of the strongest connections were noted decades later, toward the end of the twentieth century. First, "the Jewish workers' movement [both in Europe and America] placed the workers and wage earners at the center of its existence, and focused on the struggle to improve their working conditions and their lives, to enhance their self-esteem and lend them dignity" (Mishkinsky 1994, 17). And second, the various Jewish unions were "profoundly concerned with the physical welfare and educational improvement of their members," all of which reflected "the Jewish community tradition of concern for its people's well-being and education." And "although the rhetoric of class consciousness could be heard, the movement's deepest desire was to achieve industrial peace and harmony, and to affirm the human dignity of the proletarian Jewish workers. Not 'dictatorship of the proletariat,' but rather the improvement of the world was the ideal that would lead to an era of peace and well-being for all" (Gartner 1994, 91, 93).

One reason why unions were so popular was that, as previously mentioned, they provided the major and easiest way for workers to join the American mainstream (Lederhendler 2009, 71–72). Before America's entry into World War I, Jewish labor unions had already turned their attention to life-enhancing activities, such as their pioneering efforts in creating social and welfare benefit programs. These programs included providing unemployment relief, building low-cost housing cooperatives, and establishing banks as well as educational, recreational, and philanthropic services. The International Ladies Garment Workers Union's large educational program included dancing, music, sports, lectures, health and credit services, and a summer camp.

By 1938, novelist Louis Adamic (1898–1951), commenting on union activities at the time, felt that "outside the predominantly Jewish garment workers' unions whose headquarters are in New York and whose interests in education are already a matter of decades, none [of the union leaders of the Congress of Industrial Organization] had any real idea of the new labor movement members' educational needs" (qtd. in Deming 1996, 58). One might also speculate that non-Jewish union leaders were not fully aware that Jewish unions had in part replaced in America those local organizations in eastern European towns that tended to community needs and uplift. The point here is that social concern was a long-term interest long before Communist Party rhetoric became so obtrusive in the 1930s.

By 1900, newspaper and journal illustrations depicting these activities fell into at least four categories: (1) generalized political cartoons without evident religious content; (2) cartoons aimed at specific political targets; (3) institutional cartoons that represented the benefits provided by unions as well as other organizations; and (4) cartoons in which religious and political references were intertwined.

The illustration that appeared on the front page of *Di Arbayter Tsaytung* for April 18, 1890, is of the first kind (fig. 15). Standing at the front of the huge rowboat is a figure reminiscent of Liberty in Eugene Delacroix's painting of 1830, *Liberty Leading the People*. The words "The Coming Socialist Storm" appear in Yiddish across the top. But all of the other words are in English, indicating that the print might have been copied from an English magazine, apparently a common occurrence. The boat, labeled

15. *The Coming Social Storm*, 1890. Cover illustration of *Di Arbayter Tsaytung*, April 18, 1890.

"Organization," includes a person holding a flag with the exhortation "Workmen of all Countries Unite," a direct quote from Marx's *Communist Manifesto*. Another person with a spiked hammer breaks up the ice jam of modern civilization represented by the clergy, the military, monarchists, and the institutions and activities they presumably support—corruption,

modern prostitution, and monopoly, among others. The meaning of this print is that nothing will be able to stop the ship and the ultimate triumph of socialism.

Another such illustration fitting within the first category served as the cover for the February 1894 issue of *Di Tsukunft*. It featured an image of a Greco-Roman-style woman holding the torch of liberty in her left hand, adjacent to the dawn of a new day, and a tablet with the words "Workers of all Countries Unite" in her right hand (fig. 16). Just under the title of the magazine, the names of editors of the Yiddish-speaking section of the "SAP" (Socialist American Party?) are given. (The Socialist Party of America was formed in 1901.)

And the last of this first category to be considered here is the souvenir program of the fourth convention of the Arbayter Ring in 1904 (fig. 17). The figure of Liberty, another Greco-Roman-style woman, stands atop a column supporting a globe flanked by the date the organization was founded for the mutual benefit and education of Jewish workingmen. The patriotic words on the ribbon wrapped around the column state: "We want the nation to be a great benefit to society." A man dressed in his work clothes holds a banner on which is printed, "We struggle against sickness, premature death, and capitalism"—a sequence that is worth a second glance. As one might expect of a Jewish organization, individuals were more important and took precedence over social systems; or, to say it differently, the human trumped the purely political. Well-dressed businessmen stand behind and obviously support the workingman holding the banner.

These illustrations are general in nature. They present the benefits of socialism without describing specific ways to bring it about. In the second category, illustrations that indicate specific methods, one that appeared in *Der Groyser Kundes* in 1911 shows a strike scene in which two women who dominate the composition plan to join an endless column of men who are marching for better wages and workplace conditions (fig. 18). The words "To the march" appear at the top. The banner held by a man reads, "Down with the sweatshop system. An eight-hour workday." The number 8 appears at least three more times in the cartoon. Of the two women, the one on the left with her arm raised is the more militant. The other woman

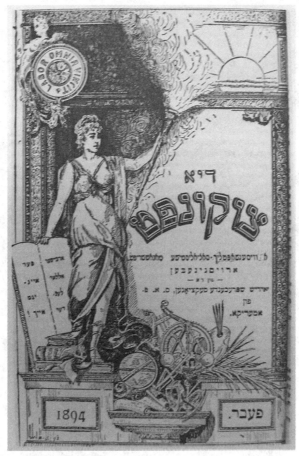

16. Cover illustration of *Di Tsukunft*, February 1894.

appears reluctantly willing to join the strike. The phrase "White goods union" (probably meaning a shirtwaist or waist makers' union) appears on each dress. The caption at the bottom reads, "Ladies Shirtmakers' Union: Let's go. Our men are marching. Let's join their ranks," a series of phrases that in essence encouraged political activism and reflected mutual community support even if the women appear on an elevated plane and are separated from the men, perhaps an unconscious reflection of the concept of the woman of valor (*aishet chayil*) as described in the Book of Proverbs 31:10–31, which orthodox men repeat to their wives on returning from synagogue on Friday evenings.

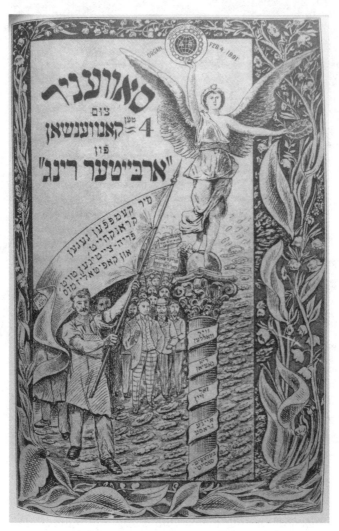

17. Cover of the souvenir program of the Arbayter Ring meeting, 1904.

In some works, religion and politics more obviously interface with each other. Sam Zagat (1890–1964), a major and prolific illustrator during the early years of the twentieth century, was best known for his humorous cartoon strip *Gimple Beinish, the Matchmaker,* which ran from 1912 to 1919. He also created cartoons for *Warheit* beginning in 1912 and for *Forward* from 1919 to 1962 (for his work, see Zagat 1972). In a spare style that

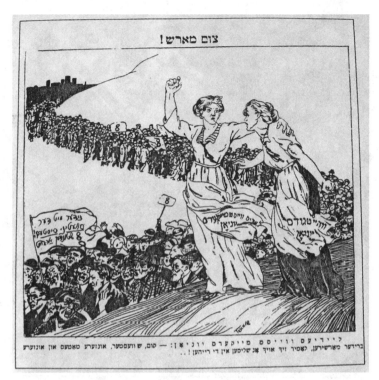

18. *To the March*, from *Der Groyser Kundes*, 1911. Courtesy of the American Social History Project/Center for Media and Learning, Graduate Center, City University of New York.

made his meaning clear, he displayed his opposition to greedy landlords (read: capitalists) by showing what presumably poor renters would like to do, a political variation on instructions in Leviticus for the poor to help themselves (fig. 19).

For the third and fourth types of cartoons, editors of socialist journals understood the value of visually mixing religion with politics, the more astute among them understanding how important it was to conflate one with the other to demonstrate their compatibility (Hindus 1927, 369). Or to say it another way, radicals let it be known that they had not forgotten their heritage or traditional culture and that their interests coincided with all beliefs, whether radical or nonradical, religious or nonreligious. In effect, such cartoons papered over the constant bickering between secular and

I know we should help anyone who's down
but not if he's our landlord.

1920

19. Sam Zagat, *The Landlord*, 1920, from Ida Zagat, ed., *Zagat Drawings and Paintings: Jewish Life on New York's Lower East Side, 1912–1962* (New York: Rogers Book Service, 1972).

religious individuals by implying that one could attend a synagogue and be a socialist without having to choose one or the other (A. Liebman 1976, 291; Sorin 1992, 109). As a consequence, several political cartoons were couched in imagery suggestive of Jewish holidays, weekly Torah portions, Jewish history, and biblical characters (Strauss 2008, 34, 42). As sociologist Arthur Liebman observes, Yiddish culture and language enmeshed the political Left within the Jewish community (1979, 135–36).

May Day, often celebrated in articles and cartoons, celebrated the importance as well as the successes of unions and worker organizations. Of one demonstration in 1890 in New York that attracted ten thousand workers, Abraham Cahan wrote in a moment of exhilaration: "This imposing demonstration is the beginning of the great revolution which will overthrow the capitalist system and erect a new society on the foundation of genuine liberty, equality, and fraternity" (qtd. in Doroshkin 1969, 109). Brave words, partly socialist, partly invoking the French Revolution. Cahan was evidently susceptible to such outbursts. Historian Ronald Sanders describes a speech Cahan gave in which he exhorted "the audience to charge up Fifth Avenue with axes and swords." The remark, Sanders explains, was meant as an intoxicant for the soul rather than as a real call to action (1987, 65). In fact, actual revolution was something rather vague and far off in the future rather than a serious consideration or even a remote possibility in the 1890s.

On the rare occasion, May Day imagery could be presented with Jewish overtones, or so one can infer. In the cartoon entitled *In Honor of May Day* by Walter Krine (dates unknown) for the frontispiece of the May 1908 issue of *Di Tsukunft*, a young woman in a gown of indeterminate style and the symbolic cap of liberty pushes apart a flower-filled trellis wrapped around with slogans describing the bounties of socialism (fig. 20). The English-language words suggest that the print originated in an English magazine. Starting at the top right and continuing clockwise, they state: "A commonwealth when wealth is common"; "Art and enjoyment for all"; "Hope in work & joy in leisure"; "Cooperation and emulation, not competition"; "Shorten working day & lengthen life"; "Socialism means brotherhood, equal opportunity, freedom"; "No people can be free while dependent for their bread"; "No wage slavery"; "No child toilers"; "Production for use, not for profit"; "Solidarity of labor"; "The cause of labor is the hope of the world"; and "Socialism means the most helpful and happy life for all."

Perhaps this image was published in a Yiddish-language journal because some of the phrases have liturgical overtones that might have been familiar to the journal's multilingual readers. At the beginning of the Friday evening service in synagogues everywhere, congregations sing

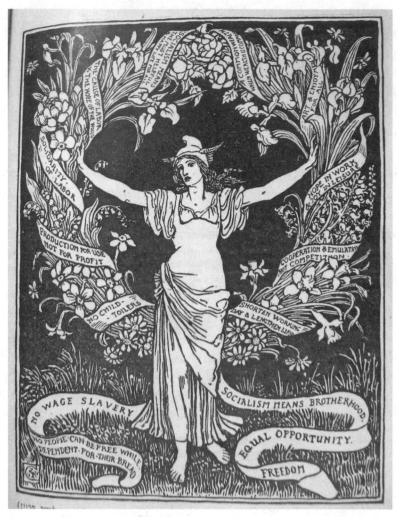

20. Walter Krine, *In Honor of Mayday*, from *Di Tsukunft*, May 1908.

the song "Lechah Dodi," composed by the sixteenth-century kabbalist
Rabbi Shlomo Halevi Alkabetz to welcome the Sabbath. The essential
meaning of the song, sung every week, week after week, year after year, is
that the entire community of Israel is the groom awaiting the bride, the
Sabbath, as she approaches the wedding canopy. But if we think of the
bride as the socialist bride, each four-line stanza of the song addresses
symbolically some aspect of her unique qualities, most of which can easily

be applied to the politics of the day as calls to arms. These calls include changing one's situation and witnessing a reversal of fortune—in particular, "May your oppressors be downtrodden, and may those who devoured you be cast far off. Your God will rejoice over you like a groom's rejoicing over his bride" (*Complete Art Scroll Siddur*, 316–19). One can imagine, then, that any left-wing person who had ever attended Sabbath services in 1908 would have understood that "your God" was a stand-in for socialism and the bride represented the benefits brought to the public by socialism.

Closer to street level, a message similar in its praise of socialism appeared in a cartoon published in the December 6, 1912, issue of *Der Groyser Kundes* (fig. 21). It is an unalloyed, easy-to-read example of how a political statement can be presented within the Jewish cultural framework of social responsibility and human betterment. The action in the cartoon is a simple one. A worker lights a menorah, each of its candle stems labeled with a political activity. The caption at the top is the beginning of the prayer said on Hanukkah on each of the eight days when the candles are lit: "These are the candles that we light." The tailor, his tape measure around his neck and the words for *tailor* written on his shoulder, holds the candle that lights all of the others. On it, the cartoonist, LOLA, wrote "Enlightened." Reading from right to left, the following words are written on each candle holder: *agitation, organization, strong union, general strike, higher wages, shorter work hours,* and *better life.* The caption at the bottom states: "When the tailor lights the menorah, then all will be illuminated. Then there will be more joy and happiness in New York." The tailor, gaunt and tired, seems nevertheless pleased that he is calling attention to these activities and thoughts as he lights the candles.

Several other cartoons that combined socialist themes with biblical, Talmudic, and liturgical references tapped into the community's shared Jewish heritage. LOLA created one of David slaying Goliath for the July 5, 1912, issue of *Der Groyser Kundes* (fig. 22). The words *Socialist Party* are printed on David's sash, *political corruption* on Goliath's belt. The stone launched from David's slingshot and now implanted in the giant's head reads *socialism.* The word *unconscious* is printed on Goliath's sword. The caption reads: "In today's generation, who will subdue the present Philistines (political corruption)? It will not be Roosevelt or Bryant. Only

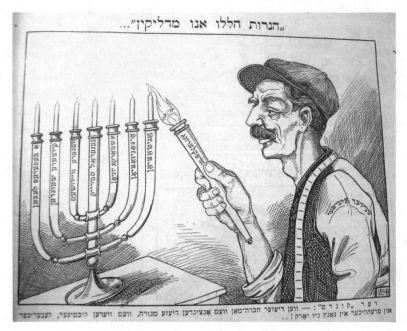

21. Leon Israel (LOLA), *Those Are the Candles We Light*, from *Der Groyser Kundes*, December 6, 1912.

the Socialist Party of America." (Theodore Roosevelt and William Jennings Bryant competed in the 1912 presidential election won by Woodrow Wilson.) In terms of figure placement in the cartoon, LOLA evidently acknowledged that the smaller, distant figure of David, symbolizing the Socialist Party, still had considerable ground to cover before he or it could defeat the giant forces represented by Goliath.

For the December 16, 1912, issue of *Der Groyser Kundes*, artist and writer Saul Raskin (1878–1966, discussed more fully in chapter 2) modified a cartoon from the November 30, 1881, issue of *Puck* that shows Karl Marx in place of Moses leading highly caricatured, hooked-nosed Jewish proletarians across the Red Sea to America (fig. 23). (In the New York edition of *Puck*, Uncle Sam had replaced Moses.) Reading from right to left, as in the Hebrew alphabet, we see a family in transit from the Old Country to the New, illuminated by the sun, around whose perimeter are the words *economic freedom*. The bent posture of the man behind the family

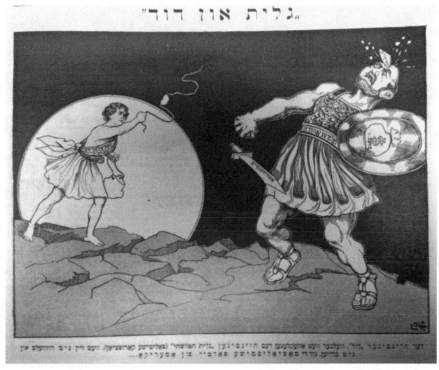

22. Leon Israel (LOLA), *David and Goliath*, from *Der Groyser Kundes*, July 5, 1912.

suggests that he has yet to begin the process of reinvention. The gentleman positioned under Marx, standing erect and wearing American-style clothing, turns to his wife and points to the future.

The words in the upper right state in large print: "The Modern Liberator." The passage in the upper left states: "With the magic wand of science, the modern prophet will part the sea and bring the working folk to the land of milk and honey, the land of economic freedom." The drapery over Marx's suit spells out his name. The words on the parting of the sea enumerate what the folk will avoid in the land of milk and honey: *prostitution, war, hunger, need, slavery, corruption,* and *high prices.* (On this cartoon, see also Buhle and Sullivan 1998, 164; Manor-Fridman 1994, 122, 125.)

Another cartoon, this one on the front page of the March 1, 1907, issue of *Der Tsayt Gayst* (Spirit of the times) requires explanation. Placed

23. Saul Raskin, *Karl Marx the Liberty Giver or the Modern Redeemer*, from *Der Groyser Kundes*, December 16, 1912.

in the middle of articles about the Russian Duma (Parliament), it shows a man with a crown leading a horse and rider (fig. 24). The caption under the cartoon reads, "This is how it is done. The end of all rulers. They have elected a red Duma. I don't think that this Duma will be happy with my leading it." The person saying those words is the man sitting on the horse. Behind him, a man carries a flag with the inscription "Freedom."

In the election for seats in the Duma held two years before this cartoon was published, in 1905, the anticzarist liberals made a very strong showing. As a result, the czar dissolved that Duma. Expecting a better showing of his party in the 1907 election, the czar was surprised once again by the strength of the anticzarists. So he dissolved that Duma as well. Before it was disbanded, the cartoonist made this cartoon; the man on horseback was the opposition leader to the czar.

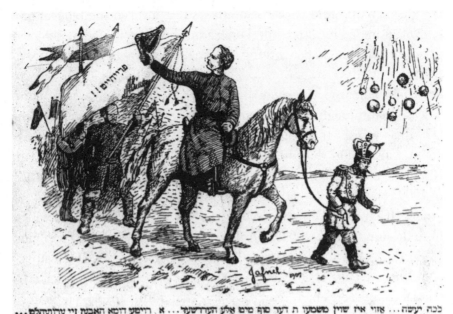

24. From *Der Tsayt Gayst*, March 1, 1907.

What is Jewish about the man on horseback? The headline in the lead article in *Der Tsayt Gayst* on that date translates as "The Revolution Is Dead? Long Live the Revolution." The article's subheadline translates as "Russia Prepared for Us a Nice Purim Gift." (In the Hebrew calendar, the holiday of Purim is usually celebrated in March, the month in which the cartoon was published.) Anybody with knowledge of the biblical story of Queen Esther, the story recited every Purim, would then immediately associate the man on horseback with Queen Esther's relative Mordecai. The evil Haman, whose machinations to kill all the Israelites were discovered by the king, thought that he would celebrate his triumph by riding the horse. Instead, he was ordered to lead the horse that carried Mordecai, his arch enemy. Mordecai waves a three-cornered hat that in this context takes the traditional, triangular shape of the cake called *hamantashen*, eaten especially on Purim, the holiday that celebrates Esther and Mordecai's actions that saved the Israelites from certain death.

One can also find passages in articles that invoked the biblical past to explain the political present. For example, Abraham Cahan quoted a passage in Leviticus when writing about collective bargaining and union strikes: "Saith the Law of Moses: 'Thou shalt not withhold anything from thy neighbor nor rob him; there shall not abide with thee the wages of him that is hired through the night until morning.' So it stands in Leviticus [19:13]. So you see that our bosses who rob us and don't pay us regularly commit a sin, and that the cause of our unions is a just one" (qtd. in Rischin 1962, 182). Historian Jonathan Sarna found a reference written in 1909 concerning an oath taken during a strike of a shirtwaist makers' union: "If I turn traitor to the cause I now pledge, may this hand wither from the arm I raise" (2004, 169). The line was no doubt based on Psalm 137:5, which says, "If I forget you, O Jerusalem, let my right hand wither."

Other such references exemplify Moses Rischin's observation that even secular labor leaders had "religious *élan*. . . . Industrial exploitation and a Marxist dialectic combined to crystallize a folk religious ethic. Scriptural calls to a courageous new era betrayed continuity with the past" (1963, 236), the very point of this study. So it is not surprising that prominent left-wing figures would invoke biblical authority to explain their political positions. For example, the radical Zionist and Yiddishist Chaim Zhitlowsky, liberally quoted by Milton Hindus in 1927, declared that if the prophets Micah and Isaiah were alive today, they would say that God expected Jews to be socialists. Zhitlowsky went on to say, "A Jewish section of the [Communist] International is in a deep religious sense a more thoroughly Jewish organization than all of the religious orders put together because the International is the only organization that seeks to realize the world of the prophets, to achieve a life of brotherhood among the people of the same nation and to unite all nations into one humanity." He concluded by stating that a Jew who is not a socialist is not a Jew in a religious sense (qtd. in Hindus 1927, 368; for more on Zhitlowsky, see Knox 1945, 172–75). Again, one could be a socialist and at the same time attend synagogue or at least not have to choose between the two.

Morris Winchevsky (1856–1932), known as an inflexible antireligious "patriarch of Jewish socialism," said that he had Isaiah to thank for almost everything he wrote. Isaiah "entered my heart and mind with love for

orphans and widows and other defenseless and oppressed people . . . [and with hate for] everything that stands for robbery and murder and deceit under whatever mask it parades." He also thanked Amos, Hosea, and Micah for his beliefs (qtd. in Sorin 1985, 114).

And in the 1930s generation, left-wing journalist and *New Masses* editor (until his break with communism around 1940) Joseph Freeman (1897–1965) noted that he knew many biblical passages by heart, especially those in Isaiah, Amos, and Jeremiah for their "resounding phrases about justice" (1936, 24).

And finally, individuals who participated in rallies, strikes, and various aspects of union organizing also conflated their religious heritage with their political beliefs. For example, a strike leader for the Amalgamated Clothing Workers of America said: "Keeping kosher isn't [being] a good Jew. . . . You [have] to be good and [practice] *tzedaka*. *Tzedaka* means to help a person. . . . In our heritage the first thing is *tzedaka*" (qtd. in Sorin 1985, 110, 8, citing Kramer and Masur 1976, 101). Historian Beth Wenger quotes a Jewish resident of the Brownsville neighborhood in Brooklyn as saying, "We wanted to make a better world. My original commitment to social justice was intensified by my struggles over the dispossessed." Wenger also points out that "the rhetoric of Jewish protestors contained . . . frequent references to Jewish texts and teachings which [were] used to support the legitimacy of their efforts." So radicals often remained "rooted in the shared language and culture of Jewish neighborhoods [in New York City]." She concludes that "neighbors often behaved like extended family, offering emotional and material aid to one another in times of economic distress," and that "Jewish neighborhoods were genuine communities, nurturing a shared culture and providing informal networks for economic assistance and personal support" (1996, 81, 110, 115, 118). Historian Eli Lederhendler notes in similar fashion that boycotts, strikes, and demonstrations became neighborhood social events and were occasionally organized in local synagogues (2009, 67). And, finally, Moses Rischin suggests that "the moral unity of the *shtetl*, the Jewish small town of Eastern Europe, was to be scaled to fit the needs of a world community" (1963, 236).

Even during the worst years of the Depression, radical and conservative Jews, just like immigrants earlier in the century, felt a sense

of responsibility for their entire community. Rabbi Abbe Hillel Silver (1893–1963) noted at the time that the adverse effects of the Depression on community organizations' philanthropic support would not "alter the psychology of our people. . . . The Jewish people is not liquidating its Jewish life because of the Depression" (1932, 44–45).

All of these individuals' statements have been quoted to make the point that choices did not have to be made between Jewish particularism and universalism, that it was possible to meld together religious heritage with political beliefs and actions, whatever tensions individuals experienced over the course of several decades. Furthermore, one has to take into account those who equated the Torah with the Declaration of Independence and the Constitution. For them, being a good Jew in both a religious and a cultural sense also meant being a good American responsible for one's fellow citizens whatever their background. The turn, then, to left politics by labor figures, writers, and artists, whatever their memories of life in eastern Europe and whatever their religious or secular beliefs, was based on their experiences as Jews, their beliefs in American democracy, and their socialist political beliefs—all serving in an intertwined manner as their "conduit to universality" (Goldstein 2006, 178).

2

Aesthetics on the Left

THE IDEA OF PATRIOTISM was apparently taken more seriously than we can imagine today. Allusion to it even appeared in an art review written in 1912 by Henry Moscowitz (1875–1936), cofounder of the Downtown Ethical Society, concerning an exhibition of Russian Jewish immigrant artists at the Madison House on the Lower East Side (1912, 273; see also AAA, Weichsel, roll N60-1, frame 417; Chamberlain 1914, 193; Dyer 1917). In it, he challenged the artists to retain the finest aspects of their heritage as they became Americans. Moscowitz had noted that second-generation, American-born artists were discarding traditions too rapidly by shedding the "spiritual anchorage of the race" and taking on less attractive American characteristics. He cautioned, "We must deepen their [the artists'] conception of an American by relating these conserving forces in their race inheritance with the idealism of American democracy" (273). Although Moscowitz did not explain precisely what he meant or how to achieve it, we can assume that he believed that the best in art, just like the best in citizenship, would be formed from an amalgam of Jewish and American qualities.

Because of Moscowitz's concern for the relationship between artists on the Lower East Side and their public as well as their culture, he might have had more in mind than just Jewish matters. Through books, articles, and perhaps many discussions, he must also have been familiar with the aesthetic theories, notions, and ideas of figures such as the German Karl Marx (1818–83), the Englishmen John Ruskin (1819–1900) and William Morris (1834–96), the Russian Georgi Plekhanov (1857–1918), and the Frenchmen Pierre-Joseph Proudhon (1809–1965) and Hippolyte Taine (1828–93). In their writings, which influenced art critics in the Jewish

American press, these men had considered the ways art was used, in particular art's role in and reflection of the society in which and for which it was made and its relationship to the working classes.

Unfortunately, it is no longer possible to determine which critics read which authors, to what extent, and, in the multilingual world of the Lower East Side, in which language or what they might have absorbed through coffeehouse conversations. (For example, Harry Sternberg, discussed in chapter 5, gave his bar mitzvah speech in German, Yiddish, and English [Moore 1975, plate 5].) And it is also impossible to know the political positions of the critics in America at any given moment in the always volatile political, cultural, and religious climates of the Lower East Side. For example, the artist and critic Saul Raskin, perhaps the most prolific writer on art during the teens and twenties of the twentieth century, called himself initially an international Marxist, then a social revolutionist, then a Bundist, and then, after World War I, a Jewish nationalist (1938, n.p.). The first descriptive term reflected his interest in a universalizing socialism based on class rather than ethnic considerations; the second indicated a more militant period in his political development; the third suggested that he was still a socialist but had considerably modified his universalist position in favor of preserving some type of secular Yiddish culture; and the fourth indicated his positive position on Jews living in a Jewish Palestine. (A fifth position, revived religious interests, is apparent because his late artistic efforts were based on the Bible and on religious rituals [see Raskin 1940, 1942, 1966].)

To simplify matters, we can isolate three major points that commanded the attention of art writers in America right through the 1930s. First, art did not exist in a vacuum but was an integral part of society and needed to be considered in this light. Second, it was as important to bring art to the working classes as to bring musical, literary, historical, and political knowledge to them because art was an essential component to improve their quality of life. Third, artists, cast adrift from the working classes and creatively stifled by the bourgeois world, were encouraged to rejoin their brethren in the larger community of workers in order to release their artistic potential.

Although Marx's writings were known and commented upon by 1900, it was only after the Russian Revolution in 1917 that a change in attitude

can be discerned. Prescriptive directives concerning artists' attitudes and appropriate themes began to be written by those sympathetic to Communist Party dictates published in Communist-controlled publications (see chapter 4). Yet, as historian Hellmut Lehmann-Haupt has indicated,

> there is nothing in the relatively sparse and usually incidental comments on art that one finds here and there in the writings and correspondence of Marx and Engels which could be directly connected with such dominant features of the current doctrines as the insistence on an immediately and easily comprehensible message, the demand for a completely realistic style, and the limitation to a narrowly prescribed range of content. (1954, 5)

In the first two decades of the twentieth century, then, writers tended to discuss Marxist aesthetics in general terms. As Louis Boudin (1874–1952), author of *The Theoretical System of Karl Marx* (1907), explained in an essay entitled "Life and Art" and published in *Di Tsukunft* in that same year,

> Marxism is itself a free platform. Marxism cannot be dogmatic, because it contains no definitions of abstract concepts and no eternal truths. It is purely a method of investigation. As such it may or may not be useful, but it cannot be dogmatic. As a form of literary criticism, it does not say what must be and what must not be; instead, it explains what something is and how it comes to be what it is. ([1907] 1999b, 95–96)

Even though it has often been made clear that aesthetics were not central to Marx's political and economic thought, he did raise certain issues that nevertheless became part of the common discourse among writers on art. As Stefan Morawski, who has written one of the best short summaries of Marxist aesthetics in the English language, has observed,

> Aesthetic phenomena [came to be] studied in a context of socio-historical processes and in this way [were] regarded as part of a broad "civilizational" activity by which the species *homo sapiens* [advanced] slowly to realize an innate potential. Art objects [were] not isolated phenomena but [were] mutually dependent with other cultural activity of

predominantly social, political, moral, religious, or scientific character. (1973, 8; see also Lifshitz 1938; Laing 1986; Raphael 1980)

That is, Marx did set a tone for the way art and its relationship to culture were to be viewed. For example, writers clearly understood and applied indirectly to their own writings Marx's often remarked upon preference for Greek art. He had believed that the significance of Greek art did not lie in its value as a model for proper behavior among the aristocratic and upper classes. Rather, it had for Marx greater "use value" for the Greek populace in terms of the way it was used for public celebrations than "exchange value" as a commodity to be sold and bought independent of its "use value." This concept was often repeated in one way or another right through the 1930s.

Marx's economic theories were also well known by 1907, when Boudin wrote his book. Boudin alluded to and described the many arguments for and against Marx's theories that had developed over the years in both European and American publications, and he described in very understandable terms Marx's "scientific socialism." He explained that, according to Marx, economic conditions were the prime motivational force in history, that economic structures were the bases on which legal, political, and intellectual superstructures were built, and that in order to "change the material productive forces of society" all else must change as well. With the breakdown of the capitalist system, as Boudin explained, the working classes would take charge in order to form ultimately "the cooperative commonwealth," an ideal society that Leon Trotsky (1879–1940) also found very attractive (1907, 24, 16, 18–19; see also chapter 4 for more on Trotsky).

Both Boudin and the editor of *Forward*, Abraham Cahan, two figures among many, were also familiar with and commented on Hippolyte Taine's point of view. Cahan mentioned his name in an article written in 1896 (see Cahan [1896] 1999), and Boudin quoted freely from Taine's writings in his essay "Life and Art" ([1907] 1999b, 94–97). Both understood that Taine rejected visionary and metaphysical theories of art, believing instead that to understand an artist's choice of style and character, "we must seek for them in the social and intellectual conditions of

the community in the midst of which he lived. . . . The productions of the human mind, like those of animated nature, can only be explained by their *milieu*" (1883, 30, 34; see also Taine 1872). In brief, it was the historical and economic circumstances—the social context—in which the artist lived that determined the nature of his work, a point of view not too distant from that of Marx.

Art writers also discussed and were especially responsive to the dilemma of artists who depended on an educated elite that had, to the artists' detriment, turned their creations into commodities for purchase. Writers were also sensitive to the fact that the subject matter of much contemporary art was often too rarified to appeal to the working class, which, by general agreement, had been cut off from any type of art appreciation except at the most base levels. The formerly broadly based community of interest (a questionable but believed idea) between artists and their audience had grown culturally impoverished. Because the working class was no longer involved with art, it had become irrelevant to artists, who were now isolated and therefore had little choice but either to cater to the bourgeoisie, a class to which they might not belong, or to become bohemians, which isolated them from all segments of society.

As for the impoverished masses, social and cultural uplift were of primary importance. To ameliorate their impossible working conditions and to cement their relationship to artists, opportunities for personal betterment were encouraged within the working class. These opportunities were perhaps based on the examples set in England by John Ruskin and William Morris. Ruskin stated in 1871 that he was a "Communist of the old school" and was particularly concerned with bringing culture to the working classes during their leisure time as well as ending their "perpetual toil from morning to night" (1872, 5; see also Ruskin 1875). William Morris also addressed cultural uplift, succinctly stating his position this way: "It is the Aim of Art to increase the happiness of men, by giving them beauty and interest of incident to amuse their leisure, and to present them wearying even of rest, and by giving them hope and bodily pleasure in their work; or, shortly to make man's work happy and his rest fruitful" ([1910–15] 1966, 23:84; see also Morris 1979, 89–90). The desire to bring art and culture to workers, to elevate their tastes, to enhance their living

conditions, and to contribute to their sense of personal dignity resonated deeply with Jewish artists and critics. In this regard, it is easy to understand that even though most workers did not come from a class that supported the arts or had leisure time and discretionary income to purchase art objects, several Yiddish-language publications included illustrated articles on art. And by the 1880s, art instruction had already begun in settlement houses as a means of cultural uplift and life enhancement equal to the creation of up-to-date medical, sanitary, and educational facilities.

As a result, the contents of journal and newspaper articles on art were meant for both educated and uneducated workers. After all, poets and writers also worked in the garment industry and other industries to support themselves and obviously spoke with their fellow workers. Illustrated articles appeared in journals such as *Naya Leben* (New life), *Dos Naya Land* (New land), *Der Groyser Kundes,* and especially *Di Tsukunft* at least as early as 1905. The range of topics was wide and included essays about women artists and European figures. Some articles described the holdings of the Metropolitan Museum of Art and the Brooklyn Museum. Illustrations included examples of classical art, art nouveau, and other contemporary styles as well as objects from other cultures. And regarding the link between art and religion, an article entitled "Art and the Old Testament" was published in the *American Hebrew and Jewish Messenger* as early as 1906.

What kind of contemporary art was appreciated or at least encouraged by those on the left? Two small items that appeared in newspapers around 1890 established a point of view that would be ever present in art criticism for the next several decades. Workers did not appreciate or understand the idealized figure produced by academically trained artists because this kind of art did not reflect their generally horrendous living conditions, and, besides, such artists catered to an elite audience whose tastes were meaningless to ordinary people. In an article entitled "Realism," published in the April 6, 1889, issue of the *Workmen's Advocate,* Abraham Cahan asked artists to stop creating images that beautified reality. He considered such images as lacking in honesty and catering to capitalists. These images meant little to the general public. He believed that artists should instead concentrate on the plight of the working class. As Cahan reminded artists

in the purplish prose of the time, "Let your brush emit the heart-rending cries of the downtrodden and the frantic laughter of their reveling oppressors." And in a section titled "Di Velt in Velcha Mir Leben" (The world in which we live) in an 1891 issue of *Fraye Arbayter Shtime* (Voice of free labor), the poet and anarchist David Edelstadt (1866–92) commented: "The suffering and the tears of the poor and the inhumanity of the rich. Why? Is this not the most noble and beautiful of themes for a modern picture by a true artist?" (qtd. in Manor-Fridman 1994, 115).

In addition to articles on art, the actual art scene was surprisingly lively, despite the difficult circumstances under which immigrants lived and labored. Well-intentioned curators, despite meager resources, organized exhibitions in stores and settlement houses such as the University Settlement as early as 1886, the year of its founding. In addition to local exhibitions, objects from the Bezalel School of Arts and Crafts, founded in Jerusalem in 1906, were shown in the fall of 1915 (AAA, Weichsel, roll N60-1, frame 117). And in that same year, 1915, the Peoples' Art Guild, the most important Jewish-sponsored art organization at the time, was founded. (It was disbanded in 1918.)

Unfortunately, very few works survive from the earliest years of art teaching and training, but it is safe to say that classroom instructors agreed with Cahan and Edelstadt that art should reflect the lives of people rather than be engaged in academic concepts of beauty or abstract designs independent of narrative meaning. This certainly was the guiding philosophy of the Educational Alliance Art School, founded in 1889, in which classes were taught from 1899 until 1905 and from 1917 to the present. The People's Art Guild also organized art classes, among other activities.

The policy of the Educational Alliance Art School was set by Abbo Ostrowsky, its long-time director who had emigrated from Russia in 1905 because of pogroms and the failed revolution that year (AAA, Ostrowsky, roll 1394, frame 620). Insistent and emphatic about encouraging and fostering the development of an art that reflected community culture, he mentioned in a letter written in 1914 that he wanted "to help Jewish art students develop a spirit for Jewish art," and, by implication, a Jewish national art (roll 1394, frame 364). And in an autobiographical statement, he also indicated clearly that he wanted an art center devoted to the

neighborhood's cultural heritage (roll 1394, frame 656). In a nod to the influence of Hippolyte Taine, he wrote in a letter a few years later in 1917: "The mutual understanding between the people and the artist depends [on] the impetus of the growth, depth, and height of the art of a country" (qtd. in Lipschutz 2004, 22).

Because we are still lacking a biographical study of Ostrowsky, we do not know if by "country" he meant either a state such as the United States or the Jewish people as an imagined Jewish nation. Possibly he had gotten himself caught up in the contentious, endless debates between assimilationists on the one hand and those wanting to maintain Yiddish culture in America on the other. Regardless of what he thought in 1917 or earlier, he believed that art should devolve from the culture of those who made it. In this regard, Ostrowsky believed that although some artists found European modernism—exhibited for the first time in America on a grand scale in the Armory Show in New York in 1913—attractive, it was not in tune with immigrant needs and actually lowered the cultural level of the Lower East Side, "where human values are paramount, where [resides the] rich, deep, ardent, and dynamic spirit of that cluster of humanity that has never craved sensationalism and publicity, that has never broadcast its doings in self-praise, that has gone about its pursuits working and dreaming" (AAA, Ostrowsky, roll 1394, frame 677). Modernist art in Ostrowsky's mind, then, was simply not relevant to the lives of immigrants.

This seems to have been the critics' attitude when they reviewed shows by Lower East Side artists. Of one exhibition held in 1917, a critic mentioned that Jewish artists emphasized the "intensely human" and, in their realist styles, "the human attitude and countenance" (Dyer 1917, LI), a clear comment both on the kind of images exhibited and the artists' ties to their community. In an undated article entitled "Labor and Art" in *Advance*, the newspaper of the Amalgamated Clothing Workers of America, another reviewer mentioned that among the portraits on display in that particular exhibition,

> all faces are seared and furrowed by conflict, anxiety, and uncertainty, as if they were in one long, continuous state of solving a trying problem. Every painting conveys the spirit of conflict, the wrestling with forces

that are unyielding and cold. . . . The artist is of the same stuff as the material out of which he wrests the elusive gestures and converts them into lines. The artist is the model made articulate. (AAA, Ostrowsky, roll 1394, frame 885; see also Pirozhnikov 1917)

In other words, artists who lived in the same community as their subjects shared the same values and experiences and were sympathetic to others' struggles to find jobs, pay the rent, raise children, learn a new language, and all the rest. Louis Lozowick summed up this point of view well when describing the Educational Alliance Art School's major aim, which was to give each student a strong social orientation: "[The student] is made to feel his identity with the community of which he is a product by drawing inspiration from its life, reflecting the peculiarities of its environment and embodying in permanent form its cultural heritage" (1924, 466).

Among those who wrote art reviews and art criticism during the first three decades of the twentieth century, Saul Raskin was probably the most prolific. He wrote forty-three articles for *Di Tsukunft* alone, according to Steven Cassedy's brief introduction to Raskin's article "Proletarian Art" (see Raskin [1914] 1999),124). Some were general in nature, some were exhibition reviews, and some had strong left-leaning political content. The article "The Proletariat and Art," which he wrote in 1907, three years after he arrived in this country from Russia, provides us with some sense of his point of view and interests at the time (see Raskin 1907). (The words *proletarian* and *proletariat* were initially used to indicate sympathy for workers [Freeman 1936, 375].)

Basically, Raskin was familiar with what by that time had become the standard socialist line on art. Following Marx, he agreed that primitive as well as Greco-Roman art was designed for the public and that it was a social necessity. But at the turn of the century, the proletariat had become estranged from aesthetic experiences of any sort because so much contemporary art created for the bourgeoisie was alien to them. Raskin stated that in the performing arts, theater ticket prices were too high. Art academies produced artists trained to please the few and not the many (with the exception of the Educational Alliance and similar institutions) and to gratify the art critics rather than the public. Workers did not have the time

to study individual works with, as Raskin stated, "magnifying glasses," and so they ignored such efforts. This state of affairs was unacceptable because, Raskin argued, in a democracy artists should serve the public by creating art with appropriate spiritual meaning. To say this differently, art objects (paintings, sculptures, etc.) had become commodities to be bought and sold. They no longer expressed workers' yearnings or desires, let alone reflected the state of their souls and psyches.

Nevertheless, according to Raskin, proletarians were a gifted people and would come to art only under socialist leadership. At such a time, art would reflect the joy of life and the dignity of people. Artists would also take an active and forward-looking rather than a passive stance, and in the antagonistic relationship between workers and the bourgeoisie artists would (or should) side with the workers. He then cited Ruskin to the effect that a peoples' art possesses a moral force. In his conclusion, Raskin also evoked the romantic notion of the reciprocal, upwardly spiraling process whereby the more life is ennobled, the more art is elevated, and the more art is elevated, then the more life is ennobled. A society that aspires to become socialist would then become more refined and obviously be better for it. Unlike Communist pronouncements made more than a decade later, Raskin's view in 1907 did not consider art an instrument for changing governments or supporting the revolution. Instead, it was a means to uplift people, to help them lead a more cultured and therefore happier existence. Again, people first, policies second; again, art as a vehicle of social concern, not a political weapon.

In "The Future of Jewish Art" published in September 1911, Raskin discussed the nature of Jewish art and its contributions to humanity (see Raskin 1911b). By so doing, he invoked his Jewish heritage whether intentionally or not. He began by comparing the Dutch Jewish artist Josef Israels (1824–1911) with the French artist Jean-François Millet (1814–75). Raskin said that the two were spiritual brothers because they painted poor, hard-working people who led bitter lives. But they differed in that Millet was not interested in individuals. Israels was more sensitive to the particularities of people because he painted their world, their social environment, and their suffering with empathy and pity. Further, Israels's subjects were invariably seen in relation to others, not as isolated individuals. Implicit in

Raskin's way of thinking was that Israels, as a Jew, thought in communitarian terms.

This attention to human interactions, Raskin held, probably marked the future of Jewish art. Jewish artists, he believed, rather than painting landscapes, still lifes, or animals, had a penchant for painting individuals in the sense of painting man's fate. The artists' most important subject was people and society, the kind of subject matter that came from their sense of spiritual power and from a deeply rooted morality. It is no wonder, then, that Raskin felt that encounters between people rather than the study of individuals as isolated beings expressed the greater moral value.

Raskin also hoped that in the future artists would express more pathos in their art than was evident at the time. He felt that people yearned for pathos, whereas boundless idealism not based in reality might interfere with the state of one's soul and with the spirit of humanity. Because Jewish artists as Jews had suffered so much over the centuries for their God, they would be able to bring pathos back into art in order to recover the sense of godliness in humans. Art by Jewish artists, an art based on their religious heritage, was, he said, a scream to heaven.

As a follow-up to this article, Raskin wrote another piece for the November 24, 1911, issue of *Dos Naya Land* entitled "An Exhibition by Jewish Artists" (see Raskin 1911a). In it, he bemoaned the fact that Jewish artists were sorely neglected by both the educated and the uneducated public in comparison to musicians and theater people. Especially in the plastic arts, a chasm had opened between artists and the people. As others had in the past and would in the future, such as Dr. John Weichscl, founder of the People's Art Guild in 1915 (discussed later), Raskin asked for a coming together of artists and the public through exhibitions to improve artists' ability to survive as well as to enable the public to become culturally enriched. After all, as was commonly stated in socialist circles at the time, artists should draw their inspiration from the people.

Raskin returned to the theme of proletarian art in an article entitled "On an Exhibition of Constantin Meunier's Work in New York" for a 1914 issue of *Di Tsukunft*. Raskin praised the Belgian sculptor enthusiastically, claiming his work to be "Socialist art." He continued, "Meunier [1835–1905] did not issue any wail of lamentation." Rather, he had "sung

a hymn to labor, built a monument to the worker's power and the worker's will." There was no idealization or beautification here. Raskin went on to say that Meunier's art was "the first *genuine proletarian art* in the proper sense, for there is not so much a hint of tendentiousness in it, not a trace of symbolism or 'literature,' no effort to say something 'great' or to generalize with a particular aim in mind" ([1914] 1999, 125, 127 italics in the original). Clearly, the ordinary person would understand such art because, in effect, it would eschew academic formulas and modernist styles.

Raskin then made a series of assertions that should be included in their entirety because of the date in which they were written—1914. They have the same kind of intensity one finds in writings during the 1930s.

> When people speak of proletarian art, they say that such an art does not yet exist, because no one can create it for the proletariat. The idealists of the well-to-do classes cannot do it for them, even with the best intentions. The proletariat has been given a political economy and a proletarian philosophy of history, but art, which is an expression of the spirit and not of hollow thought—this is something a member from the well-to-do classes, no matter how good and honorable he might be, cannot give the worker. Art must be born in the depths of the worker's soul itself. Meunier's art, the art of this giant child of the people, is a beginning. ([1914] 1999, 127)

His argument boiled down to an easily understood position. The proletariat at some future date would create an art of its own based on its own sense of self-expression and its own presence in the world. Artists would then reflect the will of the people but would not dictate that will to the people. Such an art would grow from within and not be imposed from without. It follows then that art made by middle-class artists, however sympathetic they might be, can never be called proletarian art. Raskin, like others, was not certain—nobody was certain—what proletarian art would look like, but under socialist leadership it would come into existence in time. In effect, the working class would learn how to express itself, to create its own art through proper guidance, but not through the control by others, whether capitalist or, as it would soon emerge, Communist.

In other articles, Raskin reiterated the points just made. Art needed to have a purpose beyond aesthetics; otherwise it was a betrayal of working-class interests. Art, therefore, needed to reflect people's experiences and what they knew and understood. At the same time, it should not appeal to the basest tastes and instincts of the working class. Art should not be leveled down but, with the working class in mind, elevated up from below, and, equally important, nobody should dictate appropriate themes to artists but rather inquire into the kinds of subject matter that would dignify workers' lives.

Even Max Weber, an international modernist who helped organize Matisse's first art classes in 1907, wrote an important but apparently unpublished article in 1916 quite sympathetic to socialist beliefs. Intended for the socialist daily the *New York Call*, it summed up contemporary attitudes toward art and anticipated future ones (AAA, Weber, roll NY-6, frames 245–46). It also raised unanswerable and hotly debated questions about political, national, racial, and universal aspects of art. In addition, by using the word *Bolshevik*, Weber indicated that he and others were aware of Communist activities before the Revolution of 1917. As Weber wrote,

> Art is neither national nor racial. It is neither Bolshevik nor aristocratic. Art is the universal tongue of mankind. Art is meant for the whole race; it was never meant for the few, for from the entire race it springs, and invariably from the poor. . . . Art is no more luxury than bread. The great masses and all classes have a right to beauty. The present social order with its colossal greed, its merciless materialism, is such that it treats art and artists as superfluous and undeserving quantities. . . . Were art more fostered, were it more manifest in daily life, man would value men more; more of the man that is spiritually significant. It would develop that spirit of brotherhood, of communism, and not the tools and methods of deadly competition.

A modernist who understood and used the rhetoric of the left, Weber considered artists to be sympathetic to miners and to mill and factory workers. But in 1916 not yet the committed political activist he was to become in the 1930s, he wanted little more from art than beautiful shapes and colors

rather than images that roused pity for the poor or for those whom he called "factory slaves." Straddling both modernist and socialist positions, he indicated his preference for freedom of artistic expression and political and economic justice for all. In 1916, his politics were changing, but not yet his art.

Dr. John Weichsel (1870–1946), a teacher at the Hebrew Technical School in New York and an occasional writer on art in the years before he founded the Peoples' Art Guild in 1915, was among those who agreed with the basic socialist position on art and the place of the artist within the community. In an article on Abraham Walkowitz (1878–1965) published in *Di Tsukunft* in 1913, Weichsel pointed out that artists needed to be independent of capitalist society in order to be able to ignore the kind of mediocrity that would be apparent if they copied academic models (see Weichsel 1913). Capitalist society, plainly and simply, prevented artists from realizing their potential. Further, artists needed to express the joy and beauty of life and to reveal the humanity in their subjects, free from the falseness of capitalist culture. Weichsel then praised the Belgian Socialist Party as the first to recognize the necessity of a free art in order to contribute to the workers' struggle for a better future. He ended his article by suggesting that the Jewish masses should become familiar with Walkowitz's work because it would contribute to that future. He also emphasized this last point in a letter he wrote to Ostrowsky on July 15, 1915, mentioning that if Jews could learn to value art, then perhaps the working class "could be raised up and even liberated from a life of cheerless drudgery" (qtd. in Strauss 2004, 118), no doubt here echoing Ruskin's and Morris's beliefs.

In another article, "Jewish Workers and Jewish Artists," published in 1915, Weichsel broached another subject that provoked years of disagreement between socialists willing to work within the system and those who preferred a more revolutionary outcome (see Weichsel 1915b). Despite his dislike of capitalism, Weichsel thought that workers needed more exposure to art than to the rhetoric of revolution or anarchy because the measure of a full life was knowledge of art. Such knowledge allowed workers to gain trust in their own instincts. In this regard, cultural programs sponsored by organizations such as the Arbayter Ring were very important

both to elevate workers' self-worth and to bring artists and the public closer together. Exposure to cultural activities opened the darkness of tenement living to a life of creative activity. Weichsel also insisted on the impossibility of artists fulfilling their own creative potential if they were not true to their feelings. Their inner spirit would flourish, and their ability to achieve greatness would occur only when connected to their own culture—that is, working-class culture. Like Raskin's, Weichsel's politics was more human based than theory based. (Weichsel also wrote articles on Eli Nadelman and Samuel Halpert making roughly the same points [see Weichsel 1915a, 1916]).

As one goes through the literature, it becomes clear that many people of this period commonly had the desire to provide not just decent wages and housing for workers but also cultural opportunities. For example, historian David A. Gerber notes that his Communist grandfather, who was well read despite minimal formal education, believed that "socialism meant nothing if it failed to hold out the promise of opportunity for workers to live a cultured, dignified life rather than a beastly existence of unremitting toil and fearful insecurity" (1996, 120).

Weichsel, motivated to create an organization in which his ideas might be brought directly to the community, established the People's Art Guild in 1915, the most important Jewish art organization of the early decades of the twentieth century. Through it, he addressed directly the twin matters of bringing art into the lives of the masses and supporting those Jewish artists who remained in the community. In its three years of existence, the guild sponsored more than sixty exhibitions in settlement houses and community centers as well as in coffee shops, and it offered lectures and art classes, organized museum trips and study groups, and planned to build a museum of Jewish art.

The first article of the guild's constitution stated clearly its purpose and guiding philosophy: "The aim of the People's Art Guild shall be to reclaim the people's life for *self-expression* in art and to make it a hospitable ground for our artists' work" (AAA, Weichsel, roll N60-1, frames 103, 385, 686, italics added). By "our artists," Weichsel meant Jewish artists, although many non-Jewish artists also exhibited with the guild, including Robert Henri (1865–1929), John Sloan (1871–1951), George Bellows

(1882–1925), Kenneth Hayes Miller (1876–1952), Gifford Beal (1879–1956), Jerome Myers (1867–1940), Stuart Davis (1892–1964), Marsden Hartley (1877–1943), and Thomas Hart Benton (1889–1975), among many others. Before Benton helped popularize American Scene painting in the 1920s, he became quite friendly with Weichsel. He said that Weichsel and others introduced him to authors such as Robert Owen (1771–1858), Karl Marx, Hippolyte Taine, and Pierre Proudhon as well as to several left-wing contemporaries, including Robert Minor (1884–1952), Max Eastman (1883–1969), Mike Gold (1894–1967), John Sloan, and others associated with the *Masses* and other leftist publications (AAA, Baigell, roll 2068, frames 1063–64; Baigell 1989, 3, 19).

The Peoples' Art Guild sponsored solo exhibitions by figures such as Sloan at the Hudson Guild in the spring of 1916 and, in at least one instance, the very ambitious *Exhibition of Etchings, Engravings, and Woodcuts* held at the University Settlement in the spring of 1916, presenting artists ranging from Albrecht Dürer (1471–1528) to early-twentieth-century figures (AAA, Weichsel, roll N60-1, frames 480, 501, 527). For virtually every one if its major exhibitions, the People's Art Guild also held satellite exhibitions in smaller Neighborhood Houses, Young Men's Hebrew Association halls, and coffee shops (AAA, Weichsel, roll N60-1, frames 417, 419, 440).

In a statement in the guild's prospectus, distributed at several exhibitions, Weichsel laid out the guild's general program using the kind of language that Raskin had used earlier and that Communist Party stalwarts would use again and again during the 1930s. Artists, as a result of being dependent on a small class of patrons, "seek neither inspiration nor subsistence among the masses." They therefore suffer from spiritual and economic poverty. And, likewise, the masses "feel no vital reality in our art." Thus, "the people's aesthetic privation is as complete as the artists' physical and mental discomfort. . . . Hence, the People's Art Guild invites artists to re-enter the life of the people and to make their art a token of kinship, and, the people to take a rightful share in art creation, to foster its own aesthetic powers, and to grow to a sensitive appreciation and enjoyment of the best in art" (AAA, Weichsel, roll N60-1, frame 464). Again, like Raskin, the guild argued that it is the people who will

develop an art appropriate to their needs and desires. That art cannot be forced upon them.

In a dig at those artists who had abandoned the Jewish community, the prospectus stated that even though "an art-proletariat is fast evolving," many former Lower East Side artists have grown spiritually impoverished by moving to "uptown" galleries. (Regarding those artists who chose to abandon the community, see Antliff 2001.) In contrast, the guild wanted to keep artists and the public together "in the belief that art is the strongest bond uniting all sections of mankind" (AAA, Weichsel, roll N60-1, frames 464, 601, 611, 686).

Weichsel was also well aware of the relationship of the individual to the community as a whole. By culturally elevating the former, the latter would be enhanced. A firm believer in his cause, Weichsel added: "[For] the greater glory of [the Jewish] civilization, the People's Art Guild [advocates] the establishment of an East Side Art Center . . . and in it the flowering of the local soul shall enhance the vigor and the beauty of the commonwealth" (AAA, Weichsel, roll N60-1, frame 602). In a letter Weichsel wrote to Abbo Ostrowsky in July 1915, he noted the endless hours that sweatshop workers toiled, but he hoped that if Jews could be taught to value art, then perhaps the working class "could be raised up and even liberated from a life of cheerless drudgery" (qtd. in Strauss 2004, 118). Key to Weichsel's intentions was the development of an artistic climate of personal growth rather than of implementing political programs. Ameliorating living and working conditions guided Weichsel's ambitions, his version of the benefits that socialism could provide for the general public.

Weichsel also supported the establishment of a Jewish museum. "It is the mission of art," he believed, "to evolve the national soul" of the Jews. A museum, in addition to holding exhibitions and rescuing from obscurity Jewish art objects, would also bring art—the art of their best artists—into the houses of the Jewish masses through sales of paintings, prints, and reproductions, a goal, it should be noted, that both Communist and non-Communist left-wing groups vigorously supported in the 1930s (AAA, Weichsel, roll N60-1, frame 42; AAA, Ostrowsky, roll 1394, frames 656–57). (In the aftermath of the Holocaust, the idea of creating a Jewish museum in face of the near total destruction of traditional European

Jewish culture took on added resonance. Finally, by the late 1940s, the Jewish Museum was established in New York under the aegis of the Jewish Theological Seminary [Goodman and Nelson 1946].)

The desire to establish a Jewish museum in 1915 raised the issue of nation building, an issue that remained relatively benign but ever present in the art world. Nation building could mean two things: either maintaining a strong secular Yiddish culture in America by not assimilating into the mainstream or immigrating to Palestine ("Who Patronizes Jewish Art?" 1905, 162). That Weichsel, although a socialist with universal leanings, considered this a vital issue indicates how conflicted many Jews felt about maintaining a secular Jewish culture in America or assimilating into the majority culture or immigrating to Palestine to establish, ultimately, a Jewish state (AAA, Weichsel, roll N60–2, frames 127–41; Baigell 1991, 42; Kampf 1984, 64). (Many cartoons concerning this matter appeared regularly in *Der Groyser Kundes*.)

In part, the issue of nation building in America lay behind the formation of the Jewish Art Center founded in 1925 (Tofel 1927). For the three years of its life, the Art Center tried to counter the assimilationist position by emphasizing the connection between Jewish American artists and their Jewish culture. Jennings (Yehuda) Tofel, who with Benjamin D. Kopman (1887–1966) was one of the Art Center's first directors, acknowledged that the earlier generation of Jewish American artists (presumably figures such as Max Weber and Abraham Walkowitz) had become too Americanized. But by the early 1920s, he now felt that younger artists had grown more interested in creating a secular Jewish culture in America. Intimacy with the community, Tofel believed, was essential to assure the development of this secular culture. "If there will be a close relationship between the people and its artists," he reasoned, "then the culture of Jewish artists will become of itself riper as an expression, intimate and whole. The artist will feel the clarity of the source. And as such, he'll be able to travel around the whole world, and still remain his own, whole pure man," meaning that his cultural heritage will remain intact (Tofel 1927, 56). (Tofel's and Kopman's points of view do not relate directly to social concern and so are not considered more fully here. However, the conclusion touches on the position they hold in the history of Jewish American art.)

It is necessary to digress briefly here to say a few words about the contemporary New York realist painters led by Robert Henri. Politically, they were left of center; John Sloan had joined the Socialist Party in 1911. And certainly some of the cartoons by Sloan and others were interchangeable with those found in the Jewish socialist magazines. Generally, they were in the nature of light-hearted political and nonpolitical observations. But the differences are important to note, most obviously the virtually complete omission of specifically Jewish content in the cartoons by non-Jewish artists.

That aside, the New York realists' general attitude toward their subject matter was different. An article written in 1906 pointed out that Henri had suggested again and again that individual artists should express their own natures and personalities as well as paradoxically and simultaneously obtain a picture of "real life, intimate, truthful, carrying its own message" (Forrester 1906, qtd. in Doezema 1992, 221 n.). Henri, adding his thoughts to this point of view, said: "Painting . . . is the study of our lives, our environment. The American who is useful as an artist is one who studies his own life and records his experiences" ([1923] 1960, 116). This kind of generous, open-ended but personal search, based on William James's radical empiricism and Walt Whitman's desire to know the common man, led Henri to believe that "the only thing is that a man should have a distinct vision, a new and fresh insight into life, into nature, into human character, that he should see the life about him so clearly that he sees past the local and the national expression into the universal" (1920, 192). The emphasis on the individual's reactions did not allow much space for empathy or for the kinds of communal feeling and responsibility common to Jewish artists and art writers. In addition, to assume that an individual's expression reflects something universal, that under the skin we are all the same despite cultural differences, is really an untestable assumption.

In any event, the Lower East Side, which Henri encouraged his friends and students to visit, was the place to get fresh insights into life. But as has often been pointed out, Henri's followers felt quite separate from the people they painted. John Sloan, for example said that he "did not examine the life of the poor like a social worker. . . . I saw it with an innocent poet's eye." Nor did he admit to mingling with the people he

painted and sketched. He saw himself rather as "a spectator of life" (qtd. in Elzea and Hawkes 1988, 9, 3). Henri's compatriots were outsiders and middle-class onlookers, as it were, observing denizens of foreign countries without having to go abroad.

Two examples among many make this point. The artist Everett Shinn later said of *The Spielers* (1905) by George Luks (1867–1933) (both Shinn and Luks were compatriots of Robert Henri), a painting showing two young frolicking Lower East Side girls,

> [It is a] masterpiece of gamin life, his record of adolescent freedom in the cluttering confines of New York City's Lower East Side. . . . Their drab attire is in harmony with the grime of the slums, but so applied, so reverently treated are the heads of the two laughing girls that even the white frock and veils of communion, if he had so preferred to clothe them, could have given no greater illusion of childhood innocence. (1966, 1–2)

Communion aside, Shinn's view does not reflect a likely response to this painting by a Jewish critic or artist of the early twentieth century, neither of whom had illusions or fantasies about innocence on the Lower East Side.

James Huneker wrote in his book *The New Cosmopolis* (1915) about an imaginary tour of the Lower East Side. An acquaintance wanted to see the area as if through the eyes of George Luks. The acquaintance spotted a small, thin girl wearing a huge shawl and selling flowers, and Huneker observed that the girl looked like "a regular Luks," meaning that she looked tired, had a pale complexion, and wore dirty, hand-me-down clothing (1915, 9, 20). The visit, although considered a success by Huneker's friend, was really about seeing people as exotic objects, not as people.

In contrast, cartoonists such as LOLA (Leon Israel) and Sam Zagat painted many scenes of Lower East Side life with a sympathetic eye and found little there of entertainment value. Nor did they turn their subjects into objects or seek the true nature of their own individuality in their views of the neighborhood (see Israel 1954; Zagat 1972).

After the Russian Revolution in 1917, the general tone of articles in the Jewish and non-Jewish left-wing press grew increasingly strident.

People-oriented articles gave way to theory-based and prescriptive essays. As early as 1919, an anonymous article appeared in the *New York Call* entitled "Artists Donate Pictures to Be Sold at *The Call* Bazaar," in which the author wrote: "The artist feels that the capitalist system restricts his individuality because usually he is unable to sell pictures that do not coincide with the ideas of those who buy them for a capitalist world" (AAA, Weber, roll NY59-6, frame 414). The author then encouraged socialists to develop their own presses so that artists could develop their own individuality in association with the working classes, an idea that Meyer Schapiro championed in the 1930s (see chapter 4).

In 1924, Louis Lozowick said much the same thing but now in the more directive language associated with the Communist Party. Of the type of instruction then given at the Educational Alliance, Lozowick said that the aim of its art school was to give each student "a *definite social orientation*. He is made to feel his identity with the community of which he is a product by drawing inspiration from its life, reflecting the peculiarities of its environment and embodying in permanent form its cultural heritage" (1924, 466, italics added). That is, artists' values, which were now being prescribed more insistently, should be those of the community. Artists, through their art, should help develop a working-class point of view that was understood by its members for art to be relevant to their lives. Some of the students who responded to this attitude included Saul Berman (1899–1972), Peter Blume (1906–92), Philip Evergood (1901–73), Chaim Gross (1904–91), Lena Gurr (1897–1992), Louis Ribak, Ben Shahn (1898–1969), and Moses Soyer (1899–1975).

By the end of the 1920s, the Peoples' Art Guild and the Jewish Art Center had passed from the scene. But their programs providing instruction and lectures and connecting artists with the public as well as their interest in selling artworks mostly in the form of affordable prints were continued or, rather, reestablished in 1929 by various Communist-controlled groups such as the John Reed Clubs (1929–35), the AAC (1936 to early 1940s), and various governmental art programs (1934 to early 1940s), especially the Works Project Administration (WPA) of the Federal Art Project, under the leadership of Holger Cahill (1887–1960). Cahill stated that the origin of the WPA, which started up in 1935, "has proceeded on the principle that it

is not the solitary genius but a sound general movement which maintains art as a vital, functioning part of any cultural scheme." He asserted that "an attempt to bridge the gap between the American artist and the American public has governed the entire program of the [Federal Art Project]." And in words reminiscent of statements made by Dr. Weichsel and others on the left, Cahill said that art "should have use; it should be interwoven with the very stuff and texture of human experience" (1936, 18; see also Park and Markowitz 1984, 3–9).

Differences obviously existed between the Peoples' Art Guild, the Jewish Art Center, the Communist-controlled groups, and the New Deal art programs, but it is not without a certain irony to realize that several guild and Art Center activities that were directed at particularist Jewish artists and the Jewish public foreshadowed both the universalist Communist Party and the nationalist American governmental programs that flourished in the 1930s.

3

The Attractions of Communism

THIS CHAPTER, exploring the attractions of communism, and the next two are concerned with the period between the Russian Revolution and the start of World War II.

First, a brief history. It is an understatement to say that the Russian Revolution of 1917 changed the relationships of artists to left organizations. A Communist government had taken control of a country; official party proclamations could now be issued from a single source in a single place. The Socialist Party in America initially had few quarrels with Bolshevik aims, but disenchantment set in after the Communist Party made several proclamations concerning the revolution and the dictatorship of the proletariat. Where socialists wanted equality, solidarity, minimal opposition between individuals and society, the realization of the promise of America, and the gradual end of class conflict by constitutional means, the Communists formed an elite vanguard of activists to lead the masses, a revolutionary cadre that at the right moment would seize power and install a dictatorship of the proletariat. Or, as Theodore Draper stated simply in 1957, the socialists basically worked through unions to better working-class lives, whereas the Communists wanted fundamental changes in the social order (17; see also Fried 1997; Gitlow 1940, 12; Glaser and Weintraub 2005; Klehr 1989; Michels 2001).

In January 1919, the Communist Party and the Communist Labor Party were formed in the United States from left-wing elements in the Socialist Labor Party and the Jewish Socialist Federation. The first manifesto was issued in September 1919. The two organizations merged to form the Workers Party of America. In 1921, the Communist Party of America was formed, and in 1929 its name was changed to the Communist Party

of the USA. In any event, by the mid-1920s control of various party appa-
ratuses passed to Moscow. One way to tag that change is to realize that
before the newspaper *Di Frayhayt* (Freedom), founded in 1922, came
under party control in 1923, its editors announced that it wanted to edu-
cate the masses "in a truly cultural manner, in a truly revolutionary way."
They wanted to "refine their [the masses'] tastes, make them into people
with higher concepts and ideals . . . , enriching and refining Yiddish lit-
erature and art, as well as developing the literary and artistic tastes of the
Jewish masses" (qtd. in Michels 2001, 25, 172; see also Klehr 1989, 3–15; A.
Liebman 1979, 55–58; Michels 2005, 238). Although the editors acknowl-
edged the revolution, the language of their program was virtually identical
with the goals of the Jewish Socialist Federation, founded in 1912, as well
as of Dr. John Weichsel's Peoples' Art Guild.

Over the next few years, of course, party control tightened, and the
newspaper's priorities changed when so directed. During the so-called
Third Period, which lasted from 1929 to 1935, the concerns of national
and religious groups were replaced by an emphasis on class interests. The
intention was to replace ethnic and nationalist hatred and competition
with class antagonism. For Jews, this shift meant that hatred of the rich
would replace hatred of Jews.

In 1935, because of the rise of Nazism after Hitler's election as chan-
cellor in 1933, the aims of the Popular Front replaced those of the Third
Period. At this time, Moscow decided to reach out to all political and
social groups in order to create a united front against fascism, which now
replaced capitalism as the prime enemy. As a result, calls for revolutionary
class activity and the proletarianization of art virtually disappeared. By
1940, in the wake of Stalin's dictatorship, the Moscow Trials of 1936–38,
the Hitler-Stalin Pact of 1939, and the Russo-Finnish War of 1939–40, the
party, although retaining much of and even increasing its membership,
lost most of its influence in the art world (Baigell and Williams 1986a).

The question that needs to be asked is: Why were Jewish artists
attracted to communism? We can find some answers in interrelated psy-
chological, political, and economic factors. Certainly two of the most
important considerations were that many thought, first, that Russia recon-
stituted as the Soviet Union would be good for the Jews and, second, that

socialism would mark the end of anti-Semitism. Historian Richard Pells observes that despite the approximately 1,520 pogroms and sixty thousand deaths that occurred primarily in Ukraine after the revolution, "a residual loyalty to the intellectuals' dream of social democracy," a sentiment "particularly true of Jewish writers, many of whom were refugees from Czarist oppression and who cared deeply about the transformation of their original homeland," colored their view of events in Russia (1974, 61; see also Kenez 1992, 293–308; Listchinsky 1940, 515; Michels 2011, 26–27).

Sociologist Nathan Glazer noted in similar fashion that more Russian immigrants were attracted to communism than were native-born Americans, perhaps because of their memories of anti-Semitism. Impressed by the early Bolshevik commitment to equality, they allied themselves with communism less because of "their desire for a revolutionary reorganization of American society than [because of] their sympathy for the achievements of the Russian Communist Party" (1961, 245). Moses Rischin observed around the same time that "nostalgic immigrants, intimidated by the world around them, participated vicariously in the march of events that promised to turn 'the home that had never been home' into a paradise." Polish Jews, victims of that country's anti-Semitic practices, were also "captivated by the idealistic, universalist message emanating (or so they thought) from the doctrines of Marx and other radical thinkers" (1963, 238). One might also say that many on the left joined virtually any organization opposed to the anti-Semitic czarist government and to the politically conservative and equally anti-Semitic White Guards because of their memories of humiliations and abuses they had directly suffered in the Old Country (Listchinsky 1940).

The most significant transformation that heralded the start of a new era for many was the new Soviet government's commitment "to grant cultural-national autonomy to all national minorities, including Jews," who under the czars had been denied equality with other citizens. Yiddish publications were started, various Jewish theatrical and artistic groups were formed, and studying Hebrew was encouraged. Unfortunately, after 1921, these developments were increasingly curtailed as the regime began to assume full control of the country (Levin c. 1987, 1:36, 75, 99–100; see also Ettinger 1970, 15–19).

Despite the fact that overt anti-Semitism still existed in the Soviet Union, many felt that Jewish people could live comfortably there insofar as they were no longer confined to restricted areas or subject to pogroms and were now constitutionally guaranteed the same political and economic opportunities as every other Soviet citizen. A significant caveat was that Jewish culture could flourish, but it had to be subsumed within Soviet culture, a difficult and ultimately impossible goal (Aaron 1961, 150; Kunitz 1929, 134, 175, 182). Nevertheless, the attraction of communism grew even stronger in the 1930s when the Soviet Union, unique among nations, openly opposed and excoriated German anti-Semitic policies, at least until the Hitler-Stalin Pact in 1939.

One of the more determinedly positive statements praising the Soviet government's treatment of the Jews was written by Moissaye J. Olgin (1878–1939), a founder of *Di Frayhayt* in 1922, the Communist Yiddish-language newspaper, on the occasion of the exhibition in New York in 1936 of works intended for the Museum of Birobidzhan, the Jewish Autonomous Region in Siberia (discussed more fully in chapter 5). Olgin's remarks reflected the intentions of the Popular Front, established in 1935, to enlist as many people as possible in the fight against Hitler's fascism. (For further discussion, see the next two chapters.) "To one who grew up in Russia as a Jew under the Czar, and who has witnessed a new life of the Jews under the Soviets, the change seems little short of miraculous. It is something to stir the imagination, something to arouse the enthusiasm of even a casual observer. . . . The Jews were pariahs. They lived in Russia but were not considered citizens." Olgin continued in this vein, describing how well Jews were now being treated in a country "where every Jew feels at home and where there is full freedom for the development of his abilities. A new life is in the making for one of the oldest peoples on earth" (1936, n.p.).

Hard-liners as well as moderates in America might also have felt reassured that communism created ways to uplift the Jewish masses and provide them with a life free from discrimination, economic servitude, and physical harm as well as ways to counter feelings of Jewish self-hatred and to help promote and develop a coherent and positive view of the world at a time, during the 1930s, of increasing fears for the survival of both Judaism and Western civilization. Communism, after all, allowed one to live as a

Jew without, on the one hand, remaining within the parochial world of eastern European Jewish religious tradition or, on the other hand, abandoning all vestiges of one's Jewish heritage by total assimilation—a critical point to consider for Jews in America, who wanted to identify Jewish but whose politics were also left of center (Aaron 1969, 254–64; Howe 1982a, 9–11, 53, 1982b).

An important aspect of political belief at that time was the flat-out assumption that communism would finally eliminate anti-Semitism. For example, *Opinion* magazine held a symposium on the subject in 1934, which was subsequently condensed in the *Literary Digest*. Plainly and simply, the prevailing point of view held that capitalist economics caused anti-Semitism; that anti-Semitism would thus "disappear with the destruction of the capitalist system (*vide* the Soviet Union); and that if a Jew wishes to survive he must identify himself with the historic movement (Communism) that is destined for creative survival. . . . Only Communism can save [the Jews] as against Fascism" ("Jewish Writers' Symposium" 1934, 19).

These thoughts became common currency among party followers—that anti-Semitism had economic roots and was a phase of fascism. Even Isidore Schneider's proletarian novel *From the Kingdom of Necessity*, published in 1935, invoked an economic solution to anti-Semitism. Schneider wrote: "Among Jewish workers, there is an intuitive understanding that their difficult national problem will be solved finally, and only when a proletarian revolution solves the world's economic problems" (qtd. in Harap 1987, 97–98).

Because fascism was considered to be an extension of capitalism, this kind of explanation took on added resonance as the Nazi regime began its systematic disenfranchisement of Jews in Germany. In 1935, the magazine *Modern Monthly* held a symposium entitled "What Will I Do When America Goes to War? A Symposium." When the symposiasts were asked if they would oppose Hitler should he conquer Europe, Bertram D. Wolfe (1896–1977), a founding member of the Communist Party of America in the early 1920s but an anti-Communist by the 1950s, responded in 1935 by stating that it was an improbable speculation, and, anyway, capitalists were all the same. Only the working class could overthrow capitalism (Wolfe 1935, 297).

Even the art critic Clement Greenberg (1909–94) held a similar position early in his career. In his 1940 essay "An American View" (Greenberg [1940] 1986), he set up capitalism and socialist democracy as polar opposites without mentioning the increasingly impossible situation of Jews in Europe. And in the essay "10 Propositions on the War," Greenberg and political columnist Dwight MacDonald in 1941 agreed that the choice was "to deflect the current of history from fascism to socialism." The United States, they held, faced only one future under capitalism: namely, fascism (Greenberg and MacDonald 1941, 271). Again, they said nothing about Nazi policies, indicating that Greenberg perhaps still believed that capitalism was in part responsible for anti-Semitism. As art historian Andrew Hemingway observes about those holding varying political positions who chose not to contain Hitler's policies, fascism was the probable destiny of capitalist development and not simply some aberrant form it had taken in the Axis powers (1994, 24; see also Burck 1935, 335; Klehr 1989, 15).

Irving Howe described this point of view succinctly many years after the end of World War II when he stated: "We underestimated the ferocious urge to total domination characterizing Nazism. We were still thinking [back then] about Nazism as the last, desperate convulsion of German capitalism, and had not yet recognized that the society created by the Nazis was something qualitatively new in its monstrousness" (1982a, 87). Even as late as 1958, some still believed in the Marxist interpretation of the cause of anti-Semitism. In a history of the Jewish Labor Bund, the anonymous author wrote: "Anti-Semitism has its causes in the economic, political, and psychological conditions of society and, like any other human evil, it can be cured by changing the conditions which brought it about. . . . The Jewish problem is part of the general problem of mankind and can be solved only by the improvement of the lot of humanity as a whole" (*Jewish Labor Bund* 1958, 17).

So it is not too difficult to believe that during the 1920s and 1930s the most militant, secular Jewish Communists were among the most virulent anti-Judaists. They were not necessarily anti-Semites, but rather antireligionists. Perhaps they really did believe that anti-Semitism would disappear under certain economic conditions and that religious Jews were helping prevent that from happening. Or perhaps loyalty to the party took

precedence (or was demanded) over everything else, whether personal, professional, or religious. Another not to be overlooked reason was the very negative memories of early religious instruction in heder (religious grade school) among figures such as party functionary Mike Gold and artists such as Louis Lozowick and Ben Shahn (see Gold [1930] 1965, 43–45; Greenfield 1998, 8–9; Lozowick 1997b, 15–30). Nevertheless, in an essay entitled "Anti-Semitism on the Left," sociologist Charles S. Liebman subsequently noted that assimilated Jews' unwillingness to cut ties to the Jewish community allowed communism to become "a secular ideology of a quasi-religious nature." He then cited French author Albert Memmi's observation that Jewish party members immersed themselves in party matters more completely than non-Jewish party members (1973, 156; see also Memmi 1966).

But it is still a shock to find in the *Daily Worker* for November 2, 1925, the comments of one Jew who believed that in Talmud Torah (afternoon) religious schools "ancient rabbis are poisoning the minds of working class children" and that rich Jews support these schools to keep "workers mentally enslaved" (qtd. in Gerber 1996, 343). And George E. Sokolsky wrote in 1935 (well after Hitler assumed power): "The Jewish capitalist, like his German brother, will not stop even at the decimation of his co-nationals, if it assists his ends" (1935, 27).

In America, there was always some wiggle room to remain both Jewish and socialist or Communist despite the rhetoric of the Third Period (1929–35) (Michels 2011, 28). The Communist Party never developed a clear and consistent position on matters of Jewish concern and interest despite overtly hostile articles in the Communist press. For example, there existed the Jewish Bureau of the Central Committee of the Communist Party USA, renamed in 1938 the Council of Jewish Communists of the National Committee. In addition, realizing that many Jews would not abandon the Yiddish language or Yiddish culture, the bureau had even organized Proletpen for writers in September 1929, a Jewish-language equivalent of the John Reed Clubs that tried to promote revolutionary fervor among writers and artists between 1929 and 1935 (Zucker 1994, 175–78).

In effect, Proletpen was both a Communist-Yiddish cultural organization and a Jewish proletarian writers' group. To make certain that its

policies were understood, the Jewish Bureau contrasted "national Jewish culture" with "Jewish proletarian culture." The former was designated bourgeois-capitalist. It glorified the past and was sustained by rabbis and the wealthy, who stifled the Jewish working class. Jewish proletarian culture, however, encouraged bonds among workers in order to oppose the bourgeoisie.

This kind of equivocation, both political and linguistic, set up an intricate and never resolved conflict between national (bourgeois/capitalist) Jewish and proletarian Yiddish cultures. With the implementation of the Popular Front in 1936, matters were not simplified because one could now officially remain both a good Communist as well as a loyal Jew (Klehr 1989, 382–83). Choices no longer had to be made. In an odd way, the Popular Front, therefore, encouraged Yiddishist desires to prevent assimilation into the American mainstream because Jewish nationalism and communism could be conjoined, although within party priorities (Buhle 1980, 17). But individuals, to be sure, believed and acted as they so desired, regardless of directives from above.

Remaining both a good particularist Jew and a good internationalist socialist or Communist was an old, unresolved dilemma that dated back to the Great Migration. As early as 1887, Jewish-language sections were formed within the internationalist Socialist Labor Party—fourteen sections by the 1890s—as a way to reach Yiddish speakers (Michels 2005, 69; Sorin 1985, 79). A few years later the Hebrew Labor Federation of the United States and Canada, which, despite its name, did not want to be identified as a Jewish labor organization, tried but failed to organize all Jewish workers in an international alliance by trying to reach them primarily through the Yiddish language. The organization failed because it was impossible to erase distinctions between Jews and non-Jews, to enjoy solidarity with the exploited, and to surmount the issues of class versus ethnic consciousness or universalism versus particularism (Epstein 1959, 181–84).

So whatever one's relation to the Jewish Bureau in the 1930s was, the bureau nevertheless served the conflicted purpose of reaching masses of Yiddish-speaking people in order to advance its goals of both developing a proletarian culture and preserving the Yiddish language and Yiddish culture (A. Liebman 1979, 492–94; Zucker 1994, 175–81). For many,

including artists, Yiddish rather than English would remain the Jewish lingua franca. And if the documents preserved in the Smithsonian Institution's Archives of American Art are any indication, several radical artists wrote letters to each other in Yiddish and, no doubt, spoke Yiddish to each other. As much as they wanted to escape their background by joining or being sympathetic to a universalist organization (the Communist Party), they certainly found comfort in friendships with others from similar backgrounds. The federally sponsored WPA even established the Yiddish Writers Group (Kobrin 2008, 357).

Perhaps some felt, without really thinking about it, that they could transport a Yiddish-speaking, eastern European shtetl into the Soviet Garden of Eden. Short of that, others managed to juggle universalist and particularist interests without too much effort within the relatively closed-off world in which they resided. Such individuals were living examples of, in Isaac Deutscher's phrase, "non-Jewish Jews" who straddled the permeable borderlines between disparate cultures (1968, 27).

Whatever were the real or imagined beliefs in the efficacy of socialism as a political system and of Soviet leadership in stamping out anti-Semitism, the hard fact on the ground was that anti-Semitism took on new virulence in America during the 1920s, becoming a serious and frightening issue for artists on the left. They would have known about the growth of the Ku Klux Klan into a national organization; the immigration restriction laws passed by Congress in 1924; the rabid hatred of communism and with it the positioning of Jews as foreigners, radicals, and internationalists rather than 100 percent Americans; the institution of quotas for college-bound Jewish students; the publication and dissemination of the anti-Semitic tract *The Protocols of the Elders of Zion* by Henry Ford; and the anti-Semitic tone of Ford's newspaper, the *Dearborn Independent*, among other anti-Jewish manifestations (Levinger [1925] 1972, 13–15, 71–73, 117). Artists and others might also have been particularly upset by the secretary of the Chamber of Commerce of St. Petersburg, Florida, who in 1924 announced that the time had come to make his city "a 100% American Gentile City" (qtd. in McWilliams 1948, 38). What had happened to America as the land of freedom, artists might have asked, the land in which they might live a life free from the burdens of anti-Semitism?

Leonard Dinnerstein, a historian of American anti-Semitism, notes that "a quiet sense of desperation engulfed American Jews who had witnessed several decades of increasing attacks on them from almost every major segment of society" (1994, 127, and chaps. 5 and 6; see also Higham [1955] 1990, 278–86; Masserman and Baker 1932, 224–26, 233–35, 344–58; Waldman 1932, 19). The phrase "a quiet sense of desperation" is not a mere figure of speech in this case. As historian Beth Wenger describes the situation, for many during the 1930s "the deteriorating prospects of Jewish employment [because of undisguised anti-Semitism in the job market,] unfolding against an international climate of fascism and Nazism and the growing strength of American anti-Semitic movements, enhanced Jewish insecurity and informed Jewish responses to the daily challenges of survival." Whether rich or poor, college graduate or not, Jews were made to feel socially inferior (1996, 24). All of these factors made communism, or at least some form of leftist ideology, appear very attractive at the time.

Anti-Semitism, then, was a fact of life in America during the 1920s and 1930s. Artists might or might not have read Ludwig Lewisohn's article in *The Nation* in 1924, but they would have understood his words and tone:

> We are hated for our wealth and for our poverty, for our plutocrats and for our Reds, for display and for hard-headedness and warm-heartedness, for arrogance and servility, for pushingness and reserve, for speech and silence, for political participation and non-participation. If we desire assimilation you drive us out of your universities by chicanery and insult; if we do not strive after assimilation, you say we ought to go where we came from. (qtd. in Levinger [1925] 1972, 92)

In 1932, even party hard-liner Mike Gold was greatly offended by what he thought was an anti-Semitic slur in Archibald MacLeish's poem *Comrade Levine*. Whatever negative thoughts Gold might have held about traditional Jewish culture, he was very sensitive to what he considered to be fascist and exclusionary undertones in the writings of others (Aaron 1961, 281–84).

Anti-Semitism in America became the subject of a long article in the February 1936 issue of *Fortune Magazine* ("Jews in America" 1936). First,

its author(s) cautioned Jews to control their anxiety because "only" fifteen thousand people (!) in the entire country were members of Jew-hating groups, a "fact" presumably meant to allay Jewish fears and anxieties. But the article also listed the nation's principle anti-Semitic organizations, a list so long that it is terrifying to read even today.

The article, like the Communists' argument about diffusing anti-Semitism through economic change, refused to acknowledge the fact of sheer, irrational Jew hatred. The article also asked rhetorically: Why do people think Jews are Communists? It answered its own question: because Jews in the Communist Party are intellectual and articulate. Second-generation Jews, who are intellectual and good at Talmudic argument, are "mentally predisposed to Marxism to a degree which [they themselves] rarely appreciate[]" ("Jews in America" 1936, 130). And, the article argued, Marxism with its internationalism and antinationalism is eminently fitted to the emotional needs of a people without a fatherland—a view that was, in effect, a version of the venerable Jews-as-cosmopolitans argument. The article also touched on restrictions and quotas that affected Jews. It concluded by stating that because they are an articulate people, they become radicals. The editors were evidently satisfied with this combined cultural and biological explanation of the Jewish personality.

By this time, 1936, the Yiddish- and English-language Jewish magazines and newspapers as well as the mainstream press were reporting the increasingly menacing state-sponsored physical attacks on Jews in Europe virtually week by week and in the monthly magazines month by month. Organizations were formed to confront in whatever way possible the events taking place abroad and at home. For example, the American Jewish Alliance notified members in July 1939 to attend a meeting to develop a strategy to halt the violent attacks on Jews in New York City by the followers of the anti-Semite Father Charles Edward Coughlin because they "directly affect the peace and safety of the Jewish community." And the Assembly for Justice to National Minorities, sponsored by the magazine the *Jewish Survey*, put out a call on October 13, 1941, to unite all Americans against "Hitlerism" (AAA, Weber, roll 69-86, frames 31, 32). Many were aware as well of Nazi propaganda within the borders of the United States (Belth 1939; Goodrich 1940).

Many artists also worried about relatives in Europe and, no doubt, remembered their own experiences with anti-Semitism in the Old Country, whether on the street, in schools, or on the job. Given contemporary circumstances and historical memories, Jewish nationalism was impossible to stamp out and probably grew stronger as the decade progressed. As Irving Howe describes this phenomenon, "The central myth of Jewish life can be regarded as *the experience of memory*, a shared burden or obligation to remember the lashes and fires of the past" (1978, 94). And as literary historian Ruth Wisse tersely sums up Jewish responses to events *before* the Holocaust: "To be a Jew was to be on the side of the persecuted" (1987, 34).

By the early 1930s, probably every Jew who read a newspaper or a magazine would have known about the book burnings in Germany; the boycotts of Jewish doctors, lawyers, and shopkeepers; the banning of Jews from government employment; and Joseph Goebbels's attack on Jewish intellectuals—all in 1933. They would have been familiar with the Nuremberg Laws of 1935, which prohibited sex and marriage between Jews and non-Jews; the curtailment of Jews' participation in civic life and employment in many professions; the banning of Jews from public places, including libraries and parks; and the revocation of their German citizenship (Lipstadt 1986, chap. 1). With the rise of anti-Semitism in America as well, the future did not look promising.

How did all of this translate into subject matter for artists in America? Four cartoons among many that date from 1910 to the late 1930s, a period of twenty-odd years, reveal the increasingly ominous conditions of European Jewry and the ways cartoonists were able to visualize effectively the horrific accounts carried in the Yiddish- and English-language press. In the earliest cartoon, for the July 8, 1910, issue of *Der Groyser Kundes*, defenseless Jews of all ages, one holding a Torah Scroll, are being chased into Finland by a man, presumably drunk, holding a whip and a bottle of vodka (fig. 25). The man towers over the departing Jews, indicating that the powers inherent in the state, whether shown as uniformed police or as hooligans allowed to do violent acts, were absolute. The bottom caption is meant to be read ironically: "After all, the czar is not so terrible as some think he is. True, he chases out the Jews, but, therefore, well. . . ."

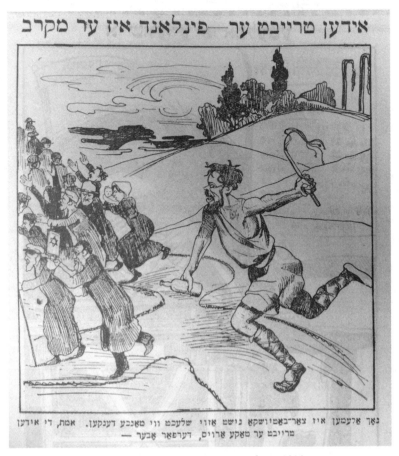

אידען טרייבט ער — פינלאנד איז ער מקרב

נאָר אַלעמען איז צאַר־באַפּיושקאַ נישט שלעכט אַזוי ווי מאַנכע דענקען. אמת, די אידען
מרויבט ער טאַקע אַרוים, דערפאַר אָבער —

25. *Jews Chased*, from *Der Groyser Kundes*, July 8, 1910.

This cartoon is relatively benign compared to Sam Zagat's *Rocks Hurled at the Jew* (fig. 26). Although undated, it would appear to have been made in the late 1920s, a time of exponentially increasing acts of anti-Semitism in Europe. Zagat, to make his point as clear as possible about increasing Jewish isolation and persecution, omitted any forms other than the running man, who cannot escape being hit by the huge stones hurled at him. Each stone is labeled with the name of a country— Greece, Germany, Poland, Rumania, and Mexico.

The third print (fig. 27) is by William Gropper, who, like Saul Raskin (see chapter 2), had his own evolving relationship with Judaism. He had

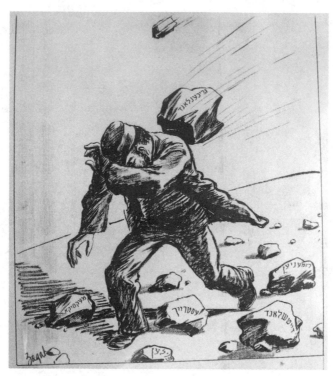

26. Sam Zagat, *Rocks Hurled at the Jew*, undated. Drawing, Samuel Zagat Drawings and Photographs: TAM 623, Box 2, Folder 11. Robert F. Wagner Labor Archives, Taimiment Library, New York University.

attended the First and Second World Plenums of the International Bureau of Revolutionary Literature in Moscow in 1927 and 1930 and had pilloried Jewish religious figures and rich businessmen in cartoons throughout the 1920s. Because of Hitler's growing popularity and the increasingly open anti-Semitism in Germany, however, Gropper began to make anti-Hitler cartoons by October 1930. In March 1933, barely two months after Hitler became chancellor of Germany, Gropper started drawing cartoons opposing his treatment of Jews. For the next twelve years, until the end of World War II, he probably made more anti-Nazi and Holocaust-related cartoons than any other artist (by my imperfect count). He also commemorated the uprising and destruction of the Warsaw ghetto in 1943 in a series of

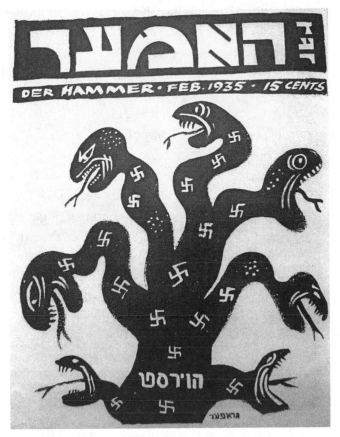

27. William Gropper, *Hoirst*, cover of *Der Hamer*, February
1935. Courtesy of ACA Galleries, New York.

annual paintings, each portraying a single rabbi, his head often upturned,
seemingly arguing with God or asking for an explanation. As Gropper said
in 1962, "Hitler and fascism made me aware that I was a Jew. I think all
intellectuals who were never concerned with their faith were thrown into
an awareness by the atrocities" (in Grossman 1962, 6). Gropper was being
a bit disingenuous here. Anybody, including Gropper, who as a youngster
had gone to a religious school known as a heder (Lozowick 1983, 16) did
not ever forget that he was a Jew.

Finally, through the 1950s and 1960s, Gropper painted many Jewish
genre scenes in a noncritical, often generous manner (see Amishai-Maisels

1993; Baigell 2002, 53–63; Freundlich 1968; Gahn 1970; Lozowick 1983; Phagan 2000).

In his prints and cartoons through the 1930s, Gropper showed past persecution and current victimization both at home and abroad (Baigell 2002, 53–63). Whatever his political affiliations, he revealed his deep concern for Jewish survival, a concern seen especially in his cover illustration for the February 1935 issue of *Der Hamer* (The hammer), the Communist monthly (fig. 27). Stark black with white markings, each of the hydra's seven forms is covered with swastikas and ends in an open-mouthed snake's head ready to attack. In Jewish legend, the serpent is a symbol of all that is wicked and hated by God, a notion Gropper might or might not have known (Ginzberg 1909, 1:315). The overall design clearly suggests a menorah, a traditional symbol of Judaism now taken over by the Nazis, its serpentine arms no longer in their usual elliptical or vertical positions.

Near the bottom, Gropper added a word that translates as "hoirst," which, at best, is an enigmatic insertion in a work whose meaning is obvious. It might be a reference to the "Horst Wessel Song," which became the Nazi Party anthem in 1930 and the co-anthem of Germany in 1933. Or he might have intended a reference to William Randolph Hearst, the newspaper publisher who was a noted racist, isolationist, anti-Communist, and anti-Semite—his last name here pronounced New York Jewish style (Hyman and Sparks 1935, 11–12, 21; Swing 1935, 146–48).

And the fourth cartoon, *Curfew Hour in Berlin* (1935) by Polish-born artist Jacob Burck, was published in the July 30, 1935, issue of *New Masses* (fig. 28). It shows Jews being roughed up by German police as they are being herded into the ghetto. At least two lie dead or wounded outside the gate, which is in the form of a swastika. Burck's drawing is quite astonishing for its date because during the so-called Third Period, the Communist Party stressed class antagonisms rather than ethnic issues, and Burck hewed closely to the party line. In 1935, he had made a series of murals on the theme of the Five-Year Plan for the Intourist Office in Moscow (Burck 1933, 1935, 334–37). At the inception of the Popular Front, however, he chose this kind of violent scene, perhaps able at last to permit himself a Jewish response to events taking place abroad.

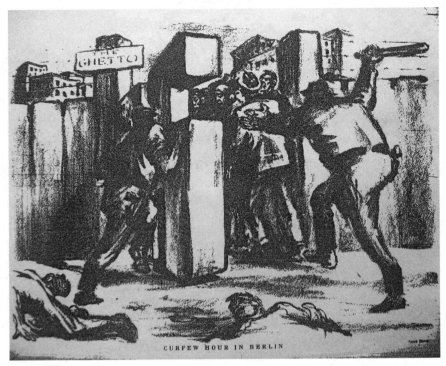

THE GHETTO

CURFEW HOUR IN BERLIN

28. Jacob Burck, *Curfew Hour in Berlin*, from *New Masses* 16 (July 30, 1935). Courtesy of the Burck Foundation.

Because many thought capitalism had already led to fascism in Europe and was on the verge of finding a home in America, it stands to reason that many Jews, with these images in mind, might have found communism an attractive alternative, especially during the 1930s, and therefore tolerated the dictatorial excesses of Stalin. Whatever the mix of psychological responses, religious and cultural backgrounds, political beliefs, economic concerns, and awareness of growing Jewish vulnerability, it is understandable that left-wing causes, including joining the Communist Party, seemed to be so attractive.

4

Soviet Communism, Nazi Germany, American Anti-Semitism

CZAR NICHOLAS II abdicated his throne on March 15, 1917, and the Bolsheviks seized power on November 7. The policy of *Der Groyser Kundes*, left leaning but not hard-line, revealed the editors' intense hatred of the old regime's politically repressive and anti-Semitic practices as well as their profound delight by this turn of events. Long before the czar's abdication, cartoons both hostile to and descriptive of his practices were regularly published. For instance, in the February 23, 1912, issue, Leon Israel (LOLA) created a cartoon meant to inflame the Lower East Side populace by showing Czar Nicholas burning a pious Jew at the stake (fig. 29). The headline at the top reads: "The Sun Rises in the East." The couple kissing within the disc of the rising sun represents the old China and the new republic of China that had begun to emerge from the overthrown monarchy. The woman, who represents the new China, wears the cap of liberty. On the can from which oil feeds the flames are the words *fluid fire*. The word *perishing* is written at the base of the fire. The caption reads: "In Asian China, the sun has already risen. Political and religious freedom. In civilized Russia, the czar continues to pour oil on the flames of Jewish extermination."

The many cartoons published with obvious Jewish overtones, some with biblical allusions, consistently celebrated, even exulted, in the czar's fall from power. One with biblical references appeared in the February 26, 1915, issue of *Der Groyser Kundes* prior to the czar's abdication. The figure, Hamen, the villain in the story of Esther who lost his dominant

100

29. Leon Israel (LOLA), *The Sun Rises in the East*, from *Der Groyser Kundes*, February 23, 1912.

position in the king's cabinet, tells the czar that he will lose his crown. Another cartoon by LOLA in the same journal, secular but with obvious Jewish meaning in its story line, was published in the issue for September 17, 1915 (fig. 30). In the celestial court, the czar is judged guilty by a jury of obviously Jewish angels. The headline at the top and the paper held by the jury foreman reads "Guilty." On the table before him, the writing on the axe reads "pogroms," and the words *Jewish people* appear on the prosecuting figure's prayer shawl. The caption reads: "The foreman: Righteous judge! Having heard the verdict from the defense when examining and underlining what he had prepared, we the jury have decided the defendant unanimously be issued a black note."

Finding the czar guilty in a Jewish court of law was apparently considered to be a sacred task in that the judge wears a prayer shawl. Only in the

שולדיג...

30. Leon Israel (LOLA), *Guilty*, from *Der Groyser Kundes*, September 17, 1915.

most holy moments of a religious service is a man's head covered, as is the judge's. The prosecutor, without an iota of sympathy in his eyes, stares at the sweating defendant, who appears to be quite worried. From the point of view of Jews with long memories, well he should sweat.

For the March 23, 1917, issue of *Der Groyser Kundes*, LOLA, in his easy-to-understand style, revealing within simple outlines depth and figural plasticity through hatchings and stipple marks, drew a cartoon showing the czar as a sideshow exhibit standing in a cage on Coney Island (fig. 31). The phrase "Coney Island Wonder" appears at the top of the cage. The sign affixed to the cage reads, "The last Romanov, a penny a look." The caption at the bottom tells us that this will be "the fourth act in Coney Island next summer." Viewers dressed in both old-fashioned and modern dress stare at the czar, who, like an animal or an exhibit in a freak show, is available for public viewing. It is not surprising to find in the same issue another illustration showing a Jew in America standing tall

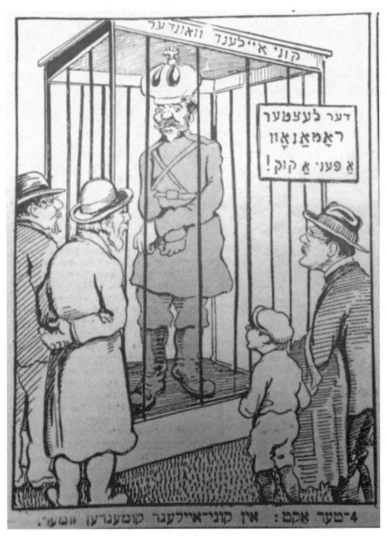

31. Leon Israel (LOLA), *Czar in a Cage*, from *Der Groyser Kundes*, March 23, 1917.

and welcoming the sunrise (to the east), with the words written around the sun's penumbra stating "Hail to a Free Russia."

A free Russia also meant freedom from the anti-Semitic policies of the Russian Orthodox Church. An illustration by William Siegel (1905–?) appeared in the issue of *Der Hamer* for November 1926 (fig. 32). In a

print given dramatic emphasis by the violent dark-light contrasts, the occasional, jagged cubist-angled forms, and the destroyed buildings, a huge worker fearlessly kicks down church real estate, knowing that the Soviet state is behind him, literally and figuratively. In contrast to the sense of violence on the left, the seemingly calmly organized new order appears in the lower right—carefully nurtured agricultural fields as well as very productive industrial plants, the smoke that billows from the smoke sacks indicating full employment and full production.

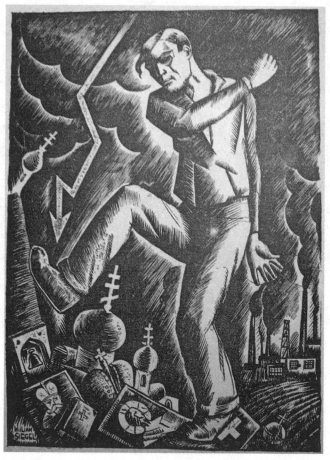

32. William Siegel, illustration in *Der Hamer,* November 1926.

Over the years, cartoonists acknowledged favorably the freedoms newly granted to Jews in Soviet Russia. In one illustration for the April 1, 1927, issue of *Der Groyser Kundes* (fig. 33), the headline at the top reads: "In the Land of the Soviets." The banner above a table states: "Union of the Soviet Republics." Representatives of the various republics sit at the table, and in the caption at the bottom area a neatly groomed Russian Jew asks in gentlemanly fashion to make room for one more person in recognition of the establishment of the Jewish Autonomous Region, Birobidzhan, in Siberia. (In 1928, Birobidzhan was officially designated a territory for Jewish colonization, and in 1934 it was made the Jewish Autonomous Region.) Everybody around the table seems pleased as the Jewish gentleman introduces himself with a wave of his cap. And as if to telegraph the equality that all Soviet citizens now enjoyed, the men's faces reveal their ethnic diversity.

33. *In the Land of the Soviets,* from *Der Groyser Kundes,* April 1, 1927.

By comparison, seven years later in 1935, William Gropper celebrated the establishment of the autonomous region in a much more aggressive fashion that reflected the success of the revolution and the Communist Party (fig. 34). In this print, the individuality of each Soviet republic is now subsumed within the party's all-embracing control, symbolized by the centrally placed huge red star. It is now the party, not individuals or groups of individuals, that assures the equal treatment tendered to Jews through the establishment of their own autonomous Soviet republic. This is made doubly clear by the placement of the star in front of the republics' pennants, including the half-hidden Birobidzhan pennant (with the last syllable of the name here spelled -*jan*).

A comparison between two images focusing on the religious ceremony of *shlogn kaporet* conducted before the start of Yom Kippur tells us further how Gropper regarded the Soviet Union, especially during World War II, and how it was believed that its policies and wartime record protected Jews (fig. 35). In comparison to the postcard dating from the turn of the century that illustrates a traditional view of the ceremony (fig. 6 in chapter 1), Gropper, for the October 9, 1943, issue of the *Morgen Frayhayt* (Morning freedom), updated the ritual by showing a smiling, powerful Soviet soldier swinging around his head a rooster with Hitler's features. The caption reads: "This is Hitler going to his death. A scapegoat for all of us." It is no longer the individual who transfers his sins to a rooster, but the Soviet soldier representing the Soviet Union who will protect the Jews by symbolically killing Hitler, the scapegoat.

These cartoons reveal the party's increasing control during the 1920s and 1930s, especially through its magazines such as *New Masses*, founded in 1925, and *Der Hamer* in 1926. At the same time, writers and critics became quite vocal in asking (really demanding) artists to search out appropriate revolutionary subject matter and to accept party positions. Historians have reminded us, however, that no single point of view or set of specific guidelines emerged even during the 1930s, the decade of greatest Communist influence, and despite endless exhortations to develop subject matter appropriate to the revolutionary cause. "In no way . . . should the turn left be taken to indicate unity, near unity, or any sort of

34. William Gropper, *Birobidzhan*, 1935, cover of ICOR Biro-Bidjan Souvenir, June 1935. Courtesy of ACA Galleries, New York.

political alliance among organizations, parties, and movements" (A. Liebman 1976, 285).

Left-wing art also was "rarely reducible to an equivalent of the frequently dogmatic and arid pronouncements of [the Communist Party's] cultural functionaries" (Hemingway 2002, 4, also 20–24; see also Harrison 1980, 245; Marquardt 1989, 1993). The basic issues revolved around the questions of whether and how a revolutionary or proletarian art could develop in a country still committed to capitalism and where artists, even

זה כפרתי! זה ההיטלער ילך למיתה — א כפרה
פאר אונז אלעמען!!!

35. William Gropper, *Shlogn Kaporet*, from *Morgen Fray-
hayt*, October 9, 1943. Courtesy of ACA Galleries, New York.

if from working-class families, did not necessarily consider themselves to
be proletarians.

Through the 1920s and 1930s, artists and art critics must have read
passages in various books, journals, and newspapers that encouraged revo-
lutionary activity and provided guidance in developing proper attitudes
toward selecting appropriate proletarian themes and subjects. Certainly,
there must have been endless hairsplitting discussions and arguments
along the way, especially when Communist-controlled art groups were
formed in the late 1920s. But as with the questions of who read Marx,
Taine, or Ruskin first and in which language around the turn of the

century, so, too, the questions of who read Lenin, Trotsky, and others first and in what order or in which language prevent us from knowing exactly how such information was passed around.

Nevertheless, it would seem that assertions about the nature and function of art boiled down to a handful of propositions that were stated and restated through the 1920s and 1930s. These propositions were not different from those presented earlier, just basically more insistent in accordance with party dictates: art should enter into and reflect the workers' lives, and artists should create from the workers' point of view. As mentioned earlier, party directives grew more prescriptive by the 1930s. According to writer Joshua Kunitz, Vladimir Lenin was the first among the Russians to enlist art directly as a weapon in the class struggle. In an essay written in the mid-1930s, Kunitz quoted a passage from Lenin written in 1905 and concerned with literary output:

> The socialist proletariat must establish the principle of party literature; it must develop this literature and realize it in actual life in the clearest and most concrete form. . . . Down with non-partisan writers! Literature must become part of the general proletarian movement, a cog in that unified Socialist mechanism which is set in motion by the conscious advance guard of the entire working-class. Literature must become a component part of the organized, unified Socialist party work. (qtd. in Kunitz 1935, 362)

This is not the language used by figures such as Saul Raskin or Dr. John Weichsel. In Kunitz's translation, the word *must* is used twice, and he evokes an "advance guard" that now leads "the entire working-class." By 1935, this kind of language had become commonplace in left-wing publications, whether based directly or indirectly on Lenin's thoughts. Many certainly would have become familiar with Lenin's ideas by 1929, when the article "Lenin on Art" appeared in the January issue of *New Masses* (all quotes from 9–10). Lenin's tone in that piece varied from a generalized socialist interest in art to one in which he insisted that the party control all Russian literary output. (He discussed the social philosophy of literature but not of the visual arts in relation to the Communist Revolution.)

Castigating bourgeois literature for its false sense of freedom, an old trope by 1929, he reasoned that communism had exposed this hypocrisy because a really free literature is bound up not with artistic profiteering but with the proletariat and with sympathy for the workers, an idea that can be traced back to the nineteenth century.

But freedom was, to be sure, a relative concept for Lenin in that the creative forces unleashed by the revolution had to be guided. "We must direct consciously and clearly and seek to form and define its results," he wrote. To do so, it was necessary to study past literature for its formal qualities of organization and structure and then combine these qualities with content derived from contemporary Soviet life. In other words, take the best from past art in order to serve contemporary needs. Only in a socialist classless society would such an art emerge.

In that same article, Lenin's famous statement recorded by Clara Zetkin in *Reminiscences of Lenin* (1934) was repeated: "Art belongs to the people. It must let its roots go down deep into the very thick of the labouring masses. It should be understood and loved by these masses. It must unite and elevate their feelings, thoughts, and will. It must awaken and develop the artistic instinct within them" (see also London 1938, 67; Lunacharsky 1932, 12; Polonsky 1934, 738; Solomon 1979, 166). In truth, this passage is both romantic in tone and prescriptive and calculating. The laboring masses are seen as an abstract entity that, it was hoped, would respond to an epiphanic force rather than as a body to be led. But the underlying message was control of the finished artistic product. All of this was not especially attractive to American artists, who for the most part did not care to be regimented and knew little about proletarian life in the Soviet Union.

In fact, in his 1935 article mentioned earlier, Kunitz related a story of worker criticism that was directed at the American delegates to the Second World Plenum of the International Bureau of Revolutionary Literature held in Kharkov in November 1930. The workers were reported to have said: "We thought that as artists, you [Americans] would give us vivid pictures, artistic descriptions of how the workers live and struggle in your country. Revolutionary phrases we can deliver ourselves. We want facts, and from artists, artistic presentation of such facts" (qtd. on 365). It would seem, as borne out by criticisms of American artists by American critics,

that artists never quite provided the vivid pictures demanded by the Soviet workers even though the critics did provide artists with the appropriate revolutionary phrases.

Leon Trotsky's ideas on the relationship of art to society were spelled out in *Literature and Revolution*, published in America in 1925 (see esp. chaps. 5 and 6; see also Freeman 1936, 385). These ideas pertained, first, to the basic project of creating a classless society and, second, to specific Soviet conditions. Trotsky held that the current period of the revolution, in which the proletariat had acquired power, was a temporary one. It existed for the purpose of doing away forever with a temporary "class culture" in order to make way for "human culture." A specific proletarian art and culture, therefore, could never exist. The revolution was only "laying the foundation for a culture which is above classes and which will be the first culture that is truly human" (1925, 14). This culture, this "human culture," had not yet emerged and would do so only after the appearance and then the disappearance of what people falsely called a proletarian culture and the resulting dictatorship of the proletariat (184–91). In time, "socialism will abolish class antagonisms as well as classes," and the resulting Socialist society will transition to "a stateless Commune" (229, 190).

Those who favored Trotsky's vision "devoured," as Irving Howe's puts it, the utopianism of the concluding chapters of *Literature and Revolution*, "where [Trotsky] polemicizes against the action of a distinctly 'proletarian culture' and ends with a lyrical rhapsody celebrating the heights that 'socialist man' would scale, even beyond Goethe, Beethoven, and Marx" (1982a, 57).

Trotsky detailed many aspects of life in that utopia, including the proper feeding of children, a task that would involve everybody. As he said, "All will be equally interested in the success of the whole" (1925, 230). In that ideal commune, all human needs would be taken care of. "The liberated egotism of man—a mighty force!—will be directed wholly towards the understanding, the transformation, and the betterment of the universe—in such a society the dynamic development of culture will be incomparable with anything that went on in the past" (188). As Trotsky described it, the endpoint to this process, decades in the future, will take on messianic overtones, both Marxist and Judaic, and is rendered in terms

vaguely reminiscent of the language one can find in Isaiah 69:12–14 and Amos 9:13–14 as well as in Raskin's remarks mentioned in chapter 2.

As a first step in the creation of that commune, proletarians had to take possession of the machinery of culture, including industries, schools, publications, the press, theaters, and so on. But regarding the creation of an appropriate art, Trotsky was somewhat vague because he understandably could not read the future. He believed that it was not necessary for revolutionary art to be created only by workers (227, 217). But at the same time intellectuals could not create an abstract culture for proletarians. Rather, their job was to help elevate the masses by educating them in their own culture, a culture that had not yet and might never gain prominence. (Trotsky wavered in his belief in the existence or nonexistence of a proletarian culture [1925, 193]). In any event, he did not intend to destroy bourgeois culture but instead wanted to build on it to maintain a continuity of creative traditions. Somehow, one culture would elide into another until the final "human culture" would emerge.

But what kind of art would emerge? Trotsky did not know because the revolution was still quite young. Nevertheless, he, like Raskin, did find the proletariat, although it was uneducated aesthetically, to have a sense of spirituality and therefore an artistic sensitivity (1925, 226). He concluded that "art must make its own way and by its own means. . . . The domain of art is not one in which the Party is called upon to command" (218). What he meant was that art not necessarily connected directly to the revolution will ultimately become imbued with a consciousness of the revolution (228).

Yet some kind of control was necessary. The question was: At what point should the authorities interfere? "We ought to have a watchful revolutionary censorship, and a broad and flexible policy, in the field of art, free from petty partisan maliciousness," he stated (1925, 221). Compared to Lenin's position, Trotsky's remained more open-ended and much less prescriptive by allowing art to develop as the revolution progressed after proletarian culture gave way to "human culture." But individual freedom was nonetheless still harnessed to the ongoing revolution.

Joseph Stalin's doctrine of socialist realism, set forth in 1932 and articulated by Andrei Zhadonov (1896–1948) in 1934, called for an "objective

reality," but, according to historian Margaret A. Rose, this reality depended on revolutionary development combined with truthfulness and "with the ideological remoulding and education of the toiling people in the spirit of socialism" (1984, 144). Basically, this doctrine had little application to the American scene.

From this comparison of the thoughts of Lenin, Trotsky, and Stalin on art, it is clear that control of art production was a closed issue. But there seemed to be some differences between them concerning the ultimate nature of Soviet art. Trotsky held that the new art would develop only when "human culture" appeared after the revolution was completed. In contrast, Lenin and Stalin felt that such an art would develop within proletarian culture by increments and under strict government direction (Hemingway 1994). Its ultimate form and character was yet to be determined. The Leninist-Stalinist position dominated discussions of left art in America in the 1930s rather than the more vague Trotskyite position, in which the art of the future would somehow evolve by itself at a time when "human culture" replaced "class culture."

But whatever the language they used, they all really meant evolution by direction from the top, not by compassion welling up from below. As Rose has suggested, "The Russian Revolution was made and saved not by a class, but by a party proclaiming itself to be the representative and vanguard of a class, that is, by an elite group" (1984, 136).

In an early essay by Mike Gold published in 1921, "Towards Proletarian Art," we can see that its author was already aware of Lenin's point of view. (Gold was the editor of *The Liberator* in 1921, a founder of *New Masses* in 1925, and its editor in chief in 1928.) Yet in his essay he moved without a pause from language that invoked Walt Whitman to comments that reflect Lenin's desire to guide and control the emergence of the artistic product. Gold was most Whitmanesque when writing these lines: "When there is singing and music rising in every American street, when in every American factory there is a drama group of the workers, when mechanics paint in their leisure, and farmers write sonnets, the greater art will grow and only then." He continued, "The art of the capitalist world isolated each artist as in a solitary cell" ([1921] 1972, 70; see also Estraikh 2005, 76). Until this point, early-twentieth-century Jewish socialists probably would

have found no fault either with this paean to working-class uplift or with Gold's understanding of an artist's untenable position in capitalist society.

But then a newer, different attitude clearly inspired by Gold's commitment to communism becomes evident in this essay. Gold found that the artist in his "solitary cell" will "brood and suffer silently and go mad. We artists will not face Life and Eternity alone. We will face it from among the people. . . . The Revolution, in its secular manifestations of strike, boycott, mass-meeting, imprisonment, sacrifice, agitation, martyrdom, organization, is thereby worthy of the religious devotion of the artist" ([1921] 1972, 66–67). Here, he suggested some subjects to explore and seemed as much concerned with stating party policy as with uplifting the masses.

By 1926, Gold was at his dogmatic crest when writing his introductory comments for a book of cartoons published that year. "Art, the Bolsheviks say, is useful or it is nothing. It springs from the life of the masses. It shapes the thought of the masses, is their expression" (Gold 1926, n.p.). Such phrases became, in one form or another, the standard line about the function of art: it should come from a particular class, and even if artists do not come from the working class, they should adopt its attitudes so that their art will become a viable part of the class struggle.

In 1930, the party's basic position on art was laid out for Americans in *Voices of October: Art and Literature in Soviet Russia* (1930), a book written by Joseph Freeman, Louis Lozowick, and Joshua Kunitz. Although their observations applied to the situation in Soviet Russia, not the one in America, at least the authors did gather in one place what were in effect a series of directives concerned with ways artists should contribute to the revolutionary cause. They encouraged artists to understand the nature of class struggle so that they might choose the proper approach to subject matter. They stated that "the struggle of economic classes determines not only the nature of political and social institutions, but also philosophy, literature, and art" and that, "in the final analysis, [the struggle] has its roots in the social structure of a given period, in its technique, and its class relations" (15). This passage seems to be little more than a restatement of both Marx's theory of base and superstructure as well as of Hippolyte Taine's sociological approach to art mentioned in chapter 2, but with greater attention to class struggle or to setting off one class against another.

For Communists, the authors continued, "all art is class art; and every artist is a participant in the class struggle" (1930, 17). Absolute freedom for the artist is an illusion. As Lenin insisted, "Absolute freedom is sheer hypocrisy . . . , a bourgeois or anarchist illusion. . . . A really free literature . . . is openly bound up with the proletariat" (qtd. on 18), free because the artist is thought to create in sympathy with the workers and is not beholden to rich individualistic members of the bourgeoisie. And then they quote a longer passage from Lenin: "No contemporary Russian artist can afford to be socially unconscious; no artist can justify his work in the opinion of the revolutionary proletariat unless it is to some extent in harmony with the proletariat's fundamental aims—which include not only the socialization of economic production and distribution but of cultural production and distribution as well" (qtd. on 17–18). Further, "the aim of Soviet cultural activities, art and literature included, is primarily to raise the cultural level of the entire population, and to create foundations of a communist culture, as opposed to capitalist culture" (qtd. on 20). In this regard, all artists must work for the general aims of the Soviet Union and the establishment of a Communist society. And, finally, "The Communist Party of the Soviet Union is perhaps the only political party in the world today which has adopted a comprehensive resolution outlining its policy on art and literature" (21).

To link together the notions that American artists should no longer consider themselves free to create as they wish or to think that they might choose to create as they so desire and that they should adopt the point of view of an American proletariat, the John Reed Clubs were formed in 1929 by a group connected to *New Masses*, including Jacob Burck, Hugo Gellert, Michael Gold, William Gropper, Jerome Klein (dates unknown), Louis Lozowick, Joseph Pass (dates unknown), and Anton Refregier (Marquardt 1989). Its manifesto was made public the following year. Given the fact that the clubs were Communist controlled, it is impossible to say today how much of the manifesto was written independently in this country or dictated by functionaries in the Soviet Union, but because those who wanted to join the clubs had to subscribe to the program adopted by the International Conference of Revolutionary and Proletarian Writers, which met in Kharkov in November 1930, we can assume the obvious.

We can also assume that the text accompanying the manifesto came in principle if not in actual words from Kharkov. It included statements such as the following: "As the bourgeois world moves toward the abyss, it reverts to the mysticism of the middle ages. Fascism in politics is accompanied by neo-Catholicism in thinking." The Soviet Union was at the time considered the new, rising civilization, a country in which there was no unemployment and "workers rule in alliance with farmers" ("Draft Manifesto" [1932] 1973, 43). In comparison, America and other capitalist countries were considered to be in the process of disintegrating.

The manifesto included six principle directives: (1) fight against imperialist war and defend the Soviet Union; (2) fight fascism; (3) fight to develop and strengthen the revolutionary labor movement; (4) fight white chauvinism; (5) fight against middle-class ideas in the work of revolutionary writers and artists; and (6) fight imprisonment of revolutionary writers and others involved in class wars ("Draft Manifesto" [1932] 1973, 42–46). Quite simply, as Orrick Johns wrote in 1934, "the purpose of the John Reed Clubs is to win writers and artists to the revolution" (26).

It is also important to call attention to some passages that appeared in the application form for membership. "The interests of all artistic, intellectual, and cultural workers are in harmony with those of the working class. . . . The John Reed Club opposes all support of capitalism by cultural workers . . . and considers its specific task the development of new worker writers and intellectuals on the side of the revolutionary working class" (qtd. in Taylor 1987, 96 n.). Compared to the tenor of discussion earlier in the century, party language had by this time become significantly more bureaucratic, focused, and prescriptive. By 1934, party concerns had reached an authoritarian highpoint. According to Irving Howe and Louis Coser, Alexander Trachtenberg (1885–1966), representing the Central Committee of the Communist Party, "made it clear that there could be no opposition between the intellectuals of our movement and the party organizers" (1957, 225; see also Johns 1934, 26).

Even if intellectuals on the left and the art critics among them disagreed with Trachtenberg, his comments would have made a strong impact on and even inhibited anybody writing for the left press who thought otherwise. Independent thinking was evidently not a high priority, at least

until 1936, when the American Artists' Congress was founded to replace the John Reed Clubs. The AAC and many other organizations were organized as part of the Popular Front to counter the rise of German fascism. The Front, initiated at the Seventh World Congress of the Communist International in Moscow in 1935, came into being because Hitler's Nazi policies rather than capitalism had now become the greater enemy to Soviet Russia and communism. Therefore, the revolutionary rhetoric of the Third Period (1929–35) was replaced by the more politically centrist desire for all people everywhere to join the fight against fascism at home and abroad (see the articles reprinted in Baigell and Williams 1986a).

In the early 1930s during the Third Period, Jewish art critics who wrote reviews of John Reed Club exhibitions critiqued artists without mercy, evidently expecting them to have developed a revolutionary attitude and art virtually overnight even when the critics themselves had only general ideas of what composed such an art. A sheet of paper in the Hugo Gellert Papers in the Archives of American Art written by an unknown person evidently involved with party affairs described the kind of knowledge a critic must possess and noted that the critic who lacked such knowledge could be harshly critiqued in turn.

> The revolutionary critic has a deep duty to our present civilization. To fulfill that duty, he must endeavor to understand the nature of the class struggle. He must understand Marxian and Lenin dialectics. He must have an understanding of the materialistic conception of history and with these he must have a literary and artistic background and education. (AAA, Gellert Digitized on the Internet, Series 1, Biographical Material, Box 1, Folder 27, Correspondence, Mar. 1934, p. 12)

No doubt, some critics grew up in working-class households and obviously had had contact with workers. But acquiring an understanding of Marxian and Leninist dialectics required significant leisure time and perhaps a college education. It is no wonder, then, that Joseph Freeman, editor of *New Masses* at the time, observed in a report dated November 1932, "We have not in this country in the English language basic Marxian writings which throw light on questions of art and literature" (qtd. in Hemingway

2002, 8). Or, three years later, in the October 1935 issue of *New Masses*, Thomas S. Willison complained that no satisfactory or classic representation of even such common themes as demonstrations, picket lines, and the unemployed had yet been achieved (cited in Hemingway 2002, 39). Insofar as there was no critical consensus presented in *New Masses* in the 1930s, it is quite possible that the critics, despite having absorbed some Leninist ideas about art, did not really know what they wanted or how to go about getting it (Hemingway 1994, 18).

Some examples of critical comments before the introduction of the Popular Front in 1936 indicate this lack of specific direction. When Louis Lozowick, an artist who often wrote exhibition reviews, published a short essay in 1931 in *Literature of the World Revolution* (Lozowick [1931] 1997a), two years into the Great Depression, he found American artists still dependent on dealers, galleries, and rich patrons even though they thought themselves to be autonomous and independent. But Lozowick believed that this situation was changing. The John Reed Club artists, he held, had begun to organize meetings to explore the class character of bourgeois art and to offer their services to the working class by designing posters, banners, and the like. And political cartoonists were being called upon to "make an annihilating attack on the capitalist regime in all its aspects" (289). But Lozowick felt that revolutionary artists had yet to develop a style that could portray the city and its inhabitants properly. (For some artists' opinions about the John Reed Clubs, see chapter 5.)

After seeing the large John Reed Club exhibition *The Social Viewpoint in Art* in February 1933, Meyer Schapiro (writing under the pseudonym John Kwait) was less hopeful than Lozowick. He felt that the point of the exhibition, the social viewpoint of art, was too vague, and without technical aid and definite models of action the artists had not been able to capture a proper revolutionary tone. He found that the "American painter has no clear idea of the world about him or the issues of the class struggle" (Kwait 1933, 23). He suggested that to illustrate "phases of the daily struggle" and "the most important revolutionary situations" (23), an artist must produce trenchant pictorial commentary that should be able to reach the masses. This could be accomplished by including prints, cartoons, posters, banners, and signs, which had been included in the program of Dr. John

Weichsel's Peoples' Art Guild years earlier (see chapter 2). Otherwise, the artist, if left to himself or herself, would remain "a confused individual, struggling for a precarious living, fussing over a picture of 'American life' which he would like to sell to a dealer" (23). In a symposium discussing the exhibition, Schapiro said: "The revolutionary artist does not only devote himself to propaganda, but builds a monument and makes a record of the present struggles of the workers, and glorifies their part in building a new social order" (qtd. in Hemingway 2002, 59).

The next exhibition, *Hunger Fascism War (December 1933–January 1934)*, fared slightly better in the eyes of Louis Lozowick, but he had to admit that it would take time to arrive at an aesthetic equivalent of the "Social Revolution" (1934, 27). As in Schapiro's review, there were brave but not very helpful words in Lozowick's review. Artists needed to develop a militant class consciousness "to depict hunger, Fascism, war not as congealed facts but as dynamic processes, to describe them not purely empirically but from a definite class viewpoint, to create the pictorial flesh that would clothe the underlying thematic skeleton—[which] is a very difficult as well as high aim" (29).

Mark Graubard's discussion of the exhibition was much more negative. He thought that the artists had never actually experienced and had never even been aware of the real meaning of hunger, war, or fascism and that they had never participated in working-class struggles. He found the art work closer to "history homework" than to "descriptive, analytical, and interpretative records of stirring events. . . . The results were empty, unconvincing, and artificial" (1934, 24). Artists, Graubard held, needed to participate in actual experiences, to participate in working-class life in an active way in order to be of any use to the revolutionary movement.

Jacob Kainen severely critiqued the exhibition *Revolutionary Front*, presented in December 1934. He found the works to be negative in outlook, the pictures lacking any sense of the heroic efforts of the proletariat and their class struggles. He singled out Selma Freeman's *Strike Talk* (1934, fig. 36) for showing drab workers rather than projecting "the rich values workers have brought to the surface of life, their power, health, and potentiality" (1935, 6; see also Harrison 1980, 246; Tyler 1990, 267). In fact, working conditions in sweatshops had improved but could still

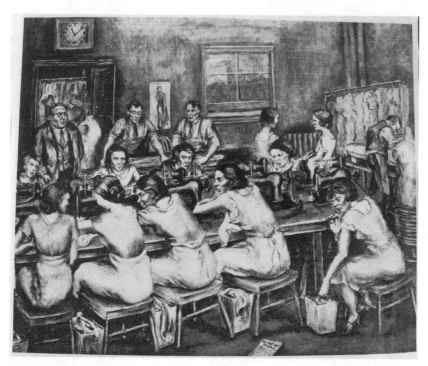

36. Selma Freeman, *Strike Talk*, c. 1935. Collection unknown.

be abysmal. Nevertheless, this painting exhibited the very qualities Kainen thought were missing. So almost eighty years later it is interesting to explore a bit further his assessment because the painting is more complex than Kainen had imagined.

First, the artist, who was Jewish, was able to portray workers, also presumably Jewish, openly calling for a strike. By itself, this subject shows how far Jews had come in America in contrast to the ghetto mentality and fear of official retribution mentioned in chapter 1 (see, e.g., fig. 3).

Second, the painting's subject, the organization of a strike, demonstrated how union activities had helped overturn degrading sweatshop conditions and how the women acted as a community to organize and carry out their actions. The piece of paper in the foreground, stating, "All out by noon," tells us about the conversation between the women. The most important figures, the organizers in the foreground, appear to be in agreement. On the other side of the long table, other women are paying

attention to the conversation. The man in the suit, portrayed as a Nean-derthal and relegated to the background, stares off into space, apparently unaware of the strike talk taking place right in front of him.

Insofar as each of the women accepted responsibility for her own future, Freeman might also have intended to illustrate their growing political strength. Many women were constantly outraged because they were usually excluded from union leadership positions, held by patriar-chal Communist and non-Communist men (Bender 2004, 17, 155–58). Perhaps these workers had decided to take matters into their own hands in the tradition of strong socially and politically minded Jewish women of the late nineteenth and early twentieth centuries. Thus, *Strike Talk* might also be read as an early and powerful feminist painting. In any event, Freeman shows the women intent on bettering their situation through legal means.

Third, we cannot be certain what kind of strike call is represented inso-far as Communist organizers tolerated losing strikes until they knew that they had enough votes to assume control of a union local. As one observer recorded in the early 1930s, "Communist leaders have freely admitted to me that they prefer not to win strikes until they have a membership in the country consonant with the assumption of such control" (Jackson 1932, 185). The painting, then, might depict a strike call to organize a union or a call organized by the party to take over an already existing union local. So we do not know if the man standing in the rear is in fact the owner of the sweatshop, an overseer, or a union leader who represents the "wrong" union the party wanted to defeat. In short, Freeman, whether intention-ally or not, raised some serious issues without sloganeering.

What sort of images would have been acceptable to the critics? They might have approved of strike scenes such as *Unemployed Marchers* (fig. 37), an undated German expressionist-style lithograph by Leon Bibel (1913–95). In the foreground, two out-of-work men are roused from their physical and psychological torpor by an endless parade of the unemployed, who march toward the city in the distance. Although the marchers' heads are bowed, their lockstep strides, reminiscent of the shuffling men in Fritz Lang's 1927 German film *Metropolis*, suggest that their presence, because of their great numbers, will be felt when they reach their destination. We can assume that the marchers will confront the capitalists/managers/

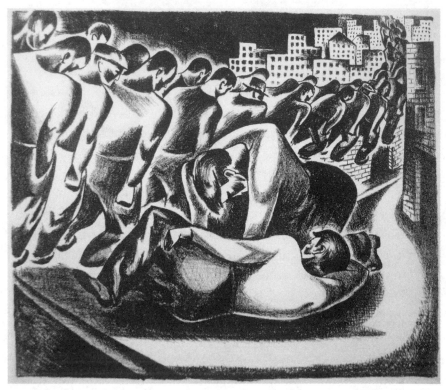

37. Leon Bibel, *Unemployed Marchers*, c. 1938 (1988). Stone lithograph, 12 × 15 in. Courtesy of Park Slope Gallery, Brooklyn, NY.

bosses in order to unionize their ranks or to obtain jobs or to improve their working conditions. The point here is that they appear to be determined, disciplined, and ultimately unstoppable in their quest for a better life.

On the one hand, the print's content would seem to be acceptable to the critics. On the other hand, because the workers appear as human automatons, let us hypothetically assume that the print might have been critiqued as an example of "leftism," an accusation leveled at basically uneducated artists who applied what they thought was a Communist point of view but one that lacked proper political perspective. Bibel, if he was so critiqued, might have been accused of stereotyping the workers because he appeared to be unacquainted with how workers actually lived and how they organized strikes. Workers' struggles, he might have been reminded,

could not be depicted accurately after "a tourist's visit" (Phillips and Rahv 1935, 369) to a factory or to a strike scene. Nor could revolutionary art be "produced by applying abstract Communist ideology to old familiar surroundings. The assimilation of new materials required direct participation instead of external observation" or, for that matter, stereotypical presentation (369).

What this boils down to is that if Bibel's print was so critiqued, then the artist might have been accused of not fully comprehending the interaction between what should have been his own developing proletarian consciousness and the workers' environment. Art, revolutionary art, steeped in sensory experiences, did not lend itself to "the conceptual forms that the social-political content of the class struggle take most easily" (Phillips and Rahv 1935, 373). Experience on the ground was essential. By contrast, Bibel's strikers remained automatons, political abstractions, conceptual forms. They did not come to life as living, breathing human beings. We are presented instead with a parade of marching men in which formal arrangements dominate character development as well as what the men might be thinking or feeling. Composition, therefore, dominates narrative—a bourgeois trait not to be tolerated. One wonders, therefore, what critics might have said about the May 1931 cover of *New Masses* by Nicolai Cikovsky (1894–1984), which, despite evident sympathy, featured caricatured, undifferentiated, slogan-shouting African Americans marching in lockstep (fig. 38).

In a very long article written in Yiddish in 1935 for *Bodn* (Base), Lozowick also begged the issue of defining an appropriate proletarian style and subject matter. Acknowledging the importance of Marxist philosophy as the driving force in evaluating the shortcomings of capitalism, he stated that the revolutionary artist clearly sees "reality," class antagonism, and capitalist failure. In what had become a boiler-plate analysis by 1935, Lozowick held that awareness of history was not derived from the thoughts of a single aristocrat or a bourgeois individual. Rather, an artist's sense of history and revolutionary art was broadened by following the party line. But as for others who wrote about this matter, for Lozowick the creation of such an art defied clear definition. Lozowick also commented on federal policy that allowed food to rot in the fields in order to maintain high

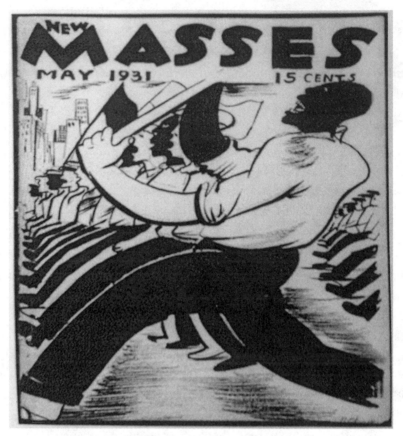

38. Nicolai Cikovsky, *May Day March*, from *New Masses* 7 (May 1931).

prices, another instance in his mind of capitalists forever compromising further their own already low levels of human decency. (Saul Schary discussed this matter in his article "Tendencies in American Art" [[1936] 1986, 151], and in 1934 Thomas Hart Benton painted such a scene in *Plowing It Under* [see Baigell 1973, 107].)

There is no reason to doubt Lozowick's seriousness and commitment to the party line as a writer even though he had no firm answers about appropriate revolutionary subject matter. As an artist, he, too, was criticized primarily for his machine-age forms, which he nevertheless justified as revolutionary art. In a letter to the editors published in *New Masses* for February 1929, a seemingly stalwart party member named Pauline

Zutinger wrote the following: "A Communist artist must endow his worker heroes with invincibility. . . . The heroes of the working class are like Atlas, carrying the burden of the universe on their shoulders. The worker hero represents the forces of creation. He is the embodiment of the new world order. His voices and his actions are spiritual and physical declarations of the working masses" ("Letters to the Editors" 1929, 31). Aside from the fact that Zutinger seemed to encourage the use of "conceptual forms," she then attacked Lozowick by calling him an opportunist, a drawer of pretty machines who served the bourgeoisie, and an artist who perpetuated "bourgeois romanticism." Lozowick responded in the same issue by agreeing that Zutinger's comments did suggest one way to affirm the revolutionary cause by heroizing the worker. But, according to Lozowick, this approach was in itself a petty bourgeois legacy. A better way, he thought, was to recognize the important contributions of machinery and industrial technique in "the achievement of the revolution and the functioning of the new society" ("Letters to the Editors" 1929, 31).

However one lined up on this issue, it would seem that from the hindsight of almost eighty years later the publication of such a well-written attack and the immediate response smells a bit fishy. It is if they were set up by the editors to protect Lozowick or to introduce a discussion of the different ways modernist styles might contribute to a proper revolutionary art. The interchange did in fact raise the important issue of whether a socially concerned, realistic presentation of subject matter defines revolutionary art or whether such an art can also emphasize compositional arrangements and include contemporary, modernist artistic developments, as in the Bibel print. In effect, the exchange in *New Masses* raised difficult questions of what contributes to and constitutes a revolutionary art—questions never really answered. Jacob Kainen spoke to this matter when he said that in the John Reed Clubs "we wanted to make proletarian art more modern, show that it didn't have to be workers with their fists raised and all that" (AAA, oral interview by Avis Berman, Aug. 10, 1982).

By his choice of words, art critic Harold Rosenberg (1906–78) addressed the matter less adversarially but no less vaguely. In his review of an exhibition of William Gropper's work, he dodged the matter:

Although Gropper has not yet developed a new form for revolutionary painting, he has, by his easy and graceful mastery of the materials of social struggle, by his presentation of it, as it were, *from the inside*, without strain, carried forward the possibility of technical discovery of revolutionary art. [By not waiting] for a revolutionary esthetic to grow out of the air, he has contributed to revolutionary art and to its dynamic history by simply painting revolutionary pictures of excellent quality. (1936, 8, italics in original)

In effect, a new form for revolutionary painting would appear, but not just yet. In the meantime, good quality is, well, good quality.

A question to ask at this point is, Why were the critics so critical, so impatient in their desire to set a revolutionary art in motion? There are no easy or complete answers, but some speculations can be offered here in no special order.

Jerome Klein alluded to his critical impatience in the early 1930s in a letter he wrote to Max Weber on December 20, 1939: "Perhaps we have been expecting too much from the artists. You know as well as I do that people long accustomed to regarding themselves as bearing the world's burden in their own creative souls do not get over the habit, even when they honestly try to face new problems, of looking for the answers within themselves" (AAA, Weber, roll 69-86, frame 373).

Impatience, possibly. Ignorance, another possibility. Historian Alan M. Wald has noted the following about some unnamed writers attracted to communism in the 1930s: "Often coming from culturally barren, plebian backgrounds, they gratefully entered the John Reed Clubs, where they found a secure home in the company of likeminded people. Their loyalty to the Communist Party, which to some degree had educated them and given a direction to their lives, was often fierce, arrogant, and purblind" (1976, 300). Historian Daniel Aaron approaches the influence of communism from a different point of view:

[Many] became radicals because they thought the economic system had gone kaput, because they saw too many hungry and desperate people, and because men and ideas they detested seemed in the ascendant.

Marxism offered a convincing explanation [of] why these conditions obtained as well as a program for changing the world; the [Communist] [P]arty satisfied their *latent religiosity* and made them feel useful. (1961, 402–3, italics added)

Perhaps the Depression and the rise of fascism abroad created a mood of desperation. Some might have thought that there might not be too much time left to work together to get the new society established and that artists therefore needed to learn their role in the social revolution and make their contributions quickly.

Some might have agreed with Joseph Freeman, who helped turn *New Masses* into a party-controlled magazine, when he summed up as well as anybody else the attraction of communism and the Soviet Union as a model to imitate. First, because the rapaciousness of capitalism caused workers to suffer so many hardships, he believed that only communism represented the best interests of humankind. Second, the revolution had improved life in Russia. Third, the Bolsheviks faced problems honestly and directly and tried to overcome them with actions, not words. And fourth, Russia was "the only country in the world where government and social organizations look[ed] on life as something to be directed[,] to be 'molded nearer to the heart's desire.'" The Soviet government, Freeman held, did not profit from or exploit the people but wanted instead to improve the country's industrial capacity for the benefit of its inhabitants and to advance the people's culture rather than to enrich a handful of individuals (1936, 311, 360). To Freeman and perhaps to others, it seemed self-evident that the works of Soviet artists in the service of their country should be emulated as rapidly as possible.

We might take Freeman's argument a step further and consider a notion more felt than precisely articulated. For immigrants and children of immigrants, as historian Richard H. Pells has suggested, there was "a residual loyalty to the intellectuals' dream of social democracy," a sentiment "particularly true of Jewish writers, many of whom were refugees from Czarist oppression and who cared deeply about the transformation of their original homeland" (1974, 61). No doubt they did care, but their dream of social democracy in Russia was fed in great measure by their

absolute, implacable hatred for the czarist government and what it repre-
sented to them both as socialists and as Jews. And as historian David A.
Gerber also notes when reflecting upon the feelings of his grandparents
and members of that generation, "Eventually I came to sense that what
remained of their feeling for the USSR was a desire to retain faith in the
idea of socialism, a world without scarcity, and the desperate hatred it
breeds" (1996, 127). It stands to reason, then, that an art that projected
revolutionary fervor, even in America, would in effect add nail after nail
to the czarist coffin and help redress remembered humiliations. As Joseph
Freeman recalled at the time of the revolution, "The Romanov dynasty
was the greatest scourge in the world. It must be crushed. . . . The over-
throw of the Czar in February 1917 filled us with joy" (1936, 72, 91).

Others might also have looked to America as the model to imitate.
Perhaps older as well as younger critics remembered the many positive
statements associating Judaism with Americanism earlier in the cen-
tury (see chapter 1). The threat of rising anti-Semitism and the effects of
the Depression might have compromised their belief in America as the
Golden Land. As Pells also points out, the "urge to do more than merely
restructure institutions reflected a profound loss of faith in the American
Dream and an effort by intellectuals to discover some new value system to
fill the void" (1974, 99, 100). So the critics might have wanted an art that
pointed to serious changes in the American political system in order to
maintain the cherished goals of the Declaration of Independence and the
Constitution with regard to freedom and equality for all. A soviet America
might just do that.

In this regard, the frequent appearance of the words *revolutionary* and
revolution in the left literature need not be taken at face value insofar as no
organized plans have come to light seriously urging the overthrow of the
American government. For some, using such language in articles might
have been little more than verbal exuberance based in part on fears gener-
ated by the political and economic climate and in part on the fact that it
was possible in America, in contrast to Europe, to use such language or
participate in demonstrations without necessarily being questioned and
possibly arrested by the police, although that did happen on occasion.
In the mid-1920s, Mike Gold, editor of *New Masses*, is reported to have

said, "America today, I believe, offers the honest young writer only one choice—Revolt!" But he then added, "If only in the name of art" (qtd. in Freeman 1936, 380).

This is an interesting qualification because it reflects the actions of those involved in writing articles on art as well as those who participated in public demonstrations and strikes during the 1930s. They conducted themselves largely within legal, constitutional limits. Any changes in government would take place only and legitimately at the ballot box. So there was an appreciable and understood disconnect between language that was appropriate to the revolution in czarist Russia and language appropriate to the situation in democratic America.

In any event, some artists attracted to radical politics spoke in less aggressive terms than the critics. For example, Philip Reisman (1904–92) remembered that "at that time people had a feeling that within ten years we'd have socialism here . . . because it was a different situation, the Depression had radicalized large segments of the population and . . . the overwhelming majority of intellectuals" (qtd. in Tyler 1990, 34). Joseph Solmon, an editor of *Art Front*, thought positively of "the new Russian experiment, the ideals of a worker's society. . . . Every one discussed it. . . . There was nothing strange about being drawn to that . . . because socialism, communism, and Russia were being discussed in cafeterias everyday. . . . Until they found out about Stalin and what he did, it looked like things were going to be rosy for ultimate socialism" (qtd. in Tyler 1990, 34).

Whatever the case, the general tone of art reviews changed with the arrival of the Popular Front. Antifascist themes largely replaced proletarian subject matter. Language became less aggressive and prescriptive. To be sure, artists were still reminded of their social responsibilities, but modernist and nonnarrative art were now deemed acceptable. At about this time, Meyer Schapiro wrote three essays, all published in 1936. The first reflected the point of view espoused by the more open-minded AAC, and the second addressed issues of racism and nationalism in art. The third, entitled "Public Use of Art," was probably the most complete statement of the Leninist position on art. In it, Schapiro pulled together older and more recent opinions and convictions published in America, so it was

historically useful but politically out of date when it was printed in *Art Front* in November 1936. It evidently represented Schapiro's long-held, hard-line political position (see also Hemingway 1994, 13–19; Hills 1994).

In "Public Use of Art," Schapiro considered the importance of federal work projects for industrial workers and for artists. Because the former were employed on a regular basis and the latter sold luxury objects at irregular intervals, it was necessary for the artists to create a public art that could reach the masses and contribute to worker solidarity if they expected worker support. They could do so through "collaboration with working class groups, with unions, clubs, cooperatives, and schools" (1936a, all quotes from 4–6). As Schapiro had indicated in his review of the John Reed Club exhibition in 1933, a public art already existed in comics, magazine pictures, and movies, but these formats were culturally low grade. To raise the level of appreciation, higher levels of culture and living standards for workers were essential. "Without these [higher levels], a real freedom and responsiveness in the enjoyment of art is impossible. We can speak of a public art and democratic enjoyment of art only when the works of the best known artists are as well known as the most popular movies."

Schapiro went on to say that "the achievement of a 'public use of art' is therefore a social and economic question." To ensure its realization, control of printing presses was necessary to make the best art available. "When these become public property, the antagonistic distinction between public and private in art must break down," at which time art will "embody a content and achieve qualities accessible to the masses of people, that the people control the means of production and attain a standard of living and a level of culture such that the enjoyment of art of a high quality becomes an important part of their life."

According to Schapiro, the artist "must become realistic in his perceptions and sympathetic to the people, [grow] close to their lives and free himself from the illusions of isolation, superiority, and the absoluteness of his formal problems. He must be able to produce an art in which the workers and farmers and middle class will find their own experiences presented intimately, truthfully, and powerfully." An artist who identifies with the masses in this way will provide workers with a means to acquire

a deeper awareness of their situation and the possibilities for their own personal improvement. "In strengthening the workers through their art, the artists make it possible for art to become really free and a possession of all society." Schapiro concluded, "[The artist] must develop in the course of his work the means of creating a real public art, through his solidarity with the workers and his active support of their real interests. Above all, he must combat the illusion that his own insecurity and the wretched state of our culture can be overcome within the framework of our present society."

True, Schapiro's article was concerned with the government art projects, and except for that last, very important sentence, which reads like a call to political action, virtually all of his comments had been articulated in previous decades, but perhaps not so resolutely, so firmly, or so authoritatively. The article was in effect a summation of ideas put forth in articles written over a forty-year span about the kinds of art that should be developed, the role of the artist in society, and the relationship of workers to art in a socialist society.

Andrew Hemingway notes that Schapiro, despite the increasingly menacing situation in Europe and Stalin's perversion of Soviet communism, still "retained a rational optimism and a faith in the proletariat's capacity for revolutionary transformation." Even in the 1940s, Schapiro believed that bourgeois governments should not be supported in an imperialistic war, but that one should work for their overthrow (not unlike Clement Greenberg's position, noted in chapter 3). Hemingway indicates that Schapiro hoped that a massive social upsurge after World War II, as had occurred after World War I, would overthrow bourgeois democracies as well as the Soviet dictatorship. In summing up Schapiro's attitude, Hemingway thinks that, "for [Schapiro], history still seemed to have an upward direction, to point towards an end" (1994, 24, 25).

Hemingway's insight is not as far-fetched as it might initially seem, even though we have no way of knowing if Schapiro consciously thought in messianic or eschatological terms. But he did exhibit in "Public Use of Art" a sense of a future not remote from Trotsky's. But, Trotsky aside, Schapiro did grow up in the Brownsville section of Brooklyn, a predominantly immigrant Jewish neighborhood at that time, and he was quite familiar

with the Bible (H. Epstein 1983). Allusions to a messianic time of one sort or another might even have been heard as part of normal, street conversation: "Ven der mashiach vill kimin" (When the messiah will come) was, and perhaps still is, a common Jewish expression among the Orthodox.

To play out this notion further, Russian-born sociologist Will Herberg (1901–77), who became a Communist while still a teenager and wrote eloquently about his life in the movement after he abandoned it in the late 1930s, found Marxism to be "a religion, an ethic, and a theology; a vast all-embracing doctrine of man and the universe, a passionate faith with meaning," according to David Dalin (1989, xv). Herberg even went so far as to draw parallels between Marxism and Judaism: history replaced God, and the proletariat replaced the Chosen People, who would then lead society to a new socialist order. Herberg's formulation makes some sense if one allows validity to two ideas he presented in an essay written in 1956. First, he indicated (without factual backup) that "Jewish messianism . . . entered into the life of the second generation [to which Schapiro belonged] to define its most characteristic response to the American environment." And, second, Herberg thought the following about the messianic passion in Judaism: "[It] was directed into new and strange channels, but neither the idea nor the passion disappeared with the disintegration of traditional Judaism. In a way, perhaps messianism became even more central in the secularized Jewish consciousness, for it was pretty much all that was left for these 'modern' Jews of the Jewish spirituality that had come down through the centuries" (1989, 124).

In her biographical account of Schapiro, Helen Epstein quotes Schapiro as saying, "We looked to Russia as the example of a successful revolution" (1983, 84). It would seem that at some point during the 1930s he no longer held that belief. But he still believed, despite all evidence to the contrary, that the Revolution might yet succeed, that the proletariat might yet triumph, which, as Hemingway has suggested, "points to an end" (1994, 25). Using different language, Allen Guttman observes that radical Jews who rejected the Torah and the Talmud and were discomforted by their marginality in both traditional Jewish and modern American cultures sought escape: "*Utopia* is the goal of that escape. Political and social revolution is the means" (1971, 137, italics added).

If one were to put a religious spin on the critics' impatience during the 1930s, then one might say that a Marxian vision provided Schapiro and other critics, whether they realized it or not, with a secular vision of redemption that replaced the never-ending unfulfilled religious one. In the years after World War II when full knowledge of the Holocaust was known, several Jewish scholars, in describing the nature of Judaism, commented on the messianic hope of the end of days and a time of universal peace. As authors Rabbi Arthur Hertzberg and Aron Hirt-Manheimer have stated: "Whether God centered or human centered, the messianic idea has been central to Jewish consciousness" (Hertzberg and Hirt-Manheimer 1998, 12). Not incidentally, he and other scholars and theologians, despite the Holocaust, also considered the sense of responsibility Jews were obligated to feel not only for their own moral, spiritual, and material welfare but for the welfare of society at large. Even in eschatological terms, then, socialism, as Moses Rischin observed, might really have seemed to be Judaism secularized (see the introduction).

However we might want to interpret Schapiro's essay "Public Use of Art," the speech he presented at the first meeting of the AAC in 1936 was of an entirely different order. In it, he took his cues from the Popular Front's less proletarianizing, more all-embracing approach to art and culture. His talk revolved around the aesthetic and social nature of a work of art, acknowledging but not emphasizing Marxist–Leninist thought. As consequence of this shift, his speech lacked fervent, revolutionary considerations but nevertheless managed to describe the negative situation of artists beholden to capitalist culture.

In the very first sentence, Schapiro distanced himself from the familiar Marxist–Leninist point of view: "When we speak in this paper of the social bases of art we do not mean to reduce art to economics or sociology or politics" ([1936] 1986, 103). He then asserted that art operates under its own laws with obvious parallels to the customs of the periods in which it was made. In concluding his paper, he stated in words that would have been anathema just months earlier that in the "apparent anarchy" of modern culture some artists thrive because "it makes possible for the first time the conception of the human individual with his own needs and goals" (112). But still the hard-liner and seemingly

wanting it both ways, he reverted to a position dating back to the turn of the century, stating in broad generalizations that "the artists who create under these conditions [of bourgeois patronage] are insecure and often wretched" and that they are detached from society and history, thus unable to realize their artistic potential, "which depend[s] on common productive tasks, on responsibilities, on intelligence, and cooperation in dealing with the urgent social issues of the moment" (113). Such an art for Schapiro "cannot really be called free because it is so exclusive and private" (113), a boilerplate observation appropriate to the years before the Popular Front.

Schapiro, no less than other AAC members, was well aware of the growing Nazi menace, to which all were vigorously opposed. At the first AAC meeting in 1936, Lynd Ward (1905–85) read a paper entitled "Race, Nationality, and Art," acknowledging Schapiro's help in its organization ([1936] 1986, 114). In it, Ward called attention to the notion of using race and nationality as a basis for judging art—not in the sense of Hippolyte Taine's desire to understand motivation, but as a tool for exclusion.

As a result of Germany's actions, AAC members were asked to refrain from exhibiting works at the Olympics in Berlin in 1936, a boycott that the National Society of Mural Painters had already requested of its members late in 1935. During the next few years, the congress protested the worsening situation of Europe's Jews and referred to the increasingly fascist and anti-Semitic turn in America. For example, in a typescript of either a radio broadcast or a lecture in which Max Weber, Stuart Davis, and Katherine Schmidt (1898-1978) participated, probably in 1936, Weber said that he supported the AAC not only because a response to poverty was necessary but also because "enemies of culture . . . would convert this free world of ours into a Nazi prison camp" (AAA, Weber, roll N69-86, frame 224). And in 1939, Arthur Emptage, then the AAC national executive secretary, in a "Report to the Membership" in January of that year charged the Nazis with "a barbarism never seen before since the world emerged in a civilized entity from the Dark Ages" (AAA, Weber, roll 69-86, frame 367; see also AAA, Gottlieb, roll D343, frame 619; Biddle 1935).

Another article Schapiro published in 1936 in *Art Front* and entitled "Race, Nationality, and Art," the same title as that of Lynd Ward's speech

at the 1936 AAC meeting, was part of the same response to international fascism and homegrown, hate-mongering anti-Semitism. It was the most powerful of the three essays. Published at a time of increasingly frightening developments abroad and at home, it marked one of the very first frontal assaults on fascist attitudes toward race and national backgrounds by anybody in the American art world. Schapiro began by stating that distinctions in the art of human beings based on national or ethnic origins have been a factor in "propaganda for war and fascism and in the pretense of peoples that they are eternally different from and superior to others and are therefore justified in oppressing them" (1936b, 10). He took issue with jingoists such as critic Thomas Craven who held that a great national art, meaning American art, could arise only from those with Anglo-Saxon blood. These artists would counteract the weakening of a native art caused by alien influences. Schapiro then described succinctly the difference between Soviet and Nazi attitudes toward class and race, the former encouraging class antagonism, the latter embracing competition between races. He stated that as political reaction grows,

> the basic antagonism of worker toward capitalist, debtor toward creditor, is diverted into channels of racial antagonism, which weakens and confuses the masses, but leaves untouched the original relations of rich and poor. A foreign enemy is substituted for the enemy at home, and innocent and defenseless minorities are offered as victims for the blind rage of economically frustrated citizens. . . . No wonder that the arguments for racial and national peculiarity are supported by the most reactionary groups in America. (10)

Schapiro demolished these racial and nationalist arguments and then commented on those who explained modern art as a Jewish invention in terms reminiscent of Ludwig Lewisohn's observations noted in chapter 3.

> The writers who try to explain modern art as the evil work of the Jews, attack Jewish intellectualism as the cause of abstract art, Jewish emotionalism as the cause of expressionistic art, and Jewish practicality as the cause of realistic art. This ridiculous isolation of the Jews as responsible for modern art is of the same order as the Nazi charge that the Jews

as a race are the real pillars of capitalism and also, at the same time, the
Bolsheviks who are undermining it. (11)

Schapiro went on to condemn Thomas Craven's nativistic and chau-
vinistic remark referring to Alfred Stieglitz (1864–1946), who was instru-
mental in introducing modern art to America, "as a Hoboken Jew [who]
cannot be a judge of American art" (qtd. on 12). (Craven's full statement
is: "Stieglitz, a Hoboken Jew without knowledge of, or interest in, the his-
torical American background was—quite apart from the doses of purified
art he has swallowed—hardly equipped for the leadership of a genuine
American expression" [Craven 1934, 314].) Certainly, according to Scha-
piro, the creation of art in America "will proceed from the conditions of
life in this country, conditions which, far from being stable or uniform,
are varied and in constant change." So the artist "is compelled to take
his stand with regard to the Americanism of his art by reactionary groups
which, in the name of Americanism, provoke racial and national antago-
nism, trample on democratic rights, and call on him to serve or starve"
(12). In effect, Schapiro aligned Craven's view of art with Hitler's.

Andrew Hemingway observes the following about Schapiro's "Race"
essay: "It is characteristic of Schapiro at this time that he should empha-
size the continuum between seemingly innocuous invocation of racial
characteristics as helping explain diversity and particularity of aesthetic
traditions, and the sinister assertions of racially exclusive Americanism
voiced by right-wing politicians and native fascists" (1994, 18). Of course.
What well-read leftist would come to any other conclusion? And what Jew
would not have made such a connection in 1936? The "innocuous invoca-
tion" was not at all innocuous. In addition to being aware of the growth of
anti-Semitism in America at that time, Schapiro would have known about
the book burnings, boycotts, attacks, and restrictions placed on Jews initi-
ated a few years earlier in Germany (see chapter 3); the boycotts of Jewish
doctors, lawyers, and shopkeepers; the banning of Jews from government
employment; and Goebbels's attack on Jewish intellectuals—all in 1933.
The future did not look promising.

Schapiro's statement that "the basic antagonism of worker toward
capitalist . . . is diverted into channels of racial antagonism," quoted a

few paragraphs earlier, needs further elaboration. Well before Schapiro wrote about the way anti-Semitism was used by those in power, Lenin had recorded a speech in late March 1919 in which he accused the czarist monarchy, in alliance with landowners and capitalists, of organizing pogroms "to divert the hatred of the workers and peasants who were tortured by want against the Jews in order to blind the workers, to divert their attention from the real enemy of the working people, capital" (Lenin 1965, 29:252). Whether anybody in America, including Schapiro, heard his speech on a gramophone record or read a transcript is moot; the point is that Lenin recognized that hatred of Jews could be turned into pure political manipulation. His thoughts on the matter might very well have entered into left-wing conversations in the 1920s and very definitely by the mid-1930s.

Three examples of such conversations will suffice. First, an item that appeared in the weekly column *"Forward* Looking Back" in the April 15, 2011, issue of *Forward* noted an article on the rise of anti-Semitism in Poland seventy-five years earlier—in an April 1936 issue, one month after Schapiro's article was published. In this 1936 article, *Forward* had reported that "the current [Polish] government is pitiably weak and has been willing to tolerate the anti-Semitism of certain political parties in order to gain their support" (qtd. in *"Forward* Looking Back" 2011, 20).

Second example: In an article in the *Menorah Journal* early in 1937, an interesting observation was made about how the word *fascism* had come to be used. The author found that attacks against Jews by individuals or by entire governments were part of political programs used by those aspiring to power or wanting to keep power. It did not matter whether Jews were or were not hated, but manipulating anti-Semitic propaganda was the vehicle to gain and sustain such power (Zukerman 1937). That is, Jew hatred was an aspect of political propaganda, a means to obtain power. Publically encouraged anti-Semitism became a useful political tool, but not necessarily one based on hatred of Jews. As the article's author claimed, "Anti-Semitism [is] the accepted chief weapon in the common offensive of the fascist forces throughout Europe. . . . Anti-Semitism has become so integral a part of fascism that the two can no longer be separated" (10). Fascism, according to the author, had made the fate of anti-Semitism its

own fate. The only thing positive as a result of this situation was that anti-fascists could rally "all the great social forces which are fighting fascism and make the destruction of anti-Semitism a condition of the destruction of fascism itself" (10).

The author indicated that before the rise of Nazism, many believed that "the Jewish problem" could be solved by a progressive social revolution that resulted in the kind of socialist state established in the Soviet Union (see chapter 3). But because fascism had internationalized and escalated anti-Semitism into a political cause, it was now necessary to defeat fascism itself and not just build socialism. Being pro-Soviet, then, meant fighting malevolent and ultimately murderous, fascist-inspired anti-Semitism. The many calls, demands, and edicts issued by the Communist Party to defeat fascism amounted to calls to eliminate anti-Semitism, a point of view that certainly resonated with Jews increasingly alarmed by the turn of events in Europe.

Third example: In a broad-ranging article concerned with Judaism and Western civilization, Jacob R. Markus wrote in 1941, "We know . . . that these new leaders [the Nazis] are shrewd, crafty politicians who are conscious of the value of anti-Semitism as a means of securing an immediate political following" (502).

Schapiro, as a left-wing critic and as a Jew, understood this relationship in the 1930s. His comments are of a piece with those of Moses Soyer, who warned artists against being "misled by the chauvinism of the 'Paint America' slogan. Yes, paint America, but with your eyes open. Do not glorify Main Street. Paint it as it is—mean, dirty, avaricious. Self glorification is artistic suicide. Witness Nazi Germany" (1935, 7–8).

Among the various organizations initiated by the Popular Front, the World Alliance of Jewish Culture was established in 1937 in Paris in response to a call by the Yiddish Cultural Front of France to gather together Jewish artists in a new pro-Soviet, anti-Nazi organization. Its goal, certainly a necessity at the time, was to defend modern Yiddish culture against Hitlerism. Almost immediately an American branch was formed; it lasted until 2006 (Ruchames 1969, 246–47). The organization's first art exhibit in New York, held in 1938, included works by 102 Jewish and non-Jewish artists. Former hardcore leftists—once opposed to maintaining, let

alone strengthening, Jewish culture—joined in the effort. Frank C. Kirk, who, as mentioned in chapter 1, had to escape from Russia after the failed Revolution of 1905, was the executive director, and Moissaye J. Olgin— who helped found the American Communist Party in 1922 and was a founder and longtime editor of *Frayhayt*, the Communist Yiddish-language newspaper—wrote the introduction to the exhibition. In his words,

> At a time when the waves of anti-Semitism are rising with murderous rapidity, when the beast of fascism has set itself the goal of destroying not only the material foundation of the Jewish people, but also their morale, the artists represented here manifest the simple truth that the Jews as creators are contributing a large share to the culture treasury of mankind; that the Jews no less than any other people have a right to their own culture; and that the creative genius of Jewish men and women, nurtured as it is by the striving of the broadest Jewish toiling masses for enlightenment and a higher social order, will not be broken. ("First Exhibition" 1938, n.p.)

And in an undated fragment of a page entitled "Friends of Jewish Culture Hold Fine Arts Exhibition," Olgin wrote: "The participation in this exhibition of both Jewish and non-Jewish artists . . . testifies to the fact that the best representatives of non-Jewish America recognize the right of the Jewish people to life, liberty, equality, and the satisfying of their cultural needs in the way they see fit to themselves as an integral part of these United States" (AAA, Ben-Zion, N69-122, frame 227; see also Michels 2011).

Whatever the pro-Jewish sentiments, there is a double sadness in these remarks: first, the recognition of the precarious state of Europe's Jews and, second, the inability to take for granted in America any longer the freedom from anti-Semitism articulated by the immigrants around 1900, their hopes for equality with others, and the pleasure many must have felt in equating Judaism with American democracy. Jews in America knew they had escaped the growing horrors in Europe, but they had become uncertain of their fate in what had become an increasingly overt anti-Semitic country.

Where to turn? Many were appalled by the Hitler-Stalin Pact of 1939, according to which Germany and the Soviet Union split up Poland

between them and the Soviet Union absorbed the Baltic countries—Lithuania, Latvia, and Estonia—into its empire. A map of eastern Europe published in the July 16, 1940, issue of *New Masses* laid out the matter directly for Jews. The map's main feature was a heavily drawn line separating German-controlled from Russian-controlled lands. The self-serving caption read: "Three Million Jews Rescued by Socialism. Two Million in Poland and the Rest in the Baltics and Bessarabia." This kind of language was nothing more than a public-relations gambit having nothing to do with Soviet policies (for the map, see Pinchuk 1978, 143). But at the time, 1940, the question was this: Even with the rescue of so many, how could the Soviet Union strike a deal with fascist Germany? For others, three million Jews saved was a very large number. Which answer was the more important, one based on political belief or one on ethnic loyalty? Or could they somehow be reconciled? The answer was made easy when in June 1941 Germany invaded Russia. The issue then became how to save the three million who had already been saved. It is no wonder that artists found communism such an attractive alternative to the economic and political policies of Western capitalism.

5

Artists' Responses during the 1930s

HOW DID ARTISTS RESPOND to the many and varying political appeals and directives, to the deteriorating economic situation, and to the growing persecutions of Jews in Europe? The balance between adhering to Communist Party dictates and holding fast to religious heritage seemed to be always negotiable depending on the particular circumstance. For some, the party's directives took precedence over religious and ethnic sentiments. For others, the reverse was the case. Each artist evidently sought his or her sense of balance between Jewish particularism and politically inspired universalism and either accepted or rejected the art critics' demands (Mendelsohn 2004, 127).

American Jewish artists as artists in a Western democracy also sought a balance between creative freedom and discipline. As Joseph Freeman indicated, he was a Communist when writing literary criticism as well as articles on economics and politics, but a romantic when writing poems and stories. Bourgeois sentiment would then influence his way of thinking, meaning that his aesthetic preferences often trumped party doctrine (1936, 627, 324–25). Not everybody who attended John Reed Club meetings were members or committed to its programs. Some participated in discussions; others ignored party discipline despite lectures, published articles, and exhibition critiques; others socialized with friends. (An elderly lady of my acquaintance told me that she went to club parties only for the dancing, remembered nobody in particular, and had no stories of interest to tell.)

People could not give up their bourgeois ways so easily. Individual feeling often eclipsed the "scientific" way of understanding capitalism's

deleterious effects. Edward Lanning (1906–81) later recalled the boredom that engulfed him at John Reed Club meetings. He said that despite the lectures and exhortations, he could not find ways to deepen the social content of his work (1972, 81). Philip Reisman remembered that club meetings tended to be democratic and that abstract artists spoke quite openly about their art. Most artists, he said, "kept on doing what they wanted to do" (qtd. in Tyler 1990, 23–24). Boris Gorelick and Harry Sternberg also recalled friendly, open, and nonrancorous discussions with other artists who were club members (AAA, oral interview with Boris Gorelick, May 20, 1964; AAA, oral interview with Harry Sternberg, Mar. 19, 1999, and Jan. 7, 2000).

In effect, American artists could not easily or quickly, if at all, internalize the demands the Communist movement placed on them, and therefore their art lacked the kind of proletarian aggressiveness the party wanted. As historian Daniel Aaron points out with regard to writers, which we might apply to artists as well, "In most cases, one suspects that most writers who went left did so because of the social and political crisis, rather than because of party persuasion" (1961, 247). After their radical moment, many moved on to other intellectual and artistic pursuits.

What effect did the John Reed Club meetings have on artists? This question is in fact impossible to answer. Artists who were sympathetic to Marxism during the 1930s might have in later years denied any associations with the club because of congressional investigations. The fear engendered by the strong anti-Communist surge during the 1940s and 1950s might have caused some artists to whitewash their past and even destroy personal records. For example, when in the 1980s I asked Raphael Soyer (1899–1987, one of my uncles was married to one of Soyer's sisters) about a pro-Stalinist petition he signed in response to those who had resigned from the AAC in 1941 because of the dictator's policies ("Artists' Congress 'Calls'" 1941, 22), he said that this period in his life had become poetry in his mind and that he would not say anything further. He preferred to remember the past in the following way:

> [The John Reed Clubs] helped me to acquire a progressive world view, but I did not let it change my art which never became politically slanted.

I painted what I knew and what I saw around me—many pictures of the unemployed, of homeless men, because I saw them, everywhere, in parks, on sidewalks, sleeping on girders of abandoned construction sites. I sympathized with them, identified with them to the extent of including myself yawning in a painting I called *Transients* to emphasize the boredom in their lives. (R. Soyer 1983, 27; see also Baskind 2004, 82–84; Heyd and Mendelsohn 1993–94; R. Soyer 1969, 72, and 1979, 222)

Soyer also insisted that he did not paint class-conscious pictures.

In fact, an exhibition of his paintings was criticized in 1935 because his images of the downtrodden, the losers, the defeated and "the rotting men and flop houses" were not part of "a healthy tendency in revolutionary painting. . . . Their value lies mainly in the fact that they represent a desirable change in direction . . . toward a more vigorous and positive statement" (Alexander 1935a, 28). The figures in *Transients*, painted in 1936, one year after this critique of Soyer's work was written, remain downtrodden, defeated, out-of-work men sitting idly, their expressions blank (fig. 39). Their passivity belies any sense of revolutionary fervor or activity.

Perhaps Jacob Burck, who adhered much more closely to the party line, had figures similar to those in *Transients* in mind when he wrote in 1935 that when visiting a John Reed Club exhibition, a group of clothing workers grew irate at a painting showing lifeless workers. "That's not us," they told Burck. "We've got life in us. Come and see us on the picket line. The people [in the painting] look like dope fiends or scabs" (1935, 337). But Burck seems to have understood that too many artists in the John Reed Clubs still harbored bourgeois illusions, and he had to admit that "the pressure of the times forced them to the left . . . driven . . . by the crisis which menaced the existence of their middle-class emotions and art" (1935, 337).

Raphael's twin brother, Moses, apparently buckled under party criticism of his work, or else he would not have confessed in print that he still felt unable to paint working-class scenes or to "align himself with the class to which he feels he belongs" (Alexander 1935a, 28; see also M. Soyer 1935, 6). In fact, he did not come from a working-class family. His remarks suggest that he had succumbed to party hard-liners who bullied him

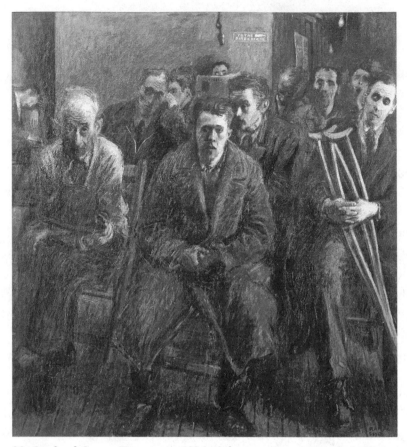

39. Raphael Soyer, *Transients*, 1936. Oil on canvas, 37³³⁄₆₄ × 34%₆₄ in. Blanton Museum of Art, University of Texas at Austin, Gift of Mari and James A. Michener, 1991. Photograph by Rick Hall.

into accepting the "proper" approach to subject matter, which included making paintings about happy, strong, and dedicated people building an American soviet. In place of revolutionary themes, the Soyer brothers preferred to paint ordinary people within the context of their ordinary lives. Raphael said that he tried to reveal something about his subjects and their environment within their daily settings. "Therefore," he stated, "I fondly believe that my work is in the tradition of the great realists [e.g., Daumier, Courbet]." And Moses stated that "our message is People. The people we paint are the plain people we live and mingle with, people we know and

understand best. . . . We try to paint them understandingly in their own surroundings, and in natural attitudes" (both qtd. in *Catalogue of an Exhibition* 1944, 135).

As with Moses Soyer, Max Weber also took seriously the adoption of a proletarian point of view, and, like Soyer, he was not certain if he was capable of actually doing so. In a letter written as late as January 31, 1939, to Herman Baron of the partisan ACA Gallery, Weber confessed that he would not submit works for a social art exhibit because they were "almost wholly void of the truly Marxian essence, meaning, and purpose." Although he painted "the people who toil, nevertheless I find there is not enough proletarian militant élan or marrow in them." He wrote that he tried very hard and found "much happiness in this striving, knowing that with each feeble effort, I am getting nearer to the world we so fondly envisage—the world of tomorrow" (AAA, ACA Gallery, roll D304, frame 379).

In the end, the cultural divide between middle-class artists and their proletarian desires was too great to bridge even with the best of intentions. And besides, artists generally reinforced their own interests, preferring other artists as companions rather than members of the working classes. (Raphael Soyer painted portraits of his many artist friends, which he displayed in his apartment.)

By the mid-1930s, the disconnect between what artists such as the Soyer brothers chose to paint or what Weber desired to paint and what the party wanted them to paint was too obvious to overlook. One wonders precisely to whom art critic Jerome Klein directed his remarks when he wrote in 1935, "The artist should portray realities with a mind to change the world for the better. . . . [The artist] should be [in] definite alignment with the working class as a progressive force" (n.p.). And in the same year Jacob Burck created in *his* mind's eye the ideal revolutionary artist, who "must begin with a Marxian re-evaluation of art history, find the dialectics between the respective ideologies of each historical period and their corresponding aesthetic manifestations," then go to the source of the new art, which is the life and struggles of the workers, and, finally, "bring to life, with the aid of revolutionary social thought, the inanimate body of technical principles developed by the best in bourgeois civilization" (1935, 336). Burck's ideal artist could remain only a fictional character.

Another reason why an effective program never developed within the artists' groups is that despite the economic depression, a Marxist model that promoted proletarian consciousness especially in the John Reed Clubs ran into the brick wall of the promise of America (A. Liebman 1979, 195–96). Artists rejected the assumptions that under communism there would be no or minimal upward social or job mobility or that people would be less able to make their own life choices, both of which were possible in a democratic capitalist society.

Commenting on artists' motivations at the time, historian David Peeler notes that artists were not very good radicals. As "protestors rather than revolutionaries," he observes, "they preferred to have exhibition spaces rather than revolutionary egalitarianism." Also, they were not overly intellectual. Obtaining better deals with gallery owners was the most important part of planning for the future (1987, 238).

Accordingly, censorship and creative control were anathema to those who consciously ignored party attempts to control their subject matter. Peeler recounts an incident when Ben Shahn became editor of *Art Front*. The party wanted to manage the magazine through Shahn, who responded by saying, "I wouldn't submit my used toilet paper to you. I share the economics of this thing with you, but not my work" (qtd. in 1987, 222–23).

Years later, in an interview of Shahn that Seldon Rodman published in 1961, Shahn explained his provocative response by stating his creed as an artist. It was an individualistic American answer to and rejection of the Soviet insistence that artists were free only when reflecting and participating in proletarian concerns, and it might well help explain why many American artists were loath to accept party directives. When discussing his Sacco–Vanzetti series of 1931–32, Shahn stated that "by presenting the two anarchists as the simple, gentle people they essentially were, I increased the conviction of those who believed them innocent."

> RODMAN: Is that zeal to increase conviction a function of art as you see it?
>
> SHAHN: It can be. But the artist's vision of truth that precedes any missionary fervor has to be a personal, interpretive vision.

RODMAN: Is that why Soviet realism always seems to fall short of art?

SHAHN: Until the Soviet artist is free to seek the truth and create real-
ity wherever he happens to see it—whether in the love life of the
cricket or in the inner torments of the social maverick—until he
has that degree of freedom, his art will be what you see. . . . Emo-
tionally gray, unconvinced socialism. (Rodman 1961, 225)

Two critics, Robert Warshow (1917–55) and Harold Rosenberg, writ-
ing in the 1940s about the 1930s, offered additional comments that are
applicable here. Warshow, discussing the connections between left poli-
tics and the rise of mass culture, noted that "the most important effect of
the intellectual life of the 30s and [of] the culture that grew out of it has
been to distort and eventually destroy the emotional and moral content of
experience, putting in its place a system of conventionalized 'response'"
(1947, 540).

Two related points can be made here. First, a number of artists were
unwilling to conventionalize their responses according to party exhorta-
tions. Second, Warshow turned on its head the party line, as explained
in the previous chapter. Instead of finding freedom as well as some sort
of emotional and moral content in creating works that reflected a prole-
tarian point of view, artists instead found "a system of conventionalized
'response.'"

Rosenberg, in his exploration of the same terrain, noted that in Russia
the idea of mass culture, if carried to its logical conclusion, meant that
"individual experience is denounced as an aberration from real life," that
mass culture is actually "real life." He noted that deploring the notion of
"being oneself," that thinking of being oneself is "a condition of misery,"
becomes "the most unambiguous sign of the triumph of mass culture over
spiritual independence" (1948, 245, 244). Despite the rhetoric to the con-
trary dating back to the beginning of the century, many artists, whatever
their commitment to left politics, were, like Rosenberg, not ready to sub-
merge their sense of individuality within the mass or to give up the notion
that their own life was not their real life.

A Jewish angle can be brought into play here. In 1915, Louis Brandeis
had indicated four qualities he associated with Judaism that might have

relevance: citizens' duties, relatively high intellectual attainments, a developed community sense, and "submission to leadership as distinguished from authority" (1915, 15). One can accept the first three qualities with a nod of the head, but the last one meant that leadership had to be earned and respected rather than imposed from above, a quality that perhaps placed Jewish artists at odds with party dictates. Because most artists probably knew that biblical figures such as Abraham, Moses, Jonah, Ezekiel, and Job had argued with God or at least questioned God's intentions, then what could prevent them from rejecting party discipline?

What about an individual artist's Jewish heritage? For example, a work that might have been sharply critiqued by Jerome Klein or another reviewer was *Miner and Wife* by Harry Sternberg (fig. 40). Sternberg visited the coal-mining region of Pennsylvania in 1936, where he spent several weeks living among the miners, a brave thing to do given the hostility there to outsiders, whom the local authorities might have thought were Communists or, even worse, union organizers. (Others who visited coal-mining and industrial areas include Minna Citron [1896–1991], Frank C. Kirk, Harry Gottlieb, Riva Helfond [1910–2002], Philip Reisman, Ban Shahn, and Abram Tromka [1896–1954] [see Djikstra 2003, 121; Strauss 2008, 47].)

Of the impoverished lives and physically demanding work of the miners both above and below ground, Sternberg said in 1937: "To have rendered only the surface drama and beauty of design and color would have invalidated all the months of living and working there; and I might better have remained in my studio and done 'pure' abstractions." On the other hand, he also understood the danger inherent in the possibility of his "free expression coagulating into doctrinaire channels" (AAA, Sternberg, roll D339, frame 146). He articulated very precisely the dilemma that party stalwarts tried to overcome and the artists' resistance to them: how to subordinate bourgeois, individualistic impulses in face of identifying with working-class experiences.

Among the scenes Sternberg recorded, *Miner and Wife* is one of his most poignant. In a hilly landscape that shows a tumbledown coal-mining community, the miner works in impossibly close and unsafe quarters below ground. He and his wife, worn down beyond their years, perhaps

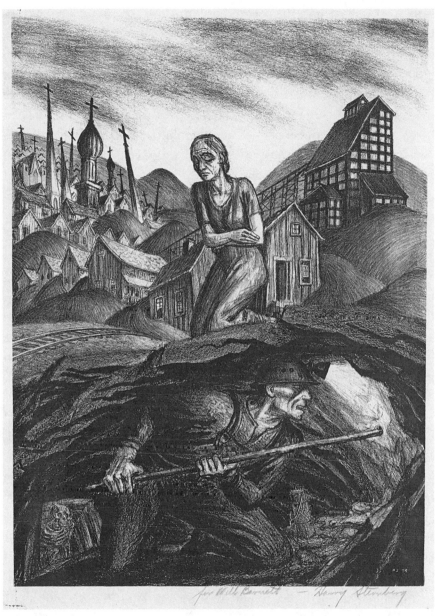

40. Harry Sternberg, *Miner and His Wife*, 1936. Lithograph, 18⅜ × 13½ in. Print Collection, Miriam and Ira D. Wallach Division of Art, Prints, and Photographs, New York Public Library, Astor, Lenox and Tilden Foundations.

suffering from silicosis, the coal miners' lung disease, live in a rural slum built perhaps thoughtlessly downwind from the mine and therefore covered with soot and likely to create unnecessary health issues. The revolutionary future was not going to be built on this couple's shoulders. But through Sternberg's expressive use of black-and-white contrasts that evoke the grim and disheartening quality of their lives, the man and his wife certainly evoke a viewer's sympathies, and their life is similar to, in Sternberg's own words, the "grinding poverty" in which he grew up on the Lower East Side (qtd. in Moore 1975, 25). He certainly captured the depressing visual aspects of coal towns that two generations later remain visible from any nearby highway.

Before visiting the coal-mining region of Pennsylvania in 1936, Sternberg wrote: "Isn't it supposed to be the function of the artist to help form and improve the society in which he lives?" (qtd. in Moore 1975, 13). Looking back on those experiences a few years later, he said: "The people— their struggles, their aspirations—are both the theme of my art and the audience I want to reach" (in Lozowick 1947, 180). Decades later, while trying to assess his turn to the political left, he said: "The Depression with its attendant suffering bred in most artists a social consciousness and a left-of-center political consciousness" (qtd. in Moore 1975, plate 115).

But something else, and to the point of this book, helped prompt that turn to the left. Sternberg grew up in an Orthodox household and experienced anti-Semitism as a youngster. While reflecting on his work late in his career, he realized that "his art and life had been ineluctably shaped by the cultural and religious ethos of Eastern European Orthodox Jewry and the immigrant community in which he had grown up in New York" (Fleurov 2000, 30, 24). In response to an interviewer's observation that everything he had done seemed to be rooted in an underlying sense of humanity and justice, Sternberg stated: "I think that's part of the Jewish tradition that affected me strongly, even though I'm still not a synagogue goer." He went on to say, as if to explain his earlier political beliefs, "In the thirties, I thought I had found truths in the political scene. I thought Russia was doing a pretty good job with phrases like 'the brotherhood of man,' which comes as near—if it were true—as anything you could want for a truth. [But] it was too narrow" (AAA, Sternberg, roll 339, frames 33–36,

210). For Sternberg, such phrases left out the human dimension and the sense of Jewish responsibility for others.

Other Jewish artists who created works of social concern and who belonged to radical organizations during the 1930s responded in similar fashion both as Jews and as people on the left. Sculptor Aaron Goodleman (1890–1978), who left Odessa because of pogroms, was a cultural Yiddishist in favor of keeping the Yiddish language, Jewish history, and Jewish folklore alive even while he belonged to the John Reed Clubs, the AAC, and the Artists' Union. "You cannot grow up without this awareness of who you are," he wrote. "You will not complete yourself as a human being. . . . We have to learn from the Negro people how they fought their way through a terrific struggle and are seeing results. Yes, only through struggle can we reach our goal" (AAA, Goodleman, roll 4930, frames 89, 92). The goal was keeping alive Yiddish culture, or Yiddishkeit, into the succeeding generations, which meant maintaining eastern European customs as a living rather than fossilized tradition.

In commenting on the necessity for Jewish youngsters to know their own cultural history, Goodleman noted that they would learn "how deeply we feel as oppressed people" (AAA, Goodleman, roll 4930, frames 89, 92). On another occasion, he wrote, "The more profound the artist's understanding of the rudiments of nature, of his surroundings, of the origins, the social aspirations, *the culture and the tradition of his people*, the larger the personality of the artist, the more significant his achievements in art, and the greater his contribution to society" (in Lozowick 1947, 66, italics added).

Harry Gottlieb, a hard-line political activist and founder and president of the Artists' Union, said in different autobiographical statements that when he was very young, his father had traveled to Ireland from Rumania in search of work. The family joined him when Gottlieb was six years old because his father refused to return home, "with its Jewish pogroms and no future for him or his family." Gottlieb mentioned that he had great respect for his father, who, knowing no English, wanted "to take his family from a country where we were born but in which a great deal of anti-Semitism existed at that time of an extreme kind." Gottlieb's knowledge of pogroms, even though secondhand, might have been one of the factors

that prompted him to hire African American artists for Artists' Union projects "as part of a special campaign for equality" (AAA, Gottlieb, roll D343, frames 509–10, 516, 711, 727, 1041).

Lena Gurr, wife of the artist Joseph Biel (1900–1943), wrote that her husband, who had witnessed a pogrom in Grodno, now in Belarus, believed that "an artist should use [his or her talents] to expose social injustice." Frank Kleinholz (1901–?) noted that "the Jewish people have learned that they must unite with all progressive forces if they and their culture are to survive." S. Lev Landau (1896–c. 1979) felt that one's "art must become a part of the process that shapes a better world" (all in Lozowick 1943, 24, 108, 114).

Max Weber always openly identified himself as a Jew and supported Jewish causes even during his years as a major American modernist early in the twentieth century. And in the last decades of his life, he wrote dozens of letters, now scattered throughout his papers in the Archives of American Art, that record his contributions to relevant charities as well as the titles of works that he put up for auctions in support of Jewish causes. Most politically active during the 1930s, he served as the AAC's national chairman and honorary national chairman from 1937 to 1940. His speeches and statements seemed to have been drafted in the main by party functionaries. Yet at a time that he was most politically involved, he included the following passage in a letter to Harry Gottlieb written on May 24, 1937:

> To refrain from doing our bit at this time would be fatal. With greed and war ravaging humanity, with distress unabated, there seems to be no other way than to gird ourselves and give until the causes of poverty and war and the reasons for charity shall forever be removed from the face of the earth as was counseled by the Hebrew philosopher and physician, Maimonides [1135–1204] of Cordova, Spain, over eight centuries ago. (AAA, Gottlieb, roll D343, frames 467–68)

And in words similar to those of early-twentieth-century socialists that combine biblical injunctions with concern for helping the poor and the downtrodden, Weber said: "By reason of the great and impending dangers,

we are *morally obligated* to look to the needs of the neglected and spiritually impoverished manual and mental workers in all fields, if we hope ever to link life with art inseparably" ([1936] 1986, 123–24, 128).

In a handwritten sheet containing notes for a speech written on March 16, 1937, about the hardships faced by the Loyalists during the Spanish Civil War, Weber emphasized the sense of responsibility he felt at the same time that he invoked memories of American valor, such as those of the soldiers who had wintered at Valley Forge. As many did in previous decades, he thus appealed to the highest ideals of both Judaism and Americanism.

> In the face of all this horror, what of the apathy on the part of the pious who preach peace, charity, and brotherly love? What is charity and when? What is justice and peace? We ask the spiritual leaders and those in high governmental places . . . , have we no right to feed the bleeding people of a young sister republic? As for citizens of a great republic, we deem it not only proper, but a sacred duty to help those whom we know are fighting not only for themselves but for oppressed people of the world. (AAA, Weber, roll NY59-6, frames 137–39)

Other artists expressed their feelings within a narrower Jewish frame of reference. Frank C. Kirk, who had to escape from Russia in 1905 for political activism, grew occupied with Jewish affairs in the early 1920s and ultimately came to believe that, "as a Jew, I am for an environment where Jewish art individuality could develop and make possible for artists—Jews to become Jewish artists" (in Lozowick 1947, 104). David Bekker (1897–1966), who had made several illustrations for left journals during the 1930s, observed that "the sad faces and looks of my persecuted people have etched themselves deeply into my young soul and found expression in my more mature years in a longing for our lost home and happiness" (in Lozowick 1947, 16). For Bekker, this meant Israel and religious study. And it was said of William Gropper that he turned to Jewish themes not "as a devoutly religious man, but because Hitler and the persecutions of the twentieth century [had] aroused in him a desire to learn more about his people—to sing of their history and achievements" (Freundlich 1968, 23).

One of the most popular subjects for Jewish artists concerned an issue that they did not encounter as children in Europe or confront so dramatically and insistently as adults in New York—the plight of African Americans in the South. But racial hatred and violence struck a responsive chord among them in America because it all seemed so familiar— the discrimination, the intimidation, the physical violence—a potentially ominous threat to their still marginalized community. As historian Beth Wenger has observed, "The Jews who came to America were a varied lot, they nearly all arrived with some history of exclusion and minority status that shaped their outlook and cultural expressions" (2010, 54; for antiracist prints, see Djikstra 2003, 138–50; Langa 2004, 128–66). Focusing on artists more directly, art historian Avram Kampf observes, "Many Jewish artists expressed . . . not only their own immediate personal experience as immigrants but tapped the roots of their social values anchored in the prophetic tradition" (1984, 66; see also Heyd 1999, 86–116).

By my imperfect count of illustrations in magazines of the period and in more recent art historical publications, Jewish artists made more sculptures, paintings, and especially prints of lynch scenes than of any other subject except boiler-plate anticapitalist, anti–big business, and anti–fat cat themes. For the record, lynch scenes were made by Phil Bard, Samuel Becker (dates unknown), Ben-Zion, Leon Bibel, Julius Bloch (1888–1966), Jacob Burck, Philip Evergood, Hugo Gellert, Aaron Goodleman, Bertram Goodman (1904–88), Boris Gorelick, William Gropper, Bernard Gussow (1881–1957), Ned Hilton (dates unknown), Irwin D. Hoffman (1901–89), Benjamin Kopman, Herb Kruckman (1904–98), Seymour Lipton (1903–86), Louis Lozowick, Fred Nagler (1891–1983), Philip Reisman, Mitchell Siporin (1910–76), Harry Sternberg, Hyman Warsager (1909–74), Nat Werner (1907–91), and Adolf Wolff (1883–?). Other popular subjects included strikes, both black and white agricultural and industrial workers, the downtrodden, and the unemployed as well as anti-Nazi and refugee scenes.

In her book *In the Almost Promised Land: American Jews and Blacks, 1915–1935* (1977), historian Hasia R. Diner points out that Yiddish- and English-language Jewish newspapers and magazines devoted as much if not more space and more front-page stories to black victimization than

mainstream publications (see also Park 1993). And Steven Cassedy has shown that in the socialist press, the insistence on publishing articles on the race issue marked a particularist exception to the preference for more universalist material applicable to all people everywhere (2001, 12). The reasons vary but revolve around the interconnected desires, as mentioned in chapter 1, to believe in the true meaning of America as a land of the free, to remind Americans of their egalitarian heritage, and to act in behalf of human rights. Artists also opposed discrimination because of the similarities they detected between racist discrimination and anti-Semitism, especially as these bigotries developed during the 1930s.

The desire to fulfill the meaning of the Declaration of Independence and the Constitution in this sense was not a mere figure of speech to the immigrant generation. For example, in 1913 Louis Boudin published the article "The Emancipation of the Negroes—and Fifty Years Later" for *Di Tsukunft*, in which his main point was that the right to vote had been taken away from Americans of African descent. As he put it, "The Fifteenth Amendment is dead as a *bar minen* [dead as a dead person]" ([1913] 1999a, 229). Decades later, as noted earlier, Max Weber, still fighting what for him was the good fight, wrote a letter in 1949 to the head of Alabama University's Art Department, excoriating him for basically telling African American students at the nearby traditionally black Talladega College to stay away from an art conference and exhibition at his institution. "As an artist with implicit faith in democracy and in the humanitarian tenets of the Declaration of Independence, I am impelled to ask you why you persist in profaning the sacred heritage and name of our great emancipator, Abraham Lincoln." Weber accused the department head of evoking the name of "the most vile, most evil and hated name in the history of civilization—that of Adolph Hitler" and memories of the six million burned in the death camp ovens, thus combining in one letter the effects of racial discrimination and anti-Semitism (AAA, Weber, Roll N69-86, frame 536).

The single racial event that perhaps most seriously distressed the Jewish community in the early part of the century, still not entirely sure of its footing especially in areas outside of the large northern cities, and that helped crystallize their attitudes about racial violence was the lynching of Jewish American Leo Frank (1884–1915) in Georgia in 1915 on

a trumped-up murder charge. In fact, according to Abraham Liessin's contemporary account in *Di Tsukunft*, the lynching aroused great fear among all American Jews. He wrote: "That Leo Frank was lynched primarily because he was a Jew has been asserted by the most serious and best informed newspapers all over the country" ([1915] 1999, 242).

Liessin also described the threats to lynch more Jews and the strong current of anti-Semitism in the South. And articles in both *Forschritt* (Progress), published by the Amalgamated Clothing Workers of America, and *Justice*, the magazine of the International Ladies Garment Workers Union, stated that union members reacted to the lynching "not as socialists but as Jews." It was also noted in other official Jewish union publications that "Jewish identity among these union leaders often overshadowed either union or socialist identity, and that their interest in blacks was rarely couched in either unionist or socialist terms" (qtd. in Diner 1977, 228).

The unions' activities did not go unnoticed by African Americans. In response to union efforts in behalf of social and economic equality of the races, the New York Negro Labor Conference congratulated the International Ladies Garment Workers Union in 1935 for its sense of labor solidarity (Diner 1977, 202).

However, it is somewhat surprising that Leo Frank's lynching prompted so few illustrations in the Jewish press. One appeared in the January 8, 1915, issue of *Der Groyser Kundes*, but it does not show the actual lynching (fig. 41). The heading at the top reads: "Take It Easy." The robed arm at the top holds a scrolled paper that reads: "United States Supreme Court order for a new trial." Frank's fists are no match for the huge hand, labeled "Atlanta," that holds his arm. Frank's name is written on his prisoner's shirt. And the caption at the bottom reads: "Georgian justice grabs by the hand," which seems to indicate that Frank is being led away from the distant uncluttered hangman's noose to what will be his much messier lynching. The emptiness of the landscape as well as the size and power of Georgia "justice" seem to overwhelm Frank, whose apprehensive bearing is the emotional heart of the print. Cartoonist Leon Israel's cool, detached style of simple outlines and hatch marks, leaving all else to the imagination, provides this print with a discomforting sense of imminent but unknown disaster.

41. Leon Israel, *Take It Easy*, from *Der Groyser Kundes*,
January 8, 1915.

Much less is left to the imagination in Hugo Gellert's *Scottsboro*
(1931) (fig. 42). The title refers to the trial of nine young African Ameri-
can men in Scottsboro, Alabama, in 1931, charged with raping two white
women. The event and its aftermath resulted in a large number of arti-
cles in the Yiddish press. The trial also generated comparisons with the
increasingly violent anti-Semitic activities then taking place in Germany
and became a cause célèbre for the Communist Party. Among the various
illustrations about the sequence of events leading to the convictions of the
young African Americans in Scottsboro, Gellert's print, published in the

November 1931 issue of *New Masses*, shows the nine young men wearing work clothes and facing the viewer. Each has on his head a kind of cap that is wired to an unseen master switch. When turned on, the switch will send a death-dealing electric charge through their bodies. The quoted capitalized text at the end of the profoundly racist caption, taken from an Alabama newspaper editorial, suggests that lynching was the best way for Alabamans to handle the situation.

> "BOURGEOIS VIRTUE IN SCOTTSBORO: The ugly demands of threats from outsiders that Alabama reverse its jury decisions, and filthy insinuations that our people were murderers when they were sincerely being as fair as ever in the history of our county, is rather straining on our idea of fair play. IT ALLOWS ROOM FOR THE GROWTH OF THE THOUGHT THAT MAYBE AFTER ALL THE SHORTEST WAY OUT IN CASES LIKE THESE WOULD HAVE BEEN THE BEST METHOD OF DISPOSING OF THEM." From an editorial in the *Jackson County Sentinel* of Scottsboro, Alabama.

Among artists on the left, there was no room for racism. For example, the Soyer brothers—Raphael, Moses, and Isaac (1902–81)—fought to include African American artists in exhibitions during the 1920s, and, as noted earlier, Harry Gottlieb, president of the Artists' Union in 1936, helped African American artists join the WPA "as part of a special campaign for equality." In the October 1928 issue of *Der Hamer*, several poems by black poets were translated into Yiddish. The poet Berysh Vaynshteyn wrote a poem in 1936 entitled "Lynching" (Heyd 1999, 55, 73, 91, 99; AAA, Gottlieb, roll 3889, frame 727). And William Gropper was quoted as saying, "I'm from the old school, defending the underdog. . . . I react, just as Negroes react, because I have felt the same things as a Jew, or my family has" (qtd. in Freundlich 1968, 28).

In his drawing *The Law* (c. 1934, fig. 43), Hyman Warsager did not rely just on personal experience to make his point. Because many leftists believed that capitalism ultimately led to fascism, Warsager connected American racism and anti-Semitism to German fascism as well as to the American political and legal systems by placing a swastika on a southern courthouse building. A monstrous dead tree that seems to explode out

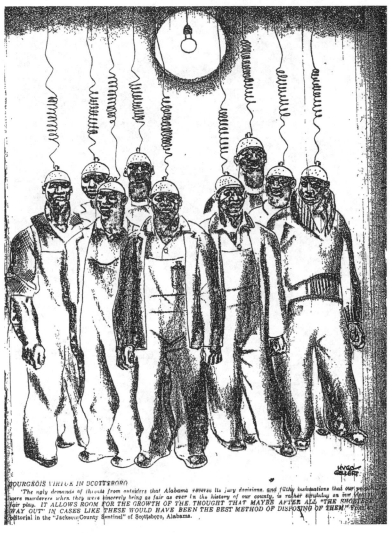

42. Hugo Gellert, *Scottsboro*, 1931, from *New Masses* 7 (November 1931). Courtesy of the Mary Ryan Galley, New York.

of a Tower of Babel–like structure extrudes tentacles through the front entrances of the courthouse. A lynched African American hangs from a branch of the tree.

Warsager might have connected the lynching, the swastika, and the courthouse with the tower based on a reading of Genesis 11:6–9. God,

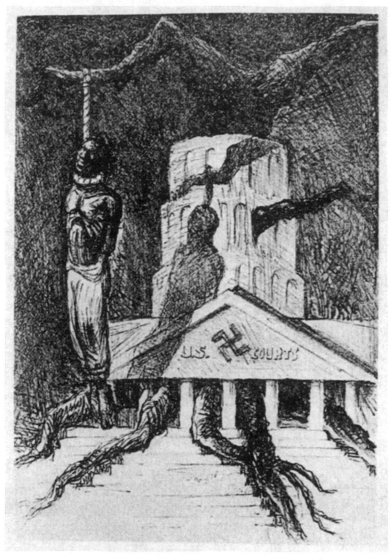

43. Hyman Warsager, *The Law*, 1934, from *New Masses* 9 (January 9, 1934).

realizing that the builders of the tower spoke the same language, decided to "baffle their language (confound their speech) so that they will not understand the other's language," and God then scattered them over all the earth. But, in effect, Warsager seems to imply the opposite, that fascists and American racists understood each other and that theirs was the universal language of hate. (Warsager was evidently not the only artist to see a connection between racism and Nazism. Hugo Gellert, in an interview in 1984, compared lynchings to German concentration camps [Park 1993, 344, 364 n.]).

It is easy to say that Jews were empathetic because of their political beliefs and their own history of discrimination. But it is also reasonable to say that artists fell back on the bedrock social concerns of their religion. The explanation by Boris Gorelick, a political activist and a founder and president of the Artists' Union, of his lithograph *Lynching* (c. 1936–37, fig. 44) is telling in this regard. In a letter written some four decades later, in 1976, he said that *Lynching* was part of a series inspired by a news item of the time. "It was a personal statement of outrage and protest. . . . It is a cry from the grave" (qtd. in Park and Markowitz 1977, 88). The passage "cry from the grave" would appear to have been taken from Genesis 4:10. After Cain kills Abel, God asks Cain of Abel's whereabouts. After Cain answers that he is not his brother's keeper, God says, "Your brother's blood cries out to Me from the ground." Perhaps a coincidental use of language, but probably not.

Gorelick placed the central action of the print, the lynching, within a phantasmagoric series of dislocated spaces filled with distorted and ghost-like figures. An hallucinatory figure throws out the keys to the jail so that the victim can be dragged out and lynched. The victim's bulging eyes magnify the lynching itself, his body turning to dust as it settles into a coffin. To the left, we see the victim's wraithlike form hanging from a tree, and at his feet he is seen again lying on the ground—all as if we are witnessing a before, during, and after sequence of events. Members of the Klu Klux Klan appear in the lower right entangled with a figure that probably represents justice. The diagonal steeple, its cross facing the Klan members, suggests that the church and the men are equally culpable for the lynching. In the lower center, a small figure with upraised arms

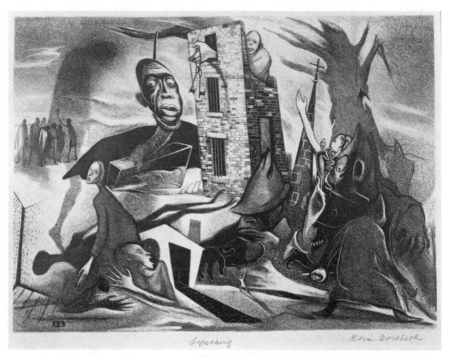

44. Boris Gorelick, *Lynching*, c. 1936–37. Lithograph, 10½ × 14 in. Collection Grunwald Center for the Graphic Arts, Hammer Museum, University of California, Los Angeles. Gift of Leon and Molly Gorelick.

invokes the presence of a crucifixion. At the lower left, the victim's wife, seen twice, gathers the body of her husband. His funeral in the middle left takes place in the shadow of his hanging form.

Julius Bloch extended crucifixion symbolism to his own work titled *The Lynching* (1932, fig. 45) by portraying a black victim strung up in crucified form by the white men below him. The moment that Bloch captured, as recorded in the mainstream art historical literature, is the moment when Jesus asks God, "Why have You forsaken me?" from Matthew 27:46 (Likos 1983, 12). But Bloch, a Jew, might instead have known the biblical passage from Psalm 22:2. And Louis Lozowick extended the idea of a crucifixion even further in another *Lynching* by turning the violence inward on himself and placing his own head, eerily lit from below, in a noose as if he were the person being lynched (fig. 46).

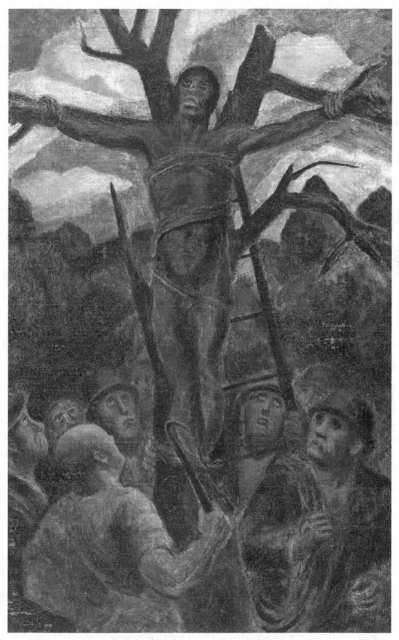

45. Julius Bloch, *The Lynching*, 1932. Oil on canvas, 19⅛ × 12³⁄₁₆ in.
Whitney Museum of American Art, New York; purchase 33.28. Digital
Image © Whitney Museum of American Art.

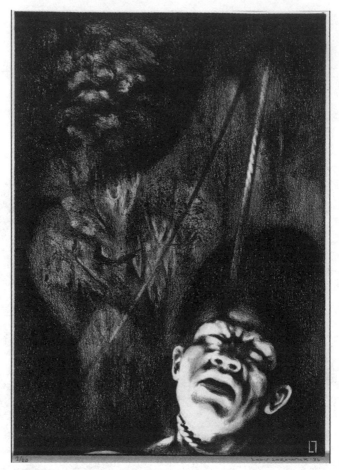

46. Louis Lozowick, *Lynching* (or *Lynch Law*), 1936. Lithograph on paper, 10⅜ × 7⅜ in. Smithsonian American Art Museum, Gift of Adele Lozowick. © 1936 Lee Lozowick.

What might Lozowick have been thinking? We know that he rejected traditional Judaism, but he did write for both the Yiddish-language and English-language Jewish press. One might surmise, therefore, that in 1936, when the plight of Europe's Jews was becoming clearer and clearer, he might have symbolically killed himself in protest as a Jew. But there are two more reasonable and intertwined explanations for this image that fit more neatly the thesis of this book. First, he demonstrated his own

sympathies for African Americans, and, second, as a way to identify more closely with such victims, he wanted to shock both white Christian and Jewish viewers by showing a white person in the process of being lynched. It is difficult to imagine a more gripping way to illustrate the biblical injunction to sympathize with the downtrodden than to identify oneself so closely with the victim of senseless aggression, as if to say that if those of us who have been abused because of racial or religious animosity are not properly protected, then lynching (murder) can become a common action directed against us.

Sam Zagat presented a different way to show sympathy for those oppressed. Instead of creating an image of despair and mistreatment, he drew one of hope and help, entitled *American Federation of Labor Extends Helping Hand to Black Labor* (1919, fig. 47). In a simple-to-read cartoon that shows the labor union in a good light, he portrayed a white worker helping an African American worker reach the summit on which the white worker stands. In fact, it would almost seem to illustrate a statement subsequently made by Meyer London (1871–1926), a socialist elected to Congress from 1914 to 1918 and again from 1922 to 1924, who, during a congressional debate on an antilynching bill in 1922, said: "I look upon the colored man as my weaker and younger brother. I owe him the duty of defending him. He is in the minority" (qtd. in Rogoff 1930, 249). London's outspoken words and Zagat's cartoon were quite challenging for the time, but they reveal to us today the similar beliefs among left-wing Jewish cartoonists, Jewish politicians, and Jewish-dominated unions in their quest for social improvement and equality.

Nicolai Cikovsky's cover for the May 1931 issue of *New Masses* shows blacks and whites marching together in a racially integrated May Day parade (see fig. 38 in chapter 4). This work raises two interesting but at this time unanswerable issues. First, the figures might have been criticized in the same way that Leon Bibel's marching robotic, automaton-like strikers might have been critiqued (see chapter 4). Second, they are not true-to-life figures, and the blacks are racially caricatured. But, more than likely, the idea of worker equality and solidarity trumped any other considerations.

In 1933, Hugo Gellert made a similar kind of statement about racial equality in *The Working Day* (fig. 48). In a quasi-cubist style, Gellert placed

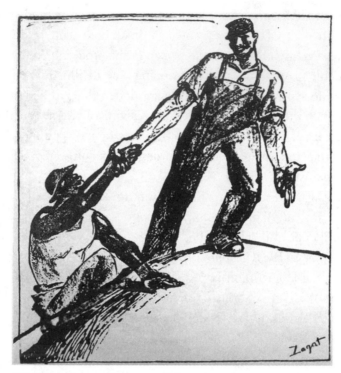

47. Sam Zagat, *American Federation of Labor Extends a Helping Hand to Black Labor*, June 1919, from Ida Zagat, ed., *Zagat Drawings and Paintings: Jewish Life on New York's Lower East Side, 1912–1962* (New York: Rogers Book Service, 1972).

two workers back to back as if to measure which one is taller and therefore the more dominant. But the black man and the white men appear equal in height and equally muscled, and both carry their work tools with the same confidence and resolution. There is no difference between them and no logical reason to think otherwise.

And a year later, in 1934, the African American in Louis Lozowick's print *Hold the Fort* feels sufficiently empowered to prevent a policeman from clubbing a white worker who lies on the ground (fig. 49). Lozowick emphasized two key points in his lithograph: first, constitutional rights belonged to all Americans whether on strike or not, and, second, labor

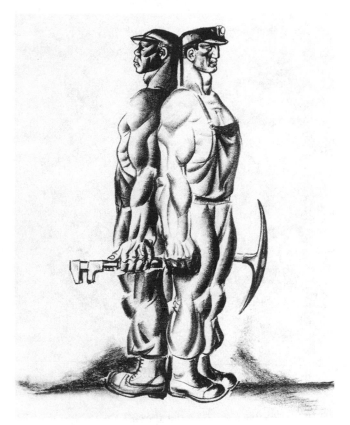

48. Hugo Gellert, *The Working Day 37*. Lithograph, 15⅛ × 13⅛ in. From the portfolio *Karl Marx' "Capital" in Pictures*, published in 1933 in an edition of 133 (New York: Ray Long and Richard R. Smith). Courtesy of Mary Ryan Gallery, New York.

solidarity transcended ethnic differences in the ongoing battles for workers' rights.

It is not surprising, then, to find illustrations of Abraham Lincoln scattered through the Yiddish press in any given year, especially around February 12, his birth date. Unlike Zagat's and Gellert's cartoons, those about Lincoln usually needed to be read, not just looked at, in order to understand what or who each figure represented. For the February 9, 1912,

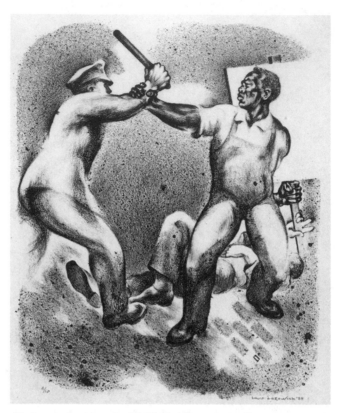

49. Louis Lozowick, *Hold the Fort* or *Strike Scene*, 1934. Lithograph, 10⅞ × 8⅞ in. Smithsonian American Art Museum, Gift of Adele Lozowick. © 1934 Lee Lozowick.

issue of *Der Groyser Kundes*, the anonymous illustrator drew a comparison between wage slavery in the North and race slavery in the South and, by so doing, enlisted Lincoln in the fight for better wages for northern workers (fig. 50). The heading at the top reads: "Dedicated to Lincoln's Birthday." At the left, a former slave, his chains broken, thanks Lincoln for his freedom. The plaque below Lincoln states: "Abraham Lincoln the liberator of Negro slavery." In the center, the cloth around the shirtless man's midsection reads: "Lawrence [Massachusetts] worker." The sign above him reads: "Slavery." The evil-looking, paunchy man to the right, compositionally balancing Lincoln on the left, has written across his belly:

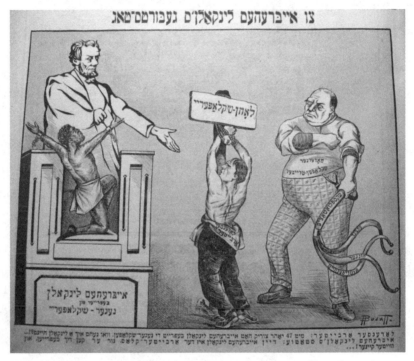

50. *Dedicated to Lincoln's Birthday,* from *Der Groyser Kundes,* February 9, 1912.

"Modern slave driver." Words such as *hunger* and *exploitation* are written on his whip. The caption at the bottom states: "Lawrence worker: '47 years ago, Lincoln freed the Negro slaves. Where can I find a Lincoln today?' The statue replies: 'Your Abraham Lincoln is working class. Only the working class can free you.'" (There were many textile mills in Lawrence, Massachusetts.)

Years later, for the February 13, 1925, issue of *Der Groyser Kundes,* the illustrator Zuni Maud (1891–1956) concentrated on slavery in the South (fig. 51). Maud, among the most prolific cartoonists and book illustrators in the Yiddish press, made cartoons for *Der Kibitser, Forvets* (Forward), and *Di Tsayt* (The time). In 1920, he was also the first American Yiddish cartoonist to create a comic strip (Portnoy 2008, 93, 112, 126). For the cartoon shown here, Maud contrasted Lincoln on the left with a Ku

Klux Klan figure on the right, setting up a comparison between good and evil. The heading at the top reads: "The white sheets. And that is an American!" Lincoln's name is written on his coat. The Klan figure has "Ku Klux Klan" written on his sheet. The paper he holds says: "Down with Catholics, down with Jews, down with niggers." In contrast to this message of hate, Lincoln's hand rests on the head of the freedperson. The bottom caption reads: "In honor of Abraham Lincoln, the liberator of the Negroes."

It is with all of this in mind that we can look again at Gellert's *Primary Accumulation* (fig. 1 in the introduction). It is one of several illustrations in his picture book *Karl Marx' "Capital" in Lithographs* (Gellert 1934). Helen Langa writes about it: "This dramatic image of an impassioned worker exhorting an interracial audience visualized ideals derived from contemporary Communist theory" (2004, 15). But it is not just the

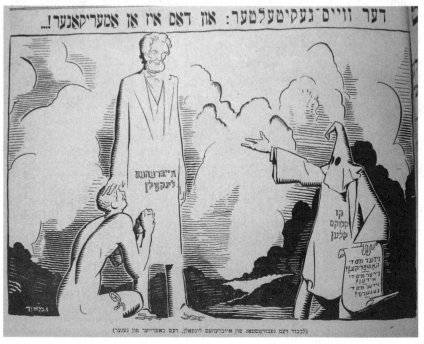

51. Zuni Maud, *The White Sheets. And That Is an American!* From *Der Groyser Kundes*, February 13, 1925.

audience that is interracial. The speaker appears to be the product of inter-racial antecedents, the offspring of black and white progenitors. In this regard, he is at one with those in the audience who are not just listeners but racially and politically familial figures. He is the new man, the new proletarian man, who has emerged as a leader of humanity, an idealized, heavily muscled figure, the closest American equivalent to the new Soviet man. He would seem to be the kind of revolutionary figure engaged in the kind of revolutionary activity that should have delighted those art critics looking for revolutionary subject matter.

In another register, at least three artists—Ben Shahn, Philip Evergood, and Joseph Hirsch (1910–81)—addressed the dreams of generations of immigrants hoping to enjoy a better life for themselves and their families in murals they created in the middle 1930s. Each mural cycle shows the early hardships immigrants encountered in their new country, the endless hours of toil in sweatshops and in menial jobs to secure a life free from want and fear, and the kind of life that would fulfill their expectations of what America meant to them. These murals, two sponsored by Jewish-led unions and the third by private businessmen, are among the clearest examples in all of American art of the old socialist desire to raise up work-ing people's living conditions and cultural level. By portraying the good life possible in America, the murals also come as close to being secular versions of biblical prophecy as any works from that period.

Ben Shahn's mural, the most famous of the three, completed in 1938 for the community center in rural Roosevelt, New Jersey, a planned com-munity built under the auspices of the International Ladies Garment Workers Union and the federal government, shows what enlightened union leadership and government aid can accomplish (fig. 52). In both his preliminary and final designs, Shahn recapitulated both immigrant and sweatshop history—the arrival in America at Ellis Island, employment in sweatshops, successful union organization, educational opportunities, and the construction of the rural town of Roosevelt, which provided work-ers with healthy rural living and working environments.

In the upper part of a preliminary sketch, Shahn showed two men sitting cross-legged on the floor, an apparent reference to piecework done

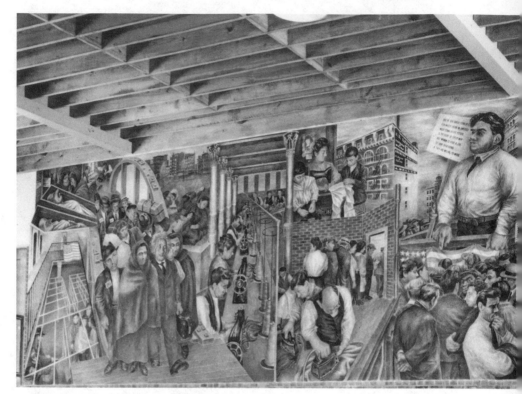

52. Ben Shahn, *Roosevelt Mural*, Community Center, Roosevelt, New Jersey, 1938. Fresco, 12 × 45 ft. Art © Estate of Ben Shahn/Licensed by VAGA, New York, NY.

at home in preunion days. In the finished mural, we see men and women in the central section sitting side by side at their machines. The genders are mixed, and the work space seems reasonably adequate, clean, and, presumably, acceptable by modern factory standards, thus revealing the power of unions and federal laws vis-à-vis the factory owners. In the adjacent scene, a woman sits at her sewing machine at home while her children help her, a reference to the bad old days of taking home piecework, for which the men and women received a pittance. But under enlightened union leadership, the scene immediately below shows pressers completing their day's tasks and the workers filing out into the late-afternoon sunlight, presumably able to enjoy a few hours of leisure time. To the right of the

center of the mural, a labor organizer gives a speech, and immediately next to him the lintel on the doorway has carved into it "International Ladies Garment Workers Union." The remainder of the mural omits references to the actual making of garments and instead shows the benefits that labor unions can bring to workers through their educational programs (see also Linden 1998; Platt 1995; Pohl 1987).

Although Philip Evergood's father was Jewish, the artist did not really identify Jewish, but a similar uplifting story is embodied in his mural *The Story of Richmond Hill*, completed in 1937 for the Richmond Hill Queens Public Library (fig. 53). (Richmond Hill, a utopian garden community, was founded in 1870.) It also illustrates the benefits that enlightened leadership can offer poor and oppressed slum dwellers who long for a better life and living conditions. The mural, its creation sponsored by the Mural

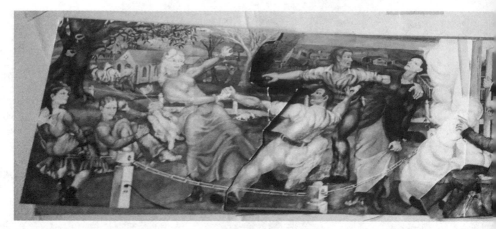

53. Philip Evergood, *The Story of Richmond Hill*, 1936–37. Richmond Hill Branch Library, Queens, NY.

Section of the WPA's Federal Art Project, reads from right to left as in Hebrew script. The first image on the far right is of a man carrying a bag as laborers and a businessman go to work in opposite directions. Immediately to his left, two young children take care of an infant, their parents presumably at work. Behind them, a man and a woman, perhaps their mother, climb a flight of steps for a purpose we can only guess, although the image does call to mind the following line in Cole Porter's 1930 song "Love for Sale": "If you want to buy my wares, follow me and climb the stairs. Love for sale." In the center, the planners dream of their utopian community, which then appears through a cloud to the left. There, we see a city woman invited to join a group of youngsters and young adults now grown healthy and robust, entertaining themselves in the fresh air adjacent to a farm. This is the American dream come true, life in the Golden Land.

Joseph Hirsch's horribly neglected and vandalized murals for the Philadelphia Joint Board of the Amalgamated Clothing Workers of America in 1936, installed in the Sidney Hillman Apartments in that city, are the least known but arguably the most complete example of social concern in an art project of the 1930s (figs. 54–58). Hirsch, a member of the Artists' Union, painted the panels in casein in colors that ranged between

chocolate and sepia. He completed them within a five-week period; the largest panel is eleven feet high and sixty-five feet long. The narrative describes immigrants arriving in America, working in sweatshops, join ing the Amalgamated Clothing Workers of America, and then enjoying the benefits the union could bring to them (AAA, oral interview with Joseph Hirsch, Nov. 13–Dec. 2, 1970). It would almost seem that Hirsh took inspiration from one of Mike Gold's most Whitmanesque passages in his early essay "Towards Proletarian Art," written under the pseud onym Irwin Granich in 1921, years before Gold became a hard-line Communist Party member: "When there is singing and music rising in every American street, when in every American factory there is a drama group of the workers, when mechanics paint in their leisure, and farmers write sonnets, the greater art will grow and only then" (Gold [1921] 1972, 70; see also Granich 1921).

In the first panel of Hirsch's mural (fig. 54), we see immigrants arriv ing, two of them, including an infant whose future lies before him, staring at the Statue of Liberty. The sense of freedom is abruptly inter rupted by a file of women hunched over their sewing machines in a sweatshop. Union organizers then call attention to union activities as a boss tries to halt their actions. The organizers point to a scene presided over by President Franklin Roosevelt (fig. 55). As delegates from many cities watch, Roosevelt leads a discussion that resulted in the passage of

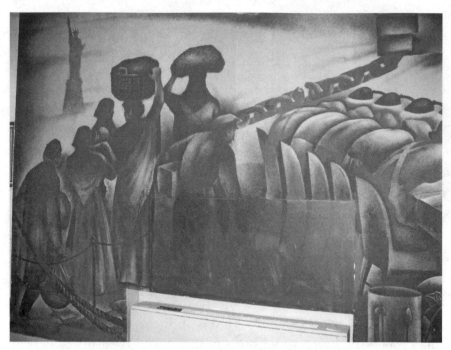

54. Joseph Hirsch, detail from mural in Sidney Hillman Apartments, Amalgamated Clothing Workers Union, Philadelphia, 1936.

the National Labor Relations Act (the Wagner Act) in 1935. Sidney Hillman (1887–1946), the union president, instrumental in helping Senator Robert F. Wagner draft the bill, sits next to President Roosevelt. There follow vignettes that show union concern not only for workplace conditions but for activities that contribute to its members' welfare—a union-sponsored orchestra, sports activities, educational lectures, children's exercise and movement classes, choral singing, and health benefits (figs. 56, 57, and 58).

Both Hirsch and Shahn show in their murals that, contrary to anti-immigrant and anti-Semitic sentiments in the early and midcentury periods, the workers and their leaders had proven themselves to be neither revolutionaries nor degenerates but individuals able to succeed within the American constitutional system, to organize themselves by legal means, and to become responsible, productive citizens. Whatever union benefits

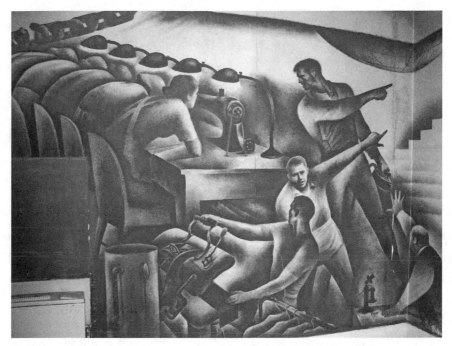

55. Joseph Hirsch, detail from mural in Sidney Hillman Apartments, Amalgamated Clothing Workers Union, Philadelphia. 1936.

are depicted, the murals also show that, in effect, the workers had now become entirely American. Such works were as a consequence important because they exhibited the immigrants' integration into American culture as well as the importance of working for the common good and helping others. At the same time, the three murals mark an ideal conjunction of religious heritage and social concern. Taken together, they present in visual form the kinds of activities it was believed that enlightened public and private support could bring to the working classes—decent housing, various forms of cultural uplift, and physical well-being.

Artists, independent of unions and government projects, could also lend their support to worthwhile causes—for instance, the settlement of Birobidzhan in Siberia. The Soviet government had started a program in 1928 to induce Jews to settle there as a way to alleviate what it considered to be "the Jewish problem" in the Soviet Union. In May 1934,

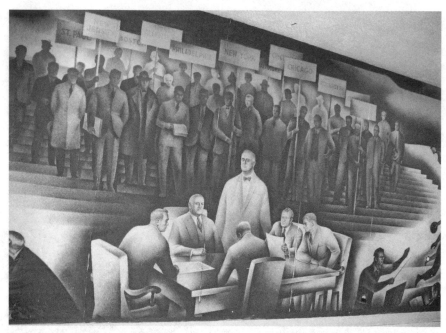

56. Joseph Hirsch, detail from mural in Sidney Hillman Apartments, Amalgamated Clothing Workers Union, Philadelphia, 1936.

Birobidzhan was named the "Jewish Autonomous Region" (see Borodulin 2002; Revutsky 1929; Strebrnik 2001; Weinberg 1998; Weinstein 2001).

In that same year, members of the John Reed Clubs became associated with the organization familiarly known as ICOR (sometimes YKOR), the Yidishe Kolonizakye Organizatsye in Ratnfarban or Association for Jewish Colonization in the Soviet Union. With Adolf Wolff and William Siegel in charge, they planned to collect artworks to donate to the Museum of Birobidzhan. The collection, made up of 203 works by 119 artists, almost half not Jewish, was exhibited initially in New York and Boston in 1935. Eighty-five oil paintings, 150 water colors, and 16 sculptures were sent to Moscow, where they were shown in 1936. The collection never arrived in Birobidzhan. Years later, some of the prints and sculptures were found in the Russian Ethnographic Museum in St.

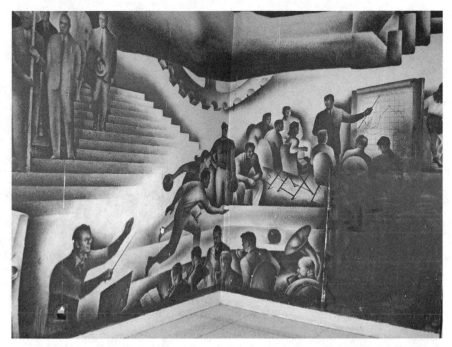

57. Joseph Hirsch, detail from mural in Sidney Hillman Apartments, Amalgamated Clothing Workers Union, Philadelphia, 1936.

Petersburg (AAA, Weber, roll NY59-6, frame 534; Borodulin 2002, 101, 104–8).

Despite this still unexplained loss, it is important to note that, as in the early days of the Great Migration, artists during the economically difficult years of the Depression were willing to contribute aid to total strangers, albeit Jewish strangers, who planned to live in a remote part of Siberia. Moissaye Olgin provided the Soviet spin for the contributions. He wrote that the works were given by "freedom-loving Americans [in] gratitude to the Soviet system for what it has done by way of liberating the oppressed nationalities in general [and] the Jews in particular" (1936, n.p.). If one were to provide a Jewish spin, it would be that religious and cultural identity prompted artists to support the settlement of total strangers in a place presumably free from anti-Semitism. As noted

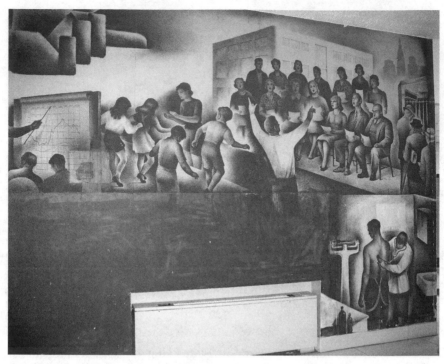

58. Joseph Hirsch, detail from mural in Sidney Hillman Apartments, Amalgamated Clothing Workers Union, Philadelphia, 1936.

decades later in the United Jewish Appeal Federation of New York survey entitled "Jewish Community Study of New York: 2011," "The key to Jewish continuity revolves around identity . . . , that if a person does not identify Jewishly, 'why would he care about a poor Jew in Brooklyn, Kiev, or supporting the Jewish state, or helping people who want to settle in Israel[?]'" (qtd. in Rosenblatt 2012, 8).

Conclusion

FROM THE 1880S to the early 1940s, the general attitude among socially concerned artists and art writers had been to promote ways to make life more pleasant for the ordinary person, to point out failures in the American political system, to support organizations and methods (unions, political parties, strikes, voting) to correct these failures, and to subscribe to the notion that art can and should have a positive social function. Whatever else socialism had offered Jewish artists through the early decades of the twentieth century, it was intimately tied to Jewish traditions, and, not least, it raised the possibility of living in a world free of anti-Semitism—not a small matter for those who had experienced that anti-Semitism firsthand in eastern Europe and who had witnessed its growth in America during the 1920s and its murderous transformation in Europe during the 1930s and 1940s.

From the mid-1920s, the Communist Party demanded a more prescriptive approach to subject matter based on support of the Soviet Union and on building a soviet future in America. If articles in magazines are any indication, such demands reached a high point around 1935 and then abruptly subsided with the advent of the Popular Front. But Soviet actions themselves also contributed to the lessening of revolutionary fervor later in the decade. Stalin's call for a socialist realist art in 1934 and the banning of modernist influences four years later obviously held little appeal for artists inclined to stylistic experiments and to those who did not want controls placed on their art ("Announcement" 1938, 3; Egbert 1967, 75, Rose 1984, 144). Between August 1936 and March 1938 in what became known as the Moscow Trials, Stalin neutralized or had murdered most of those in the Communist hierarchy who threatened his rule. Although many

questioned his tactics, his American supporters included at the time Hugo Gellert, Harry Gottlieb, William Gropper, Louis Lozowick, Raphael Soyer, and Max Weber ("The Moscow Trials" 1938, 19). The Hitler–Stalin Non-Aggression Pact of August 23, 1939, revolted many Jews, a feeling well summarized by the title of an article by Norman Holmes Pearson, "The Nazi–Soviet Pact and the End of a Dream" (1952). And the AAC's support for the Soviet Union's aggression against Finland, which lasted from December 1939 to March 1940, prompted many members to resign from the congress, thus ending the effectiveness of that organization (see Baigell and Williams 1986b, 29–36). And as social observer Stephen J. Whitfield points out, "By the 1950s, it was apparent to all but the slowest learners on the left that the Bolshevik Revolution had not accelerated the leap from the 'realm of necessity' into the 'realm of freedom' but instead into a different and more extensive form of domination" (1980, 7).

It is no wonder, then, that formerly staunch supporters of communism such as American-born Benjamin Gitlow (1891–1965), the Communist Party candidate for vice president in 1924 and 1928, rejected the notion that "the promise of a better world under Socialism would come true." By 1940, he found the Soviet system of government to be identical to that of Nazi Germany and fascist Italy (1940, 7, 12). Nevertheless, it is certainly reasonable to understand why he and others had turned to the far left for succor. Journalist Joseph Freeman's experiences were quite similar. He noted in 1936 in his book *An American Testament* that he chose socialism "because we have seen how barbarously fascism [Nazism] devours all that is living and sublime in world's culture" (vii). And, it should be noted, he, like Gitlow, also broke with communism by 1940.

Confidence in and support of the universal moral value of justice for all persons obviously did not save the lives of European Jewry, nor did belief in socialist economic systems result in an egalitarian society. The failure of socialism to prevent war and human atrocities, let alone to build a better world, destroyed the possibility of any sort of unifying vision it once held for artists. The Holocaust was certainly nothing less than traumatic for those who lived through it, albeit in America. Human reason and faith in political systems, let alone the comfort of religious traditions, were seriously questioned.

Jewish American artists born around 1900 followed diverse paths during the 1940s and after. Many political artists remained popular figures, some still committed to an art of social concern, but their centrality to the history of American art during the 1930s was eclipsed by worldwide events and by the rise of abstract expressionism during the 1940s. Some artists who had explored Jewish genres and religious themes before the 1930s continued to do so afterward, including Jennings Tofel and Ben-Zion. Others turned or returned to Jewish subject matter, including Gropper and Shahn. Still others, including Mark Rothko (1903–70) and Barnett Newman (1905–70), distanced themselves from the Jewish community. Whichever path artists followed, many lost interest in the idea of social concern as a motivating force in their art.

The most radical rejection of the idea of social concern occurred among the so-called New York Intellectuals, who viewed themselves as part of an international avant-garde. As many articles in magazines such as *Commentary* during the 1940s and 1950s attest, various Jewish figures, unmoored by the events of the time, wrote about various forms of alienation—from themselves, from their religion, and from mainstream society—and revealed in their own lives or in the lives of others the ambivalence Jews felt toward their religion and their place in the world. Unlike many artists and cultural observers in the previous decades, they did not see a bright future for Jews in America or anyplace else, and they had neither plans nor, evidently, the strength to change the world for the better.

For example, the poet Muriel Rukeyser (1913–80) noted in a symposium conducted by the magazine *Contemporary Jewish Record* in 1944: "I grew up among a group of Jews who wished, more than anything else, I think, to be invisible" (5). Theologian Mordecai M. Kaplan (1881–1983) summed up the thoughts of many when he asserted in the following year that at no time in the past had so many Jews been so ashamed of their Jewishness because of a lack of clear status as a group and of what it meant to be a Jew. In effect, both the Torah and God had failed the Jews (1945, 96; see also Zukerman 1942, 106).

As theologian Neil Gillman generalized decades later, "Never before did we feel so radically alone, abandoned, insecure, and afraid" (1990, 183.) And as historian Mark Shechner observed around the same time,

Though the sense of being out of harmony with the world is scarcely of
Jewish patent, rootlessness, marginality, and estrangement have always
had a special meaning for the Jews as a dispersed nation, and never
more so than just after the war, when the murder of European Jewry
had brought an end to an entire phase of their history. . . . Intellectu-
als suffered the general estrangement with an added poignancy, being
doubly alienated, first *as* Jews, second *from* Jews. (1987, 16, italics in
original; see also Howe 1946; Novak 2005, 232, 229; Shapiro 1952,
205–18; Steinberg 1941, 587)

Shechner was referring to those intellectuals and artists who had be-
come part of the anti-Communist left as well as to the international
avant-garde community. The Jews among them had largely severed ties
to the Jewish community, certainly the religious community, and had
largely abandoned interest in social concern. By the 1940s, their com-
munal Jewish memories had begun to fade and grew increasingly less
vital to the point of near invisibility. But it needs to be said that although
distancing themselves from the Jewish community, a significant num-
ber were unable or unwilling to jettison entirely their heritage despite
their sense of alienation and isolation. This group includes artists such
as Mark Rothko and Barnett Newman, whose works with Jewish content
are heavily coded.

Although discussed elsewhere in greater length, a single work by
Rothko can suggest something about this state of mind. Whatever else
one might note about *Entombment I* (fig. 59), it might very well com-
memorate those murdered in the Holocaust. It can be considered, there-
fore, a funereal piece, perhaps the most tragic memorial by an American
artist to the victims of the Holocaust (Baigell 2006, 73–75). *Entombment
I* is dated 1946, which means that it was painted soon after Rothko and
the rest of America saw the photographs of the piles of corpses in the con-
centration camps. These photographs had been published in magazines
the previous year and exhibited to the public what the Holocaust looked
like. The painting is a gouache, one of a series of similar works in which
a dead body lies on the laps of mourners. Because it is perhaps the only
work to include a transparent weightless figure floating in front of and

behind the heads of the mourners, it might be the first work in the series to be painted after the photographs became available.

One scholar has suggested that the two horizontal figures in the gouache, the body and the floating form, relate in some way to ascension and rebirth (Chave 1989, 155), but this is a Christian concept. The concept was undoubtedly known to Rothko, but it makes more sense to think of the work in a Jewish context.

Let it be said immediately that in Jewish burials there are certain constants, but no all-encompassing, precise rules to complete the pre-burial, burial, and postburial ceremonies except that cremation is not an option. Normal burial procedures include never leaving the body alone from the moment of death until burial, usually on the same day; washing,

59. Mark Rothko, *Entombment I*, 1946. Opaque watercolor and black ink on paper, 20⅝ × 26 in. Whitney Museum of American Art, New York; purchase 47.10. Digital Image © Whitney Museum of American Art, NY. © 1998 Kate Rothko Prizel & Christopher Rothko / Artists Rights Society (ARS), New York.

cleansing, and dressing the body; including a prayer shawl if the corpse is male; positioning the body horizontally, arms and legs straight and the mouth closed. In Rothko's painting, the body lies on straw or on a shroud, an eastern European custom. There is the belief that if a Jew is not buried properly, then his or her soul will never find rest or entirely leave the body. The condition will cause torment and pain throughout eternity.

The transparent, hovering figure in the upper part of the painting, then, might symbolize the collective souls of all those murdered and not buried properly because their bodies were cremated, desecrated, or defiled in some way. Their bodies were obviously not guarded because friends and family members were also murdered, and these persons will never be remembered through the annual observances on the date of their death because there were no survivors and no way of knowing the exact date, anyway. If this interpretation rings true, then for Jews *Entombment I* is one of the great tragic paintings memorializing the Holocaust, marking a kind of ground zero of Jewish despair—death, no release of the soul, and no annual observance.

The place of this painting within the history of Jewish American art is multivalent. Compared to the optimism seen in the early prints that heralded the start of a new life for Jews in America, Rothko's painting pays tribute to those killed in the calamity of the Holocaust. In the same way that new immigrants had been welcomed more than a century ago by those already settled in America, their children, in the person of Rothko, honored in death those who had remained in the Old Country.

The major art critics of the postwar period, Clement Greenberg and Harold Rosenberg, revealed in their writings a similar kind of ambivalence about their heritage. They wanted to keep a certain distance from it, but they evidently could not help writing about. As the major and most powerful art critics of their time, they are also shining examples of the belief articulated in early-twentieth-century America that one could leave the parochial constraints of the ghetto and achieve success within the mainstream. Although neither critic was a student of philosopher Morris Raphael Cohen (1880–1947) at City College of New York, they

might have indirectly absorbed at least one important tenet from him that evidently impressed former students such as Irving Howe and philosopher Sidney Hook (1902–89), either of whom might have passed on to them Cohen's belief that "men can change their habitation and language and still advance the progress of civilization" (qtd. in Omer-Sherman 2002, 122). Children of immigrants, Greenberg and Rosenberg could and did become players in the progression of American culture.

Both art critics were closely associated with the new American art movement of the 1940s, abstract expressionism, which Rosenberg called "the first art movement in the United States in which immigrants and sons of immigrants have been leaders in creating and disseminating a [new] style" (1959, 137). He included figures such as Rothko, Newman, Adolph Gottlieb (1903–74), Philip Guston (1913–80), Jack Tworkov (1900–1982), and Milton Resnick (1917–2004). But, of great significance with respect to them as art critics, their points of view were quite opposite to those that sustained the communitarian values, both Jewish and socialist, of their predecessors, such as Saul Raskin, Dr. John Weichsel, and the art writers of the 1930s. Paradoxically, then, Greenberg and Rosenberg mark both a high point and a certain kind of end point in the history of Jewish American art.

Like the earlier figures, they supported the idea that society must move forward, but after rejecting the more dogmatic and authoritarian aspects of the leftist politics of the 1930s, they held that society would not necessarily move forward by political means. Greenberg thought that such momentum could be maintained by the cultural elite, not the proletarian masses, and Rosenberg, influenced by surrealism's concerns for the creative process, believed that individuals who were independent minded and creative could do the same. Both encouraged artists to turn from social concerns to apolitical, self-searching themes, which came to characterize the most advanced art of the 1940s. Rosenberg especially lionized the artist as a heroic individual willing to make the solitary voyage into the self. In the words of one historian, both critics "worked to find a safe haven for radical progress within the realm of individual culture" (Herbert 1985, 2).

Critic Stephen Alexander's review of Jacob Burck's murals about the Soviet Five-Year Plan made in 1935 for the Intourist office in Moscow exemplify the kind of artistic thinking Greenberg and Rosenberg rejected.

> The artist who correctly understands his own environment has access to common factors which make it possible for him correctly to understand other environments. The highly developed revolutionary is a keen student not only of the country in which he is living but of the whole world which becomes his environment because he studies it with a purpose. It is not merely a matter of intellectual curiosity. The true revolutionary *needs* to know. A sustained and intensive revolutionary training has equipped Burck with a true understanding of the socio-political forces [involved]. (1935b, 26, italics in original)

Greenberg's two basic theses were that avant-garde art represented the best and most progressive aspects of modern culture and that each art medium should be concerned only with its own particular possibilities. In his essay "Avant-Garde and Kitsch" (in Greenberg 1986, 1:8–20), he pitted avant-garde culture against popular and commercial art, which he called "kitsch." The former, Greenberg held, would keep high culture moving forward; the latter, whose products were debased forms of high culture, could destroy it. Kitsch was the culture of the masses, which he associated with the culture of fascist countries. In effect, Greenberg sought to maintain culture as an elite function impregnable to compromise and adulteration from below.

Concerning art forms, Greenberg held that "content is to be dissolved so completely into form that the work of art or literature cannot be reduced in whole or in part to anything but itself" (1986, 1:28; see also 1:28–37 and 2:94). That is, painting should be nonrepresentational and concern itself only with the flatness of the painting surface, with texture, color, and form, but not with spatial depth or with narrative content except as these qualities evolve from the painted shapes themselves.

Rosenberg was as much concerned with existential possibilities as with aesthetic results. By 1948, he held that the process in the making of an art object, of the object's self-revelatory possibilities to the artist, was most important. When considering the matter in regard to writers, he said

that the author can either accept mass culture as a guide or "accept the fact that he cannot know except through the lengthy unfolding of his art work itself, what will prove to be central to his experience. Creating his art is then part of his very experiencing; it is his way of revealing his existence to his consciousness and bringing his consciousness into play upon his experiences. And his art communicates itself as an experience to others" (1948, 251).

In his most famous essay, "The American Action Painters" (1952), Rosenberg emphasized the idea of the give and take between creator and what is created. The canvas surface becomes "an arena in which to act— rather than a space in which to reproduce, redesign, analyze or 'express' an object, actual or imagined. What [is] to go on the canvas [is] not a picture but an event. [The images produced are] the result of this encounter" ([1952] 1961, 25). To greater or lesser degree, each work, even each brush-stroke, marks a new beginning, a creative, existential gesture that grows from the artist's inner being, as free as possible from external restraint, including politics, European art traditions, morals, and values. In effect, each brushstroke, mark, or drip is made in response to the previous one and to nothing else. In effect, by opposing the influences of mass culture, Rosenberg thought that one could advance mass culture by promoting individualism.

But neither critic could escape his background. Obviously sensitive to anti-Semitism at home and to the murder of Europe's Jewish population, Greenberg and Rosenberg discussed in several articles the nature of their Judaism, their Jewish self-hatred, and their connections to a mainstream culture that did not necessarily like Jews. They sought a kind of universal or supranational citizenship in the international avant-garde in which they might feel secure and comfortable rather than remain as minority guests in hostile environments. They wanted to leave behind and to suppress their ancestral roots, to reinvent themselves as citizens of the world, but, despite their intentions, they still felt uneasy about their status as com-plete, entitled, and safe Americans (see Gilman 1986, 303; Lewin 1941, 221–26; Patai 1977, 461–62; Rubin 1990, 120; Simmel 1946).

They lived an ambiguous existence directly on the fault line between incompatible traditional religious and modern social cultures, not unlike

members of other minority racial and national groups who were or still are in route from their ancestral identities to new American ones. The passage of time has precluded full understanding of the possible doubleness of their lives, a condition to which Irving Howe alluded on at least one public occasion (1982a, 252; see also Rabinovich 2004, 104).

For example, Greenberg wrote in 1944 that he had "no more conscious position toward his Jewish heritage than the average American Jew—which is to say, hardly any." Unless he lived life in an unconscious position, this statement is nonsense. He also said that whatever "Jewish qualities" (his phrase) he possessed were transmitted to him informally, "mostly through mother's milk and the habits and talk of the family" (1986, 1:176). This, too, is nonsense, unless one wants to parse very carefully the differences between "Jewish qualities" and Jewish concerns and interests. In this same article, Greenberg also mentioned that even if he had no conscious position toward his heritage, nevertheless a quality of Jewishness permeated everything he wrote. In effect, he assumed no responsibility for that quality.

He could even be somewhat playful about his heritage, as when in a review of an English translation of Sholom Aleichem's writings he said that the "verbal wit, liveliness, and Elizabethan fluidity of Yiddish do not survive translation; nor does the shop talk of Talmudic scholarship—something a Jew got in his bones without ever having read the Talmud" (1986, 1:155). Greenberg's use of the verb *got* is a barely coded, pure stereotypical New York Jewish locution.

For the record, whatever else Greenberg said, wrote, or did, he was certainly involved in Jewish affairs during the years in which he published some of his most important essays and reviews. Born in New York City to immigrant parents, he spoke both Yiddish and English as a child. As early as 1935, he translated from the German *The Brown Network: The Activities of Nazism in Foreign Countries*. From 1944 to 1945, he was managing editor of *Contemporary Jewish Record*, which was absorbed by *Commentary*, and then served as the latter's associate editor until 1955 (Greenberg 1986, 3:194–96). And he could hardly have remained untouched by the monthly "Chronicles" section in *Contemporary Jewish Record*, in which, from its very first issues in 1939, both Jewish affairs as well as atrocities committed

against Jews were carefully listed and documented month by month, country by country, and continent by continent. (Similar sections commonly appeared in other English-language Jewish magazines.) It should also be noted that virtually every issue of the journal included articles directly concerned with problems facing Europe's Jewish populations.

As mentioned in chapter 4, Greenberg coauthored an article with Dwight MacDonald in 1941, "10 Propositions on the War," in which they made no mention of atrocities already committed but rather, arguing from an above-the-fray left-wing position, indicated that the choice facing the country was "to deflect the current history from fascism to socialism"; otherwise, America faced a fascist future under capitalism (271). But in a review of *Metapolitics: From the Romantics to Hitler* by Peter Viereck that same year, Greenberg attacked the author for not fully understanding the importance of Nazi ideology and the cultural attributes of Nazi leaders. He also administered a backhanded slap to Thomas Mann for not breaking with Hitler until 1935 or 1936 (1986, 1:79–83).

He was also upset by the way the art collector Peggy Guggenheim was exploited by international bohemia. In his review of her book *Out of This Century*, he wrote, "As a Jew, I am disturbed in a particular way by this account of the life of another Jew. Is this how naked and helpless we Jews have become once we abandon our 'system' completely and surrender ourselves to a world so utterly Gentile in its lack of prescriptions and prohibitions as bohemia really is?" He thought that Guggenheim and others like her were Jewish martyrs who, when they escaped from their self-imposed, Jewish middle-class stuffiness, found only humiliation and victimization at the hands of others (1986, 2:97–98).

In his articles and reviews, in particular his review of *The Writings of Sholom Aleichem*, where he alluded to Jewish weakness, Greenberg also touched on something that did not so much lurk in the back of his mind as much as it was impossible to suppress—namely, the weakness of Diaspora Jews, who had endured two thousand years of persecution and in the immediately preceding months and years systematic murder in Europe.

Greenberg's ambivalence to Judaism, now mocking it, now distressed by hostility to it, might have been exacerbated by the attitude common in the midcentury period that one should aspire to be an American American

rather than a "hyphenated" American, as in "Jewish American," "African American," "gay American." The issue was not "both–and" but "either–or." For Jews, the best advice was to lead dignified, respectable lives and contribute to a democratic, secular, albeit diverse American culture rather than to flaunt their religion or heritage (Hook 1949, 468, 480). Rosenberg, too, was well aware of this issue of choice, the necessity to be "a single thing" rather than a hyphenated thing. "Isn't it the . . . modern impulse," he offered, "to be one who is one-hundred percent something that makes Jews so uncomfortable when they debate whether one can be both an American and a Jew? In comparison with the apparently single identifica-tion of others, being twice identified seems embarrassingly ambiguous." Rosenberg was further perplexed not by "any actual, greater singleness among non-Jewish Americans than among Jews but the prevalent *ideology* of total choice with its exclusion of the *possibility* of being anything else" (1950, 152, italics in original).

To understand Greenberg and Rosenberg's position better, it is nec-essary to understand some of the implications of being a 100 percent American. It might have included distancing oneself not just from Jewish art but from a certain kind of thinking about Jewish art. One example will suffice. In an article about Chaim Soutine (1893–1943), critic Alfred Werner reviewed some comments about the artist's work, including the following by critic and artist Morris Davidson: "They [Soutine's works] are the expression of a neurotic who is saturated with the savage childish mysticism of his Hebrew heritage. The frenzied rituals and superstitions of his Jewish environment in Vilna have left him a morbid urge to express emotional fancies by means of distorted figures. . . . Soutine is more poet than painter, and most of all, high priest of the synagogue" (qtd. in Werner 1948, 438). If one had a choice, who would want to be associated with this kind of Judaism or to allow this kind of flamboyant language to tarnish one's heritage? Davidson's preposterous and wildly insulting assertions would seem to have been written in Germany during the 1930s.

Greenberg clearly wanted to turn down the volume in his published responses to the Holocaust. He acknowledged that he and other Jews had a right to be sick of Europe and angry at Gentiles and that Jews collectively had "a right for the moment to indulge our feelings, if only to recover

from the trauma. But humanity in general is still the highest value and not all Gentiles are anti-Semitic. . . . No matter how necessary it may be to indulge our feelings about Auschwitz, we can do so only temporarily and privately." Otherwise, Greenberg felt, self-pity can turn Jews into what he called "swine" and even into nationalists like the Germans (1986, 3:51, 47). So his logic rested on the notion of getting over quickly and privately what was in effect a German aberration in order to maintain one's sense of civility and Jewish self-respect and to honor a universal conception of humanity rather than to retreat into rage or one's ancestral embrace.

Greenberg did not want his Jewish heritage to become his mark of self-definition. Instead, he wanted to develop a Jewish consciousness that encouraged self-realization and that liberated him from outworn parameters of belief and behavior. He was not interested in "some form of one-hundred-percent Jewishness," but at the same time he did not want to deny his identity by seeking full assimilation (Cooney 1986, 243). Rather, he wanted to accept his "Jewishness more implicitly, so implicitly that I can use it to realize myself as a human being in my own right, and *as a Jew in my own right*. I want to feel free to be whatever I need to be . . . without being typed or prescribed to as [a] Jew or, for that matter, as an American." He wanted his relationship to the Jewish community to be, as he said, personal and spontaneous. And, after all was said and done, he believed that Jews would persist "as long as Jewishness remains essential to our sense of our individual selves, as long as it is the truth about our individual selves" (1986, 3:55–57; see also E. Cohen 1947; Friedlander 1946). In other words, he meant that if he felt Jewish, he was Jewish without having to do anything about it or to feel responsible for passing on anything to the succeeding generations.

This planless kind of Jewishness might have guided Greenberg as he made his way in America, but one can certainly argue that it affected his aesthetic point of view. His cultural elitism and his sense of societal alienation as a Jew and from Jewishness, coupled with his desire to become a mainstream figure, emerged, as art historian Robert Storr has pointed out, in his preoccupation with form as "a sublimated expression of his deep alienation from the surrounding environment" (1990, 162). Content in a work of art, therefore, might become too revealing. The work's history, if

it had one, should devolve only from the history of modern art, or else it might reflect something in the history of its maker or the society in which it was made. Better to eliminate all references to the past, especially if they might be particularistic Jewish ones. As Greenberg indicated in 1940 in his essay "Towards a Newer Laocoon," emphasis should be on form and the autonomy of art rather than on art objects as "vessels of communication" (1986, 1:28).

It would seem, then, that Greenberg's aesthetic was profoundly influenced by his desire to escape his own history. Just as he chose to limit the importance of his own past, so a painting should have no past other than that which emerged from itself, from its own nonrepresentational self, impervious to anything other than "the limitations of the medium of the specific art" in that "the purely plastic or abstract qualities of the work of art are the only ones that count" (Greenberg 1986, 1:32, 34).

Rosenberg, in contrast, did not impose on art a directional flow or an endpoint. Rather, he held that art developed from the artist's individual being. As one observer notes, "In Rosenberg's mind, a painting (and by extension all art works) serve as aesthetic expressions of one's identity as articulated by the artist's (inter)action with pigment and canvas (or any other media). The manifest product of an artist's actions reveals a psychic imprimatur of the self" (Winkenweder 1998, 87). According to Rosenberg, in the best of all possible worlds the self could escape its own past by reinventing itself as a different self, a self of its own invention.

But, like Greenberg, Rosenberg could not completely disassociate himself from his background. In explaining why nonreligious Jews joined socialist movements to solve world problems, he suggested in "Letter to a Jewish Theologian" (1947) that they substituted a modern political utopia for traditional messianic expectations. "In this unconscious transference of Jewish craving from its original object to a more universal one, Judaism may have some connections to socialism. But a craving that has lost its way is not a social doctrine" (1973, 256). He also inferred a supramundane explanation for such a position in his article "Rediscovering Judaism" (1947). "During centuries of exile, Jewish thought was born and lived in a state of siege, both physical and moral, and the gates could be opened but rarely. To remain erect in his beleaguered world, the Jew had to assume a

posture of more than usual moral rigidity. Since History was his enemy, he was obliged to keep his eyes fixed at a point above events, securing himself to the eternal by the strands of the Law" (in Rosenberg 1973, 235). Here, Rosenberg saw moral rectitude as a necessity for Jewish survival. Similarly, Greenberg felt that survival led to a stifling overabundance of middle-class self-control.

And like Greenberg, Rosenberg also asserted by implication that he could be the kind of a Jew he chose to be. Disputing Jean-Paul Sartre's claim in *Anti-Semite and Jew* that Jews were the creation of anti-Semitism, Rosenberg held that "since the Jew possesses a unique identity which springs from his origin and his story, it is possible for him to be any kind of man—rationalist, irrationalist, heroic, cowardly, Zionist, or good European—and still be a Jew. Jewish identity has a remarkable richness for those who rediscover it within themselves" (1949, 18).

In "Jewish Identity in a Free Society" (1950), Rosenberg rejected the position of those who insisted on Jewishness as "the central fact of their lives," opting instead for a position not unlike Greenberg's.

> I therefore support the value of the perspective of the semi-outsider who has not willed his Jewishness and is only a Jew in whatever respect and to whatever depth he finds that he *is* a Jew. . . . The individual who seeks in himself the hidden content of his Jewishness must accept the risk of what he may find. Like all serious adventures in self-discovery, such a search is an affirmation of a faith in the value and demands moral courage as well as a certain inner stability; his daring implies a sense of being secure in his worth. (in 1973, 267, emphasis in original; see also Rosenberg 1950)

We are clearly no longer in the territory inhabited by figures such as Saul Raskin or Ben-Zion (whom I discuss more fully later in this conclusion) regarding when it becomes necessary to feel strong enough to think about, reflect on, and measure one's hidden content of Jewishness. Furthermore, Greenberg and Rosenberg must have known that Judaism is a performative religion—lighting candles on the Sabbath, saying prayers for the dead, performing good deeds, and so on—rather than a series of exercises in soul searching.

What did Rosenberg have to say about Jewish artists? He tied his answer to the possibility of the existence of a Jewish art. For him, in a phrase, it did not exist, but there was nevertheless a Jewish point of view. He found it in the artists' search for identity according to which they created as Jews, but they nevertheless did not create a Jewish art. As Jews, they evidently had begun "to assert their individual relation to art in an independent and personal way," thus helping to inaugurate a genuine American art by creating as individuals. He found this sense of independence to be a profound Jewish expression. "To be engaged with the esthetics of self has liberated the Jew as an artist by eliminating his need to ask himself whether Jewish art exists or can exist" (1966, 60).

What all this seems to boil down to is that independent search is a Jewish thing. So the search for self-expression and self-identity became for Rosenberg a Jewish issue, or really his own concern for self-identity transferred to artists. Where Greenberg found the best art to be hermetically sealed within the borders of each media's formal possibilities, Rosenberg allowed it to remain open, adventurous, and ever renewable, which he considered to be a "profound Jewish expression." However one responds to the logic of their arguments, authority for both critics resided not in community tradition or in the old neighborhood but ultimately in the Self, which, as historian Henry L. Feingold points out, is "the most distinctive remaining fingerprint of American Jewish identity." A person thus self-filled, Feingold sadly observes, "becomes a lonely tribe of one" (1999, 167, 171).

Adolph Gottlieb seems to have best captured the change from believing in the artist's social usefulness to seeing the artist's social irrelevance and individual isolation, basically negating a half-century's dreams and hopes:

> By the age of 18, I clearly understood that the artist in our society cannot expect to make a living from art; must live in the midst of a hostile environment; cannot communicate through his art with more than a few people. . . . Having no practical or obviously useful justification, and not being tied to fundamental religious, political, or social beliefs, the artist is footloose in a society which, when it does "use" art, usually does so on levels that to the artist are contemptible. (1954, 267, 271)

Among the various other paths artists chose to follow during the mid–twentieth century, Jennings Tofel, as mentioned in chapter 2, remained largely apolitical and focused his attention on maintaining a secular Yiddish art presence in New York. He founded the Jewish Art Center in 1927 for that purpose. In an autobiographical statement, he wrote movingly about his discovery and commitment to his religious heritage:

> I imbibed from earliest youth some of that vast mass of Jewish religious, moral, and cultural teachings with its many laws and so few earthly privileges. And as I come to be proud and happy in this rich heritage, I am made aware of how the goods of heaven can be shattered by the rude stroke of earth, if only intermittently I am startled into this sense of a new loss by the threats of pogroms in my native Russian-Polish town, for I am a Jew under the brutal domination of the Poles, themselves under the brutal domination of the czars. (AAA, Tofel, roll N68-36, frame 13)

In a fragmentary note probably written at the same time as the draft of his autobiography, he wrote: "I who identify myself with the Jews have the problems of the Jew. I cannot close my eyes to these problems on the grounds that I am an artist" (AAA, Tofel, roll N68-36, frame 14). As art critic Alfred Werner explained, Tofel and other like-minded artists, "despite all openness [in America,] . . . always felt like outsiders in the largely gentile art establishment." Tofel's pictorial world in particular, "with all its intensity, its mood of gravity, . . . is one that only a Jewish refugee from Eastern Europe could have created" (qtd. in Granick 1976, 10).

Even though Tofel came to America in 1905, he evidently did not try to reinvent himself as an American (see chapter 1) or choose to become a political artist but remained connected to his Jewish roots throughout his life. In fact, he held that Jewish artists should not assimilate but should always remain aware of their heritage and project in their work a spiritual presence he described with a biblical analogy. He believed that the Tabernacle carried by the Israelites in their forty years of wandering through the desert "marvelously illustrates the place of the spirit in a work of art." He related the spirit within the Tabernacle, which was hidden from view, to a work of art. For Tofel, the spirit of the latter was also to be "perceived

otherwise than by the physical senses" (qtd. in Hayes 1983, n.p.; see also AAA, Tofel, roll N68-37, frames 510, 440; Granick 1976, 222).

The biblical scenes Tofel painted throughout his career grew more and more expressionistic in style through the 1940s as he became more deeply troubled by the Holocaust. His richly textured, tumultuous surfaces and slashing brushstrokes added a sense of appropriate violence to his subject matter, awash in images of brutality and death. The war, as he wrote in February 1943, "infused anger into my work. Everything I touch becomes steel and iron, hard and impregnable." By the end of that year, he thought that artists had not yet internalized the tragedy taking place. He found that reverence for the traditions of art had "restricted [their] vision" and that they could not "see the terror of [the war] for the paint." But at the same time that visions of terror and horror should be communicated to the viewer, Tofel, in a prophetic voice, held that artists should somehow temper their anger with feelings of hope, pity, and a will to justice (AAA, Tofel, roll N68-37, frames 448, 642).

Tofel's hesitation, perhaps ambivalence, about describing the nature of appropriate subject matter in face of the destruction taking place in Europe was common at the time because few could actually understand the enormity of the Holocaust or know what it looked like until the photographs of the camps were published toward the end of the war. He worried that a memorial to Hitler's victims could not yet be completed, let alone imagined. "The real tragedy," he wrote, "is so tremendous and unexampled, there is no precedent on which to base such a work of art, and no tradition in which to construct it. Only time will find a vehicle for the proper presentation of such a spectacle." Nevertheless, he insisted that active protest was essential, especially about those who "watch and do nothing." He thought that by erecting concentration and murder camps, Germany had actually built memorials to itself because in them lie "dead and buried not the victimized Jew but the German nation" (AAA, Tofel, roll N68-37, frames 448, 642).

Unlike others numbed and spiritually paralyzed by the Holocaust, Tofel maintained a firm anchor in the Jewish community. His culture destroyed, he responded with both anger and the desire to commemorate that destruction in some way. Ben-Zion, who, like Tofel, never

abandoned his heritage and found great comfort in it, had the same responses (Baigell 2006, 45–62). He always acknowledged its importance in his professional life:

> Although the identification of an artist must be first and foremost with humanity as a whole, nevertheless the really genuine one never dissociates himself from his creed. On the contrary, he thrives on the sources of his origin, and through projecting his background reaches humanity which no matter how multiple and different its creeds and upbringing may be—at the roots is the same humanity. (1963, in AAA, Ben-Zion, roll N69-122, frame 153)

Ben-Zion, too, found art for its own sake unacceptable during the Holocaust. He wrote that he sat helpless in America, unable and unwilling to continue to make beautiful paintings in the face of events in Europe (Ben-Zion 1981, 122). At one point, he made more than three hundred sketches of heads and entire bodies in a way that was "as far as possible from esthetic niceties and show[s] the shame of mankind discussing pretty little art diversions. I wanted to show these plain art expressions without esthetic aims—the esthetics of Europe" (in *De Profundis* 1946, n.p.). His major effort during and just after World War II was a series of paintings and lithographs entitled *De Profundis* in which a series of heads of old men, perhaps rabbis, were jammed together helter-skelter behind barbed wire. He chose this subject, "the patriarchic type of Jews[,] . . . because they were the backbone of the nation and its cultural source" (in *De Profundis* 1946, n.p.).

William Gropper and Ben Shahn, among those artists who remained involved with left politics, were the two major figures in the immediate postwar years. Both created images with Jewish content. Comments by Gropper and others about his sense of Jewishness were quite guarded in comparison to statements made by Tofel and Ben-Zion, but no less heartfelt. In an interview in 1962, Gropper said that Hitler and fascism made him aware that he was a Jew (AAA, Gropper, roll 3502, frame 6)—a fact he had obviously known from childhood. Hearkening back to the days when left-wing Jews dissociated, or thought they had dissociated, themselves

from their religion, he said, "I think all intellectuals who were never concerned with their faith were thrown into an awareness by these atrocities." "An awareness" seems to be a very cool reaction; it is not the same as saying they were "upset" or "overwhelmed" or "aghast" by the atrocities. Yet when Gropper was invited in 1947 to the unveiling of the Warsaw Ghetto Monument designed by Nathan Rappaport in honor of the uprising in 1943, he responded quite profoundly as both a Jew and an artist by stating that he would create a work each year to commemorate that event within the larger context of the Holocaust. He explained: "I'm not Jewish in a professional sense but in a human sense; here are six million destroyed. There is a ritual in the Jewish religion of lighting a candle for the dead, [kaddish,] but instead of doing this, I decided to paint a picture in memory, every year. In this way, I paid my tribute, rather than burning a candle" (qtd. in Freundlich 1968, 29). The paintings usually show an old man, probably a rabbi, looking up and presumably arguing or pleading with God, as if asking the question "Why?" Of these works and the many Jewish genre scenes Gropper produced in the following years, one biographer noted that Gropper was not "a devoutly religious man, but . . . Hitler and the persecutions of the twentieth-century . . . aroused in him a desire to learn more about his people—to sing their history and achievements" (Freundlich 1968, 23). "Aroused in him a desire?" There is no emotional charge in this phrase but rather a sanitized gloss on what must have been deep feelings that remained in the minds of those unable to resolve their conflicts between Jewish particularism and political universalism (on this ambivalence, see C. Liebman 1973).

There is, however, no ambivalence in the responses from Ben Shahn, who from the late 1940s until his death created works that intermixed Jewish and political subject matter while at the same time reflecting the attitudes of Jews benumbed by the events of the time. In various combinations, some works conveyed strong civil rights messages, others relied on biblical and kabbalist sources, and still others revealed the impact of the horrific events of the time by acknowledging the fact that individuals have no control over their destiny. It can be argued, therefore, that Shahn's Jewish-themed works were the most all-embracing and inclusive in Jewish American art during the immediate postwar years. His art can be seen as

perhaps the major connecting link between what came before 1940 and what was to follow in the latter part of the century—a topic for another kind of book (Amishai-Maisels 1987; Baigell 2006, 94–116).

In one of his own books, Shahn revealed the following: "At the time I went to school for nine hours a day, and all nine hours were devoted to learning the true history of things, which was the Bible . . . , time was to me then, in some curious way, timeless. All the events of the Bible were, relatively, part of the present. Abraham, Isaac, and Jacob were 'our parents'—certainly my mother's and father's, my grandmothers' and grandfathers', but mine as well" (1963, 5). Jennings Tofel and Ben-Zion would certainly have understood Shahn's statement about his relationship to biblical figures as well as the notion held by the very Orthodox that between the giving of the Torah at Sinai and the anticipated coming of the Messiah secular history is of little significance.

At the same time, political artists would have probably agreed with Shahn's answer to critic Alfred Werner's question, In what sense are you a Jew? Quoting a passage from William Blake's *The Marriage of Heaven and Hell*—"The voice of honest indignation is the voice of God" (Blake 1970, 38)—Shahn said that one of the prophets (Isaiah) declares: "The righteous indignation over injustice is the truest worship of God" (qtd. in Werner n.d., 18).

Two works can serve to represent these varying strands in Shahn's work. The first, *Ram's Horn and Menorah* (1958), reveals the artist's regard both for his heritage and for his social concerns (fig. 60). In addition, it is a Zionist hymn to the new state of Israel, then only ten years old. The painting brings together Shahn's loyalty to and knowledge of the world of his parents and grandparents, his political interests, and his good wishes for the still young country. (The importance of Zionism and the establishment of the State of Israel for artists is a topic yet to be studied in depth.)

The painting includes a menorah on the left and a man whose head is covered by a prayer shawl, indicating extreme holiness as he blows a shofar, a ram's horn. A hand emerging from the flame in the center indicates the presence of the Lord, and five differently colored heads under the shofar represent different racial types. At the top, lines from the prophet Malachi state: "Have we not one father? Hath not one God created us? Why do we

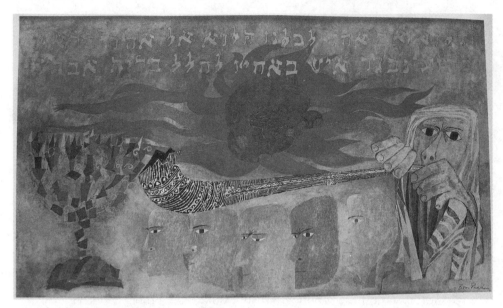

60. Ben Shahn, *Ram's Horn and Menorah*, 1958. Tempera and gold leaf on board, 16½ × 28 in. Art © Estate of Ben Shahn/Licensed by VAGA, New York. Collection unknown. Photograph by Matthew Baigell.

deal treacherously every man against his brother, to profane the covenant of our ancestors?" It has been assumed that by citing this passage, Shahn, a strong advocate of civil rights, created a work about racial equality.

The commentaries on Malachi in the so-named Soncino Bible that Shahn owned (A. Cohen 1948), however, do not suggest racial equality, although this notion might certainly have been part of Shahn's intention. Malachi lived in Jerusalem after 516 BCE, when the Second Temple would have been rebuilt after its destruction in 586 BCE. He probably wrote his prophecy around 460 BCE. The country was under Persian rule, and the people were abandoning Israelite religious practices at an alarming rate. The passages cited were actually part of Malachi's rebuke to the Israelites both for their high rate of divorce from fellow Israelites and for intermarriage with non-Israelites. The question, "Have we not one father"? is not about racial equality, but rather, as is stated in the commentaries, it indicates that "since God is Israel's father and they are His children, it follows that brotherly love should be shown one another and

family loyalty upheld." Malachi's phrase "to profane the covenant of our ancestors" refers directly to intermarriage, which is "a menace [to] the distinctive faith which was the basis of God's covenant with Israel, as well as to the national existence" (A. Cohen 1948, 335–36, 345).

Malachi's pronouncement was also a request for social reform. If the Israelites refuse to reform, they will be destroyed by fire and turned into ash—a passage that would have resonated with any Jew after the Holocaust. In the end, however, God would send Elijah "to reconcile parents with children and children with their parents," all of which had relevance to Shahn's own life because he was himself guilty of Malachi's charges. We know that when Shahn created *Ram's Horn and Menorah*, he was married to his second wife, Bernarda Bryson, a non-Jew. He did not get along with his mother, and he neglected his children from his first marriage (Greenfield 1998, 48, 114, 118). On one level, then, the painting affirmed Shahn's civil rights credentials. On another level, it was about Israelites bonding with each other, a clear reference to strengthening modern Israel. And on yet another level, it uncannily described Shahn's own life. It reveals how Shahn's sense of social concern reached well beyond the politics of the 1930s by addressing international, domestic, and personal issues in the postwar period.

The second work by Shahn of interest here is *Martyrology* (1962, fig. 61). It represents that aspect of Shahn's work concerned with mortality and human agency in that it acknowledges the fact easily understood after World War II that individuals have no control over their destiny. For works in this category, Shahn also fell back on religion and Jewish memory as a way to cope with both the savagery of the war, the Holocaust, and the now empty promises of a bright socialist future. The entire work consists of a text taken directly from the afternoon service on Yom Kippur, the day on which God is believed to decide who will live and who will die during the coming year. It is intoned in memory of the ten martyrs murdered in Roman-occupied Judea for violating the decree that prohibited the teaching of Judaism. "These I remember, and my soul melts with sorrow, for the strangers have devoured us like unburned cakes, for the days of the tyrant there was no reprieve for the [ten] martyrs murdered by the government." Because Shahn omitted from the text the actual number killed in

ancient Judea—ten—his purpose was to commemorate the many mur-
dered in the Holocaust (Amishai-Maisels 1987, 316). In either instance, in
ancient or modern times, individuals, not in control of their fate, as Shahn
inferred, could be murdered arbitrarily by governmental authority or ran-
dom chance. Shahn added these same lines to a print entitled *Warsaw,*
1943 (1963), a portrait of a man who hides his face, an obvious reference to
the failed uprising in the Warsaw Ghetto. Same story, same result.

The distancing from community values and from strong political ties
does not mark the end of the story of social concern in Jewish American
art, although it does end a chapter in that art's history. After the passing of
the immigrant generations that had dominated Jewish American art until
roughly the late 1950s, another chapter was opened that requires another
kind of book.

Suffice it to say here that beginning around 1970 several Jewish
American artists born during the 1930s and afterward abandoned a uni-
versalist view for a particularist view (Baigell 2009a, 2012). They did not
continue the line of thought associated with Tofel and Ben-Zion, about
whom they know very little, as much as they rediscovered it. In the 1970s,
they began to explore their heritage and unabashedly started to mine the
Bible, the Talmud, the prayer books, legends, and kabbalah for subject
matter. Unlike artists of earlier generations, these younger figures have
few or no direct memories of immigrant experiences or the hardships of

61. Ben Shahn, *Martyrology*, 1962. Art © Estate of Ben Shahn/Licensed by
VAGA, New York, NY. Collection of the New Jersey State Museum. Museum
purchase, FA1970.12. Reproduced with permission.

the Depression. And many were born after the Holocaust. They include, among many others, Janet Shafner (1931–2011), Helène Aylon (b. 1931), Carol Hamoy (b. 1934), Ruth Weisberg, (b. 1942), Mark Podwel (b. 1945), Richard McBee (b. 1947), Archie Rand (b. 1949), Tobi Kahn (b. 1952), and David Wander (b. 1954).

Their Judaism is less one of shared memories, traditional modes of worship, political fellowship, community responsibilities, and postwar alienation than one of a personal questioning and existential engagement with the religion, whether their concerns are feminist, psychological, or historical (e.g., the Holocaust). The net result has been the creation of a modern, largely religiously oriented art appropriate for a now decentered Jewish community in which the principle binding elements are primarily, but not exclusively, the seminal texts of the religion rather than communal and traditional concerns. In effect, they want to contribute to a modern Jewish American culture distinct from but not entirely separate from the majority culture.

Various factors have contributed to the resurgent interest in religious subject matter: coming of age during a period of minimal overt anti-Semitism; newfound pride in Judaism as a result of Israel's success in the 1967 war; a willingness finally by the 1970s to confront the Holocaust in their art; the influence of the various liberation movements in America, especially feminism; the desire of the "third and fourth generations" to return to or revisit their roots in order to construct a contemporary Jewish identity; and the spiritualism inherent in the Jewish Renewal Movement.

Of great importance, many want their art to be socially useful and instructive, but they do not define it in terms of political social concern. Rather, they find the concept of *tikkun olam* (repair of the world) closer to their way of thinking. In this regard, they seek universalist values within their particularist Jewish concerns. Like the earlier artists, they want to leave the world a better place than the one they were born into, but their subject matter is not as dogmatic, didactic, prescriptive, or directive, and they are not as interested in specific social and communal themes. Nor are they as invested in passing on to succeeding generations religious rituals and traditions that presuppose shared religious and cultural habits other than those involved with the public good.

They do not merely illustrate ancient stories, but rather they—especially the feminist artists—riff on and challenge traditional interpretations. A particular passage in an ancient text is considered to be a point of departure, and as such their art reflects the religiously pluralistic and independent-minded contemporary Jewish American community. Like Greenberg and Rosenberg, they want to be their own kind of Jew, but with the major difference that they prefer to think and work within a much more judaically oriented framework. Instead of independent self-expression, as Harold Rosenberg might have it, these artists are engaged in a genuine Jewish self-expression that is based on but not beholden to their source material.

It also needs to be said that in today's market-driven, profit-making artistic climate, the creation of works with *tikkun olam* in mind does provide them with moral and socially minded reasons to create and to give purpose to their art, not unlike the social concern exhibited by their artistic forebears more than one hundred years ago. In this regard, they are keeping alive a tradition that ultimately derives from their time-honored Jewish heritage. And many contemporary artists, like Saul Raskin and Ben-Zion before them, embrace their religious heritage very positively, exult in it, and honor it, but not by cleaving to its established rituals. Instead, they project its social values through their art in a way they feel appropriate for twenty-first-century America. As in days of old, these contemporary figures are invested in keeping alive the long-held desire to see art as a means to improve humankind and to invigorate the community. And this is not a bad thing.

Artists' Biographies

Selected from and based on available materials.

Bard, Phil (1912–66): Contributing editor and cartoonist for *New Masses* beginning in 1930. Also created cartoons for the *Daily Worker* and made a set of murals for its offices. An instructor in the John Reed Clubs and involved in 1933–34 with the organizations from which the Artist's Union evolved, he served as its president in 1935. He was also the first political commissar for the Abraham Lincoln Brigade in 1936–37.

Ben-Zion (1897–1987): Born in the Ukraine, immigrated to America in 1920. A writer and a poet, he turned to painting during the 1930s, thinking it a more effective tool with which to oppose Hitler. Intended for the rabbinate by his family, he was deeply religious and spiritual but nonobservant and probably remained closest to the mindset of an eastern European yeshiva student than any other artist in America. He made hundreds of paintings and prints based on the Bible. Espousing a soft, expressionist style, he joined the Ten in 1936, a group of relatively nonpolitical artists including Mark Rothko who exhibited together for a few years. Ben-Zion was among the first to create works that related directly to the Holocaust.

Bekker, David (1897–1966): Born in Vilna, Poland, immigrated to America in 1920. A printmaker and painter, he moved to Chicago in the late 1920s, where he created murals for the WPA in Illinois.

Bibel, Leon (1913–95): Born in Poland, came to the United States as a child. A painter, he left California for New York in 1936, where he joined the WPA. At that time, he portrayed working-class scenes. After his WPA days, he became a chicken farmer but took up art again in the 1960s.

Bloch, Julius (1888–1966): Born in Kehl, Germany, immigrated to America in 1893. Lived in Philadelphia and fought in Europe during World War I. By 1930, he had turned to themes of poverty and racial inequality, but in the 1940s he began to create abstract paintings.

Burck, Jacob (1907–82): Born near Bialystok, Poland, immigrated to America in 1914. Moved from Cleveland to New York in 1924, where two years later he began cartooning for the *Daily Worker* and *New Masses* and worked for other Communist magazines. When in Moscow in 1935 to hang the still uncompleted and never installed murals in the Intourist offices, he refused to glorify Stalin's image. After returning to America, he cut his ties to the Communist movement and moved to Chicago, where he continued as a cartoonist and a painter. Before his break with communism, he published the collection *Hunger and Revolt: Cartoons by Burck* (1935).

Cikovsky, Nicolai (1894–1984): Born in Poland, immigrated to America in 1923. Turned to scenes of social concern around 1930. During the 1940s, he began to paint landscapes and seascapes.

Dershowitz, Yussel (dates not known): Lives in Brooklyn, New York, where his work has been shown at the Hassidic Art Institute.

Epstein, Jacob (1880–1959): Born in New York's Lower East Side and immigrated to England in 1905, where he became one of that country's major sculptors. His autobiography, first published as *Let There Be Sculpture: An Autobiography* (1940), was republished as *An Autobiography* in 1955.

Evergood, Philip (1901–73): Born Philip Blashki in New York to a Jewish father and a Gentile mother. A politically active, socially concerned artist who worked on various government art projects during the 1930s. After World War II, he turned increasingly to a fantasist approach to subject matter.

Freeman, Selma: No information available.

Gellert, Hugo (1892–1985): Born in Budapest, immigrated to America in 1905. He considered himself a Communist by 1919, although he did not join the Communist Party USA until 1934. A founding editor in 1926 and an art editor

of *New Masses* in 1928, a founder of the John Reed Clubs and a director of its art school, a co-organizer of the Artists' Committee of Action and of the Artists' Union in 1934, he created what is considered to be the first proletarian mural in America for the Workers' Cafeteria in New York. He once said, "Being a Communist and being an artist are two cheeks of the same face and, so for me, I fail to see how I could be either one without also being the other" (Wechsler 2002, 199). He is the author of, among other books, *Karl Marx' "Capital" in Lithographs* (1934) and *Comrade Gulliver* (1935).

Goodelman, Aaron (1890–1978): Born in Odessa, immigrated to America in 1907. Sculptor involved with several left groups during the 1930s. He said, "It is the artist's duty to deliver the struggle of the working class against the forces of bourgeois reaction in art" (AAA, Goodelman, roll 4930, frame 84). But he was also a strong supporter of keeping alive a sense of Yiddishkeit, especially in the teaching of the Yiddish language to youth.

Gorelick, Boris (1912–1984): Born in Russia, immigrated to America in 1913. Active in left-wing politics from the mid-1920s, he contributed cartoons to *New Masses* beginning in the mid-1930s and was a founder of the Artists' Union in 1934 and its president for three years. He moved to California in 1942.

Gottlieb, Adolph (1903–74): Born in New York City. A founding member of the Ten in 1935, a group of nonpolitical artists who exhibited together until 1940. Their styles were loosely expressionist. In the early 1940s, he added surrealist elements to his art, sometimes based on symbols of indigenous American peoples and ultimately leading to his "Burst" paintings of the 1950s. Associated with abstract expressionism from the mid 1940s, he published important statements in the *Tiger's Eye* and the *New York Times*.

Gottlieb, Harry (1895–1992): Born in Bucharest, Rumania, immigrated to America in 1907, settling in Minneapolis. Moved to New York in 1918, became active in left politics, and joined the Communist Party in the mid-1930s. He served as president of the Artists' Union in 1936 and was a pioneer in the development of the silk screen technique.

Gropper, William (1897–1977): Born in New York City, he grew up in poverty, which affected his outlook on life as an adult. Among the most prolific cartoonists,

he initially pilloried capitalists, including capitalist Jews, but was among the first American artists to attack Hitler when he came to power in 1933 and to call attention to his murderous policies regarding Jews. Gropper's works appeared in several left-wing publications. A founder of the John Reed Clubs in 1929, he also created murals for the government projects in the 1930s. After World War II, he made many works with Jewish themes. He also made a series of annual paintings memorializing the victims of the Warsaw Ghetto after its destruction in 1943.

Hirsch, Joseph (1910–81): Born in Philadelphia, he was primarily a painter but also made etchings and lithographs. He joined the WPA's mural division during the 1930s.

Israel, Leon (LOLA) (1887–1955): Prolific cartoonist for Yiddish-language journals, most notably *Di Tsukunft*, and painter of Lower East Side scenes.

Kirk, Frank C. (1889–1963): Born in Zhitomer, Russia (now Ukraine), immigrated to America in 1910. Graphic artist and painter, active in political movements especially in the 1920s and 1930s.

Kopman, Benjamin D. (1887–1966): Born in Vitebsk, Russia, immigrated to America in 1903. Involved with forming the Introspectives in 1917—a group of Jewish artists who wanted an art of suggestion, insight, imagination, and feeling—as well as the Jewish Art Center in 1925, which favored a secular Yiddish orientation.

LOLA. See *Israel, Leon*.

Lozowick, Louis (1892–1973): From Ludvinovka, Ukraine, he studied at the Kiev Art Institute before joining his brother in the United States in 1906. When in Germany in 1922–24, he befriended several avant-garde Russian artists, whose "machine style" he brought back to the United States. A teacher and a prolific writer in both Yiddish- and English-language journals, he gave voice to advanced styles in the 1920s and to political radical ideas in the 1930s. Best known for his prints, he also painted in oils.

Maud, Zuni (1891–1956): Born near Bialystok, immigrated to America in 1905. His comic strip in *Di Tsayt* in 1920–21 marked the first serious interest in

this form among Yiddish artists. Beginning in 1914, he drew cartoons for *Der Kibitzer, Der Groyser Kundes, Der Hamer, Forvets*, and other journals. A writer as well as a performer, he designed theater sets and established a successful marionette theater with Yosl Cutler.

Ostrowsky, Abbo (1889–1975): Born in Elisbetgrad, Russia, immigrated to America in 1908. A painter most but importantly a teacher and mentor to generations of art students. He began teaching in 1914 at the East Side Art School in the University Settlement House, which was moved to the Educational Alliance in 1917. He served as the school's director until retirement in 1955 but remained affiliated with it until his death. He believed in the social value of art, its importance to the community, and the importance of immigrant artists drawing inspiration from their community even as they prepared to enter into mainstream American culture.

Raskin, Saul (1878–1966): From Nogaysk, Russia, he left Russia in 1893 to study in several countries before arriving in the United States in 1903. He was a prolific writer, printmaker, and painter whose politics moved from radicalism to Jewish nationalism. After the 1940s, he created several books based on Jewish prayers and other texts.

Reisman, Philip (1904–92): Born in Warsaw, immigrated to America in 1908. Explored biblical subjects in the late 1920s because he found in them all aspects of human actions from incest to murder to mythology to ancient history. He also portrayed many city scenes.

Ribak, Louis (1902–79): Born in Lithuania, immigrated to America in 1912. A founder of the John Reed Clubs in 1929, he created many left-wing prints during the 1930s and 1940s. In 1933, he assisted Diego Rivera in making a mural for Rockefeller Center, which was destroyed because it included a portrait of Lenin. He left New York for Taos, New Mexico, in part for health reasons and in part because of the disputatious art scene. When in Taos, he turned to abstract forms.

Riis, Jacob (1849–1914): Born in Denmark, immigrated to America in 1870. A social reformer famous for his writings and photographs of the blighted lives of immigrants and his plans for improving their lot. His most famous book is *How the Other Half Lives* (1890).

Rothko, Mark (1903–70): Born in Dvinsk, Russia (now Daugavpils, Latvia), immigrated to Portland, Oregon, in 1913. He settled in New York in 1923, where he decided to become an artist. He exhibited with the Ten from 1935 to 1940. Influenced by surrealism and the current interest in mythology, he gave up his lyrical, expressionist style and interest in genre scenes for an art of abstracted, vaguely identifiable forms around the time the German policy to kill all Jews was initiated. By 1949, he developed his signature style of vertical, rectangular forms stacked one atop another. In a series of published and recorded statements, he articulated the concerns of the budding abstract expressionist movement.

Shahn, Ben (1898–1969): From Kovno (Kaunas), Lithuania, he came to the United States in 1906. Well known as a political painter after exhibiting his series on Sacco and Vanzetti in 1932, the Italian anarchists accused of murder and robbery, he continued to explore similar subject matter into the 1960s. His paintings and prints on Jewish themes during the 1950s and 1960s are among the most important works done in this vein in the history of Jewish American art.

Siegel, William (1905–?): Born in Russia, immigrated to America in 1923. Provided cartoons for the *Liberator, New Masses,* and other leftist magazines during the 1930s.

Solmon, Joseph (1909–2008): Born in Vitebsk, Russia (now Belarus), immigrated to America in 1912. A founder of the Ten in 1935, a group of essentially nonpolitical artists who worked in expressionist styles, he became the editor of the Artists' Union newspaper *Art Front* in 1936 as a result of the demand for less Communist Party–driven articles.

Soyer, Moses (1899–1975): Born in Borisglebsk, Russia, immigrated to America in 1912. One of three brothers (with Raphael and Isaac) who became artists, Moses painted primarily studio subjects—portraits, dancers—and considered himself to be in the line of French nineteenth-century realists such as Courbet and Daumier. During the 1930s, he also painted the downtrodden.

Soyer, Raphael (1899–1987): Born in Borisglebsk, Russia, immigrated to America in 1912. The twin brother of Moses, he, too, painted studio subjects and felt he was an artistic descendent of the nineteenth-century French realists. His work during the 1930s also concentrated on flophouse scenes and the unemployed.

Sternberg, Harry (1904–2002): Born on the Lower East Side in New York City. He had an Orthodox upbringing and became active in social causes by 1934, creating cartoons for *New Masses*. In 1935, he became the technical adviser to the Graphics Art Division of the Federal Art Project. The following year he received a Guggenheim grant that led to a series of works on the lives of coal miners and steel mill workers in Pennsylvania. He completed four sets of post office murals: three in Ambler, Chester, and Cellersville, Pennsylvania, and one in Chicago. In keeping with the attitudes expressed in this study, he hoped that an artist could benefit society morally and aesthetically by portraying the world around him or her.

Walkowitz, Abraham (1878–1965): Born in Tyuman, Siberia, immigrated to America in 1890. Active in the art life of the Lower East Side around the turn of the century, he portrayed its inhabitants, helped organize art exhibitions, and taught art. But after a visit to Europe in 1906–1907, he returned to America, becoming perhaps the first artist here to follow the latest Parisian styles. Nevertheless, he helped found the Peoples' Art Guild in 1915 and the Jewish Art Center in 1925.

Ward, Lynd (1905–1985): Born in Chicago. Created six graphic novels and headed the graphic writers art division of the Federal Art Project in 1937–39.

Warsager, Hyman (1909–74): Worked in a variety of print mediums.

Weber, Max (1881–1961): From Bialystok, Russia, came to the United States in 1891. A pioneer American modernist and a politically active figure during the 1930s, he painted Jewish themes, mostly rabbis and men studying Torah, especially from the late 1930s until his death. He explored a variety of styles, including fauvism, cubism, and futurism as well as realism and his own version of expressionism.

Zagat, Sam (1890–1964): Born in Sebesh, Lithuania, immigrated to America in 1895. Prolific cartoonist and painter of Lower East Side scenes. His first cartoons and cartoon strips were for *Warheit* (1912–19), then for the *Jewish Daily Forward* (1919–62). He also made cartoons for *New Masses* and the *Morning Journal*. His most famous cartoon strip was *Gimple Beinish, der Shadchon* (Gimple Beinish, the matchmaker).

Glossary

aishet chayil: Woman of valor.

Arbayter Ring: Workmen's Circle.

Di Arbayter Tsaytung: *The Workers' Newspaper.*

Bodn: *Base.*

Forschritt: Progress.

Forvets: *Forward.*

Fraye Arbayter Shtime: *Voice of Free Labor.*

Di Frayhayt: *Freedom.*

Der Groyser Kundes: *The Big Stick.*

halacha: Jewish religious law.

Der Hamer: *The Hammer.*

havadalah: The ceremony marking the end of the Sabbath.

heder: Religious school for young boys.

landsmanshaft: A mutual aid society usually established by and for members from an eastern European community.

Morgen Frayhayt: *Morning Freedom.*

Naya Lebon: *New Life.*

Dos Naya Land: *The New Land.*

Pirke Avot: Translated as *Ethics of the Fathers* or *Wisdom of the Fathers* and included in the daily prayer book, or siddur.

shlogn kaporet: The ceremony practiced on the day before Yom Kippur in which a fowl is twirled around one's head as a form of redemption. A short prayer is said three times, stating that the fowl is the offering for atonement.

shtetl: Small town in eastern Europe.

strayml: Fur-brimmed hat denoting that the person is a hasid.

tikkun olam: Repair of the world.

Di Tsayt: *The Time.*

Der Tsayt Gayst: *The Spirit of the Times.*

Di Tsukunft: *The Future.*

Yiddishkeit: Evocation of eastern European Jewish culture.

Works Cited

*References to microfilms in the Archives of American Art, Smithsonian
Institution, Washington, DC, appear in the text as AAA followed by the artist's
name then roll and frame numbers, as in "AAA, Weber, roll 2, frame 2."*

Aaron, Daniel. 1961. *Writers on the Left*. New York: Harcourt, Brace, and World.
————. 1969. "Some Reflections on Communism and the Jewish Writer." In
 The Ghetto and Beyond, edited by Peter I. Rose, 253–69. New York: Random
 House.
Alexander, Stephen. 1935a. "Art Review." *New Masses* 14 (Mar. 12): 28.
————. 1935b. "Murals by Burck and Lanning." *New Masses* 14 (Jan. 22): 26.
Amishai-Maisels, Ziva. 1987. "Ben Shahn and the Problem of Jewish Identity."
 Jewish Art 12–13 (1987): 304–19.
————. 1990. "The Artist as Refugee." In *Art and Its Uses: The Visual Image
 and Modern Jewish Society*, edited by Ezra Mendelsohn, 111–48. Studies in
 Contemporary Jewry, vol. 6. New York: Oxford Univ. Press.
————. 1993. *Depiction and Interpretation: The Influence of the Holocaust on the
 Visual Arts*. New York: Pergamon.
"Among Our Brethren Abroad." 1917. *The American Hebrew* 101 (June 15): 148,
 168.
"Announcement." 1938. *Art Digest* 13 (Oct. 13): 3.
Antliff, Allan. 2001. *Anarchist Modernism: Art Politics and the First American
 Avant-Garde*. Chicago: Univ. of Chicago Press.
"Art and the Old Testament." 1906. *American Hebrew and Jewish Messenger* 6
 (Mar. 23): 552.
"Artists' Congress 'Calls.'" 1941. *Art Digest* 15 (June 1): 22.
Baigell, Matthew. 1973. *Thomas Hart Benton*. New York: Harry Abrams.

————. 1989. "Thomas Hart Benton and the Left." In *Thomas Hart Benton: Artist, Writer, and Intellectual*, edited by R. Douglas Hurt and Mary K. Dains, 1–33. Columbia: State Historical Society of Missouri.

————. 1991. "From Hester Street to Fifty-Seventh Street: Jewish American Artists in New York." In *Painting a Place in America: Jewish Artists in New York, 1900–1945*, edited by Norman Kleeblatt and Susan Chevlowe, 28–71. New York: Jewish Museum.

————. 2002. *Jewish Artists in New York: The Holocaust Years*. New Brunswick, NJ: Rutgers Univ. Press.

————. 2005. "What's Jewish about Jewish Art? Some American Views." *Art Criticism* 20, no. 1: 76–85.

————. 2006. *American Artists, Jewish Images*. Syracuse, NY: Syracuse Univ. Press.

————. 2009a. "Contemporary Jewish American Arts: A Short Review." *Art Criticism* 24, no. 2: 7–26.

————. 2009b. "Sweatshop Images: History and Memory." *Images* 2:65–82.

————. 2012. "Social Concern and *Tikkun Olam* in Jewish American Art." *Ars Judaica* 8:55–80.

Baigell, Matthew, and Julia Williams, eds. 1986a. *Artists against War and Fascism: Papers of the First American Artists' Congress*. New Brunswick, NJ: Rutgers Univ. Press.

————. 1986b. "The American Artists' Congress: Context and History." In *Artists against War and Fascism: Papers of the First American Artists' Congress*, edited by Matthew Baigell and Julia Williams, 3–43. New Brunswick, NJ: Rutgers Univ. Press.

Baskind, Samantha. 2004. *Raphael Soyer and the Search for Modern Jewish Art*. Chapel Hill: Univ. of North Carolina Press.

Beilis, Mendel. 1992. *Scapegoat on Trial: The Story of Mendel Beilis*. Edited by Shari Schwartz. New York: CIS.

Belth, Norton. 1939. "Problems in Anti-Semitism in the United States." *Contemporary Jewish Record*, May–June, 6–19; July–Aug., 43–57.

Bender, Daniel E. 2004. *Sweated Work, Weak Bodies: Anti-sweatshop Campaigns and Languages of Labor*. New Brunswick, NJ: Rutgers Univ. Press.

Ben-Zion. 1963. "An Artist's View of a Jewish Museum." *Jewish News*, Sept. 13. In AAA, Ben-Zion, roll N69-122, frame 153.

————. 1981. *Remember*. Tel Aviv: EKED.

Biddle, George. 1935. "Artists Boycott of Olympics." *Art Front* 2 (Dec.): 6.

Blake, William. 1970. *The Complete Poetry and Prose of William Blake*. Edited by David D. Erdman. Garden City, NY: Doubleday.

Bloom, Bernard H. 1960. "Yiddish Speaking Socialists in America: 1892–1905." *American Jewish Archives* 12 (Apr.): 38–54. At http://americanjewisharchives .org/publications/journal/PDF/1960_12_01_00_bloom.pdf.

Borodulin, Nikolai. 2002. "American Art for Birobidzhan." *Jews in Eastern Europe* 3 (Winter): 99–108.

Boudin, Louis. 1907. *The Theoretical System of Karl Marx in the Light of Recent Criticism*. Chicago: Charles H. Kerr.

———. [1913] 1999a. "The Emancipation of the Negroes—and Fifty Years Later." Reprinted in *Building the Future: Jewish Intellectuals and the Making of Tsukunft*, edited and translated by Steven Cassedy, 228–32. New York: Holmes and Meier.

———. [1907] 1999b. "Life and Art." Reprinted in *Building the Future: Jewish Intellectuals and the Making of Tsukunft*, edited and translated by Steven Cassedy, 94–97. New York: Holmes and Meier.

Brandeis, Louis D. 1915. "A Call to the Educated Jew." *Menorah Journal* 1 (Jan.): 13–19.

Buhle, Paul. 1980. "Jews and American Communism: The Cultural Question." *Radical History Review* 23 (Spring): 9–33.

Buhle, Paul, and Edmund P. Sullivan. 1998. *Images of American Radicalism*. Hanover, MA: Christopher.

Burck, Jacob. 1933. "Sectarianism in Art." *New Masses* 8 (Apr.): 26–27.

———. 1935. *Hunger and Revolt: Cartoons by Burck*. New York: Daily Worker.

Cahan, Abraham. 1889. "Realism." *Workmen's Advocate*, Apr. 6.

———. [1896] 1999. "A Few Words of Criticism in General." Reprinted in *Building the Future: Jewish Intellectuals and the Making of Tsukunft*, edited and translated by Steven Cassedy, 77–80. New York: Holmes and Meier.

Cahill, Holger. 1936. *New Horizons in American Art*. New York: Museum of Modern Art.

Cassedy, Steven. 2001. "The Question of Human Rights in American Yiddish Journalism: The Example of *Di Tsukunft*." In *Yiddish and the Left*, edited by Gennady Estraikh and Mikhail Krutikov, 1–23. Oxford: Legenda, Univ. of Oxford.

Catalogue of an Exhibition of American Paintings and Sculptures from the Museum's Collection. 1944. Newark, NJ: Newark Museum.

Chamberlain, Mary L. 1914. "East Side Types in Color and Clay." *The Survey* 32 (May 16): 193.

Chave, Anna C. 1989. *Mark Rothko: Subjects in Abstraction.* New Haven, CT: Yale Univ. Press.

Cohen, A., ed. 1948. *The Twelve Prophets.* Bournemouth, UK: Soncino Press.

Cohen, Elliot E. 1947. "Jewish Culture in America." *Commentary* 3 (Apr.): 412–20.

The Complete Art Scroll Siddur. 1984. Edited by Rabbi Nosson Scherman and Rabbi Meir Zlotowitz. New York: Mesorah.

Cooney, Terry A. 1986. *The Rise of the New York Intellectuals nd Their World.* New York: Oxford Univ. Press.

Craven, Thomas. 1934. *Modern Art: The Men, the Movements, the Meaning.* New York: Simon and Schuster.

Daiches, David. 1944. "Under Forty: A Symposium on American Literature and the Younger Generation of American Jews." *Contemporary Jewish Record* 7 (Feb.): 28–32.

Dalin, David G. 1989. "Introduction." In *From Marx to Judaism: The Collected Essays of Will Herberg,* edited by David G. Dalin, i–xv. New York: Marcus Weiner.

Deming, Michael. 1996. *The Cultural Front: The Laboring of American Culture in the Twentieth Century.* London: Verso.

De Profundis (exhibition catalog). 1946. New York: Berthe Shaefer Gallery.

Deutscher, Isaac. 1968. "The Non-Jewish Jew." In *The Non-Jewish Jew and Other Essays,* edited by Tamara Deutscher, 25–41. New York: Oxford Univ. Press.

Dillon, Wilton S., and Neil G. Kotler, eds. 1994. *The Statue of Liberty Revisited.* Washington, DC: Smithsonian Institution Press.

Diner, Hasia R. 1977. *In the Almost Promised Land: American Jews and Blacks, 1915–1935.* Westport, CN: Greenwood Press.

Dinnerstein, Leonard. 1994. *Anti-Semitism in America.* New York: Oxford Univ. Press.

Djikstra, Bam. 2003. *American Expressionism: Art and Social Change, 1920–1970.* New York: Harry N. Abrams.

Doezema, Marianne. 1992. *George Bellows and Urban America.* New Haven, CT: Yale Univ. Press.

Dorff, Elliot N. 2005. *The Way into Tikkun Olam.* Woodstock, VT: Jewish Lights.

Doroshkin, Milton. 1969. *Yiddish in America: Social and Cultural Foundations.* Rutherford, NJ: Fairleigh Dickinson Univ. Press.

"Draft Manifesto of the John Reed Clubs." [1932] 1973. *New Masses* 7 (June). Reprinted in *Social Realism: Art as a Weapon*, edited by David Shapiro, 42–46. New York: Frederick Unger.

Draper, Theodore. 1957. *The Roots of American Communism*. New York: Viking.

Dyer, Walter A. 1917. "An East Side Art Movement." *International Studio* 48 (Dec.): 51.

Egbert, Donald Drew. 1967. *Socialism and American Art*. Princeton, NJ: Princeton Univ. Press.

Elzea, Rowland, and Elizabeth Hawkes. 1988. *John Sloan: Spectator of Life*. Wilmington: Delaware Art Museum.

Epshteyn, Meylikh [Epstein, Melech]. 1927. *Di Goldene Medene fun William Gropper* (in Yiddish). New York: Freiheit.

Epstein, Helen. 1983. "Meyer Schapiro: A Passion to Know and to Make Known." *Art News* 82 (May): 60–85, (Summer): 84–95.

Epstein, Melech. 1959. *The Jew and Communism, 1919–1941*. New York: Trade Union Sponsoring Committee.

Estraikh, Gennady. 2005. *In Harness: Yiddish Writers' Romance with Communism*. Syracuse, NY: Syracuse Univ. Press.

Ettinger, S. 1970. "Jews in Russia at the Outbreak of the Revolution." In *The Jews in Soviet Russia since 1917*, edited by Leonard Kochan, 14–28. New York: Oxford Univ. Press.

Feingold, Henry. 1999. "From Commandment to Persuasion: Probing the 'Hard' Secularism of American Jewry." In *National Variations in Jewish Identity: Implications for Jewish Education*, edited by Steven M. Cohen and Gabriel Horencyzk, 157–76. Albany: State Univ. of New York Press.

Field, Ben. 1944. "Under Forty: A Symposium on American Literature and the Younger Generation of American Jews." *Contemporary Jewish Record* 17 (Feb.): 17–20.

Finkelstein, Louis. 1936. "The Hebraic Doctrine of Equality." *Menorah Journal* 24 (Jan.–Mar.): 16–29.

"First Exhibition." 1938. World Alliance for Yiddish Culture, "YKUF" (Yiddisher Kultur Farband), Art Section, USA. YKUF Folder, Jewish Museum, New York.

Fitzgerald, Richard. 1973. *Art and Politics: Cartoons of the Masses and Liberator*. Westport, CT: Greenwood Press.

Fleurov, Ellen. 2000. *No Sun without Shadow: The Art of Harry Sternberg*. Escondido: California Center for the Arts.

Forrester, Izola. 1906. "New York's Art Anarchists: Here Is the Revolutionary Creed of Robert Henri and His Followers." *New York World* 10 (June): magazine sec., 6.

"*Forward* Looking Back." 2011. *Forward* 114 (Apr. 15): 20.

Freeman, Joseph. 1936. *An American Testament: A Narrative of Rebels and Romantics.* New York: Farrar and Rinehart.

Freeman, Joseph, Louis Lozowick, and Joshua Kunitz. 1930. *Voices of October: Art and Literature in the Soviet Union.* New York: Vanguard.

Freundlich, August L. 1968. *William Gropper: Retrospective.* Miami: Joe and Emily Lowe Art Gallery, Univ. of Miami.

Fried, Albert, ed. 1997. *Communism in America: A History in Documents.* New York: Columbia Univ. Press.

Friedlander, Israel. 1946. "Can Judaism Survive in Free America?" *Commentary* 2 (July): 73–80.

———. [1917] 1961. "The Americanization of the Jewish Immigrant." *The Survey* (Mar. 5): 229–45.

Gahn, Anthony. 1970. "William Gropper—a Radical Cartoonist: His Early Career, 1897–1928." *New-York Historical Society Quarterly* 54 (Apr.): 132–34.

Gartner, Lloyd P. 1994. "The Jewish Labor Movement in Great Britain and the United States." In *Workers and Revolutionaries: The Jewish Labor Movement,* edited by Tamar Manor-Fridman, 76–93. Tel Aviv: Beth Hatefutsoth, Museum of the Jewish Diaspora.

Gellert, Hugo. 1934. *Karl Marx' "Capital" in Lithographs.* New York: Ray Long and Richard R. Smith.

Gerber, David A. 1996. "Visiting Bubbe and Zeyde: How I Learned about American Pluralism before Writing about It." In *People of the Book: Thirty Scholars Reflect on Their Jewish Identity,* edited by Jeffrey Rubin-Dorsky and Shalley Fisher Fishkin, 117–34. Madison: Univ. of Wisconsin Press.

Gillman, Neil. 1990. *Sacred Fragments: Recovering Theology for the Modern Jew.* Philadelphia: Jewish Publication Society.

Gilman, Sander. 1986. *Jewish Self-Hatred: Anti-Semitism and the Hidden Language of the Jews.* Baltimore: Johns Hopkins Univ. Press.

Ginzberg, Louis. 1909. *Legends of the Jews.* 7 vols. Translated by Henrietta Szold. Philadelphia: Jewish Publication Society of America.

Girgus, Samuel. 1983. "A Poetics of the American Idea: The Jewish Writer in America." *Prospects* 8:327–48.

Gitlow, Benjamin. 1940. *I Confess: The Truth about American Communism*. New York: E. P. Dutton.

Glaser, Amelia, and David Weintraub, eds. 2005. *Proletpen: America's Rebel Yiddish Poets*. Madison: Univ. of Wisconsin Press.

Glazer, Nathan. 1961. *The Social Basis of American Communism*. New York: Harcourt Brace.

Gold, Mike, ed. 1926. *Red Cartoons from the* Daily Worker, *the* Worker's Monthly, *and the* Liberator. Chicago: Daily Worker.

———. [1930] 1965. *Jews without Money*. New York: Avon.

——— [Granich, Irwin]. [1921] 1972. "Towards Proletarian Art." Reprinted in *Mike Gold: A Literary Anthology*, edited by Michael Folsom, 62–70. New York: International.

Goldstein, Rebecca Newberger. 2006. *Betraying Spinoza: The Renegade Jew Who Gave Us Modernity*. New York: Nextbook.

Goodman, Paul, and Benjamin Nelson. 1946. "Project for a Modern Jewish Museum." *Commentary* 1 (Feb.): 15–20.

Goodrich, Nathaniel H. 1940. "Nazi Influence in American Affairs." *Contemporary Jewish Record* 3 (July–Aug.): 370–80.

Goren, Arthur. 1970. *New York Jews and the Quest for Community: The Kehillah Experiment, 1908–1922*. New York: Columbia Univ. Press.

———. 1980. *The American Jews*. Cambridge, MA: Harvard Univ. Press.

Gottlieb, Adolph. 1954. "The Artist and the Public." *Art in America* 42 (Dec.): 267–71.

Granich, Irwin [Gold, Mike]. 1921. "Towards Proletarian Art." *Liberator* 4 (Feb.): 20–24.

Granick, Arthur. 1976. *Jennings Tofel*. New York: Harry N. Abrams.

Graubard, Mark. 1934. "The Artist and the Revolutionary Movement." *New Masses* 12 (July 31): 24.

Greenberg, Clement. 1986. *Clement Greenberg: The Collected Essays and Criticisms*. 4 vols. Edited by John O'Brian. Chicago: Univ. of Chicago Press.

Greenberg, Clement, and Dwight MacDonald. 1941. "10 Propositions on the War." *Partisan Review* 8 (July–Aug.): 271–78.

Greenfield, Howard. 1998. *Ben Shahn: An Artist's Life*. New York: Random House.

Grossman, Emery. 1962. "A Visit with William Gropper." *Temple Israel Light* 8 (Mar.): 6–7.

Guttman, Allen. 1971. *The Jews in America: Assimilation and the Crisis of Identity.* New York: Oxford Univ. Press.

Hapgood, Hutchins. 1902. *The Spirit of the Ghetto: Studies of the Jewish Quarter of New York.* New York: Funk and Wagnalls.

Harap, Louis. 1987. *Creative Awakening: The Jewish Presence in 20th-Century Literature, 1900–1940.* New York: Greenwood Press.

Harrison, Helen A. 1980. "John Reed Club Artists and the New Deal: Radical Responses to Roosevelt's 'Peaceful Revolution.'" *Prospects,* no. 5: 241–68.

Hayes, Jeffrey R. 1983. "Jennings Tofel: The Human Form." In *Jennings Tofel* (exhibition catalog), not paginated. Mahwah, NJ: Ramapo College of Art Gallery.

Heilman, Samuel C. 1998. "Building Jewish Identity for Tomorrow: Possible or Not?" In *Jewish Survival: The Identity Problem at the Close of the Twentieth Century,* edited by Ernest Krausz and Gitta Tulea, 77–86. New Brunswick, NJ: Transaction.

Hemingway, Andrew. 1994. "Meyer Schapiro and Marxism in the 1930s." *Oxford Art Journal* 17, no. 1: 13–29.

———. 2002. *Artists on the Left: American Artists and the Communist Movement, 1926–1956.* New Haven, CT: Yale Univ. Press.

Henri, Robert. 1920. "William J. Glackens: His Significance to the Art of His Day." *Touchstone* 7 (June): 191–98.

———. [1923] 1960. *The Art Spirit.* Philadelphia: Lippincott.

Herberg, Will. 1989. *From Marx to Judaism: The Collected Essays of Will Herberg.* Edited by David G. Dalin. New York: Marcus Weiner.

Herbert, James D. 1985. *The Political Origins of Abstract Expressionist Art Criticism: The Early Theoretical and Critical Writings of Clement Greenberg and Harold Rosenberg.* Stanford Honors Essays in the Humanities, no. 27. Stanford: Stanford Univ. Press.

Hertzberg, Arthur, and Aron Hirt-Manheimer. 1998. *Jews: The Essence and Character of a People.* San Francisco: HarperSanFrancisco.

Heschel, Abraham Joshua. 1996. *Moral Grandeur and Spiritual Audacity.* Edited by Susannah Heschel. New York: Farrar, Straus, and Giroux.

Heyd, Milly. 1999. *Mutual Reflections: Jews and Blacks in American Art.* New Brunswick, NJ: Rutgers Univ. Press.

Heyd, Milly, and Ezra Mendelsohn. 1993–94. "Jewish Art? The Case of the Soyer Brothers." *Jewish Art,* nos. 19–20: 194–211.

Higham, John. [1955] 1990. *Strangers in the Land: Patterns of American Nativism*. New Brunswick, NJ: Rutgers Univ. Press

Hills, Patricia. 1994. "Meyer Schapiro, *Art Front*, and the Popular Front." *Oxford Art Journal* 17, no. 1: 30–41.

Hindus, Maurice G. 1927. "The Jew as Radical." *Menorah Journal* 13 (Aug.): 368–78.

Hobsbawm, Eric. 1983. "Introduction: Inventing Traditions." In *The Invention of Tradition*, edited by Eric Hobsbawm and Terence Ranger, 1–14. Cambridge: Cambridge Univ. Press.

Hook, Sidney. 1949. "Reflections on the Jewish Question." *Partisan Review* 16 (May): 463–82.

Howe, Irving. 1946. "The Lost Young Intellectuals: A Marginal Man, Twice Alienated." *Commentary* 2 (Oct.): 361–67.

———. 1976. *The World of Our Fathers*. New York: Harcourt Brace Jovanovich.

———. 1978. "The East European Jews and American Culture." In *Jewish Life in America*, edited by Gladys Rosen, 92–108. New York: KTAV.

———. 1982a. *A Margin of Hope: An Intellectual Biography*. New York: Harcourt, Brace, and Jovanovich.

———. 1982b. "Pluralism in the Immigrant World." In *The Legacy of Jewish Immigration: 1881 and Its Impact*, edited by David Berger, 149–55. New York: Brooklyn College Press.

Howe, Irving, and Louis Coser. 1957. *The American Communist Party*. Boston: Beacon.

Huneker, James. 1915. *The New Cosmopolis*. New York: Scribner's.

Hyman, Nancy, and Leonard Sparks. 1935. *Public Enemy No. 1: William Randolph Hearst*. New York: District Two, Communist Party USA.

Isaacs, Ronald H., and Kerry M. Olitzky. 1995. *Critical Documents in Jewish History*. Northvale, NJ: Jason Aronson.

Israel, Leon. 1954. *The East Side of Yesteryear in Pictures*. New York: Academy Offset.

Jackson, Gardner. 1932. "The American Radical." In *America as Americans See It*, edited by Frederick J. Ringel, 181–87. New York: Literary Guild.

Jacobs, Rabbi Jill. 2009. *There Shall Be No Need: Pursuing Social Justice through Jewish Law and Tradition*. Woodstock, VT: Jewish Lights.

Jewish Labor Bund, 1897–1957. 1958. New York: International Jewish Labor Bund.

"A Jewish Writers' Symposium on Radicalism." 1934. *Literary Digest* 118 (Nov. 24): 19.

"Jews in America." 1936. *Fortune* 13 (Feb.): 79–80, 85, 128–30, 133–34, 136, 141–44.

Johns, Orrick. 1934. "The John Reed Clubs Meet." *New Masses* 13 (Oct. 30): 25–26.

Kainen, Jacob. 1935. "Revolutionary Art and the John Reed Club." *Art Front*, Jan. 2: 6.

Kallen, Horace. 1915. "Nationality and the Hyphenated American." *Menorah Journal* 1 (Apr.): 79–86.

Kampf, Avram. 1984. *Jewish Experience in the Art of the Twentieth Century.* South Hadley, MA: Bergin and Garvey.

Kaplan, Mordecai M. 1945. "Statement." *Contemporary Jewish Record* 8 (Feb.): Magazine Digest sec., 96.

Karp, Abraham. J. 1998. *Jewish Continuity in America: Creative Survival in a Free Society.* Tuscaloosa: Univ. of Alabama Press.

Kenez, Peters. 1992. "Pogroms and White Ideology in the Russian Civil War." In *Pogroms: Anti-Jewish Violence in Modern Russian History*, edited by John D. Klier and Shlomo Lambroza, 293–311. Cambridge: Cambridge Univ. Press.

Keniston, Kenneth. 1965. "Social Change and Youth in America." In *The Challenge of Youth*, edited by Erik H. Erikson, 161–87. New York: Anchor Doubleday.

Klehr, Harvey. 1989. *The Heyday of American Communism: The Depression Decade.* New York: Basic Books.

Klein, Jerome. 1935. "A Review." *Art Front* 1 (May): n.p.

Klier, John D., and Shlomo Lambroza, eds. 1992. *Pogroms: Anti-Jewish Violence in Modern Russian History.* Cambridge: Cambridge Univ. Press.

Knox, Israel. 1945. "Zhitlovsky's Philosophy of Jewish Life." *Contemporary Jewish Record* 8 (Apr.): 172–75.

Kobrin, Rebecca. 2008. "'When a Jew Was a Landsman': Rethinking American Jewish Regional Identity in the Age of Mass Migration." *Journal of Modern Jewish Studies* 7 (Nov.): 357–76.

Konvitz, Milton R. 1978. *Judaism and the American Idea.* Ithaca, NY: Cornell Univ. Press.

Kramer, Sydelle, and Jenny Masur, eds. 1976. *Jewish Grandmothers.* Boston: Beacon Press.

Kronenberger, Louis. 1944. "Under Forty: A Symposium on American Litera-
ture and the Younger Generation of American Jews." *Contemporary Jewish
Record* 7 (Feb.): 20–23.

Kunitz, Joshua. 1929. *Russian Literature and the Jew: A Sociological Inquiry into
the Nature and Origin of Literary Patterns.* New York: Columbia Univ. Press.

————. 1935. "Max Eastman's Unnecessary Tears." In *Proletarian Literature in
the United States: An Anthology,* edited by Granville Hicks, Joseph North,
Michael Gold, Paul Peters, Isidor Schneider, and Alan Calmer, 361–67. New
York: International.

Kwait, John [Schapiro, Meyer]. 1933. "John Reed Club Art Exhibition." *New
Masses* 8 (Feb. 7): 23.

Laing, David. 1986. *The Marxist Theory of Art: An Introductory Survey.* Boulder,
CO: Westview Press.

Langa, Helen. 2004. *Radical Art: Printmaking and the Left in the 1930s.* Berke-
ley: Univ. of California Press.

Lanning, Edward. 1972. "The New Deal Mural Projects." In *The New Deal Art
Projects: An Anthology of Memoirs,* edited by Francis V. O'Connor, 79–114.
Washington, DC: Smithsonian Institution Press.

Lautner, Paul. 1996. "Strange Identities and Jewish Politics." In *People of the
Book: Thirty Scholars Reflect on Their Jewish Identity,* edited by Jeffrey
Rubin-Dorsky and Shelly Fisher Fishkin, 37–46. Madison: Univ. of Wiscon-
sin Press.

Leavitt, Laura S. 2000. "Photographing American Jews: Identifying American
Jewish Life." In *Mapping Jewish Identities,* edited by Laurence J. Silberstein,
65–96. New York: New York Univ. Press.

Lederhendler, Eli. 1994. *Jewish Responses to Modernity: New Voices in America
and Eastern Europe.* New York: New York Univ. Press.

————. 2009. *Jewish Immigrants and American Capitalism, 1880–1920: From
Caste to Class.* New York: Cambridge Univ. Press.

Lehmann-Haupt, Hellmut. 1954. *Art under a Dictatorship.* New York: Oxford
Univ. Press.

Lenin, V. I. 1965. "Anti-Jewish Pogroms." In *Collected Works,* 29:252–53. Mos-
cow: Progress.

"Lenin on Art." 1929. *New Masses* 4 (Jan.): 9–10.

"Letters to the Editors." 1929. *New Masses* 4 (Feb.): 31.

Levin, Nora. c. 1987. *The Jews in the Soviet Union since 1917.* New York: New
York Univ. Press.

Levinger, Rabbi Lee J. [1925] 1972. *Anti-Semitism in the United States: Its History and Causes.* Westport, CN: Greenwood Press.

Lewin, Kurt. 1941. "Self-Hatred among Jews." *Contemporary Jewish Record* 4 (June): 219–32.

Liebman, Arthur. 1976. "The Ties That Bind: The Jewish Support of the Left in the United States." *American Jewish Historical Quarterly* 66 (Dec.): 285–321.

———. 1979. *Jews and the Left.* New York: Wiley.

Liebman, Charles. 1973. *The Ambivalence of American Jews: Politics, Religion, and Family in American Jewish Life.* Philadelphia: Jewish Publication Society of America.

———. 1974. *Aspects of Religious Behavior of American Jews.* New York: KTAV.

Liessin, Abraham. [1915] 1999. "The Frank Tragedy, the Jews, and the Negroes." Reprinted in *Building the Future: Jewish Immigrant Intellectuals and the Making of Tsukunft,* edited by Steven Cassedy, 241–49. New York: Holmes and Meier.

Lieven, Anatol. 2004. *America Right or Wrong: An Anatomy of American Nationalism.* New York: Oxford Univ. Press.

Lifshitz, Mikhail. 1938. *The Philosophy of Karl Marx.* Edited by Angel Flores. Translated by Ralph B. Winn. New York: Critics Group.

Likos, Patricia. 1983. "Julius Bloch: Portrait of the Artist." *PMA Bulletin* 79 (Summer): 12–13.

Linden, Diana. 1998. "Ben Shahn's New Deal Murals: Jewish Identity in the American Scene." In *Common Man, Mythic Vision: The Paintings of Ben Shahn,* edited by Susan Chevlowe, 37–66. New York: Jewish Museum.

Lipschutz, Yael Rebecca. 2004. *Bohemian Bridges: Russian Jewish Artists, New York's First Social Settlement, and the Creation of American Modern Art.* Oxford: Oxford Univ. Press.

Lipstadt, Deborah E. 1986. *Beyond the Pale: The American Press and the Coming Holocaust, 1933–1945.* New York: Free Press.

Listchinsky, Jacob. 1940. "Jews in the U.S.S.R." *Contemporary Jewish Record* 3 (Sept.–Oct.): 510–26.

London, Kurt. 1938. *The Seven Soviet Arts.* Translated by Eric S. Bensinger. New Haven, CT: Yale Univ. Press.

Lozowick, Louis. 1924. "A Jewish Art School." *Menorah Journal* 10 (Nov.–Dec.): 465–66.

———. 1934. "The John Reed Club Show." *New Masses* 10 (Jan. 2): 27.

————. 1935. "Phases in the Development of Proletarian Art" (in Yiddish). *Bodn* 2 (Apr.–June): 64–84.

————, ed. 1947. *100 Contemporary American Jewish Painters and Sculptors.* New York: YKUF Art Section.

————. 1983. *William Gropper.* Philadelphia: Art Alliance.

————. [1931] 1997a. "Art in the Service of the Proletariat." Reprinted in *Survivor from a Dead Age: The Memoirs of Louis Lozowick*, edited by Virginia Hagelstein Marquardt, 288–90. Washington, DC: Smithsonian Institution Press.

————. 1997b. *Survivor from a Dead Age: The Memoirs of Louis Lozowick.* Edited by Virginia Hagelstein Marquardt. Washington, DC: Smithsonian Institution Press.

Lunacharsky, A. V. 1932. "Marxism and Art." *New Masses* 8 (Nov.): 12–14.

Manor-Fridman, Tamar. 1994. "The Graphic Imagery of the Jewish Labor Movement." In *Workers and Revolutionaries: The Jewish Labor Movement*, edited by Tamar Manor-Fridman, 114–27. Tel Aviv: Beth Hatefutsoth, Museum of the Jewish Diaspora.

Markus, Jacob R. 1941. "Judaism and Western Civilization." *Contemporary Jewish Record* 4 (Oct.): 501–10.

Marquardt, Virginia Hagelstein. 1989. "*New Masses* and John Reed Club Artists, 1928–1936: Evolution of Ideology, Subject Matter, and Style." *Journal of Decorative and Propaganda Arts* 12 (Spring): 56–75.

————. 1993. "Art on the Political Front in America: From *The Liberator* to *Art Front*." *Art Journal* 52 (Spring): 77–79.

Masserman, Paul, and Max Baker. 1932. *The Jews Come to America.* New York: Bloch.

McWilliams, Carey. 1948. *A Mask for Privilege: Anti-Semitism in America.* Boston: Little, Brown.

Memmi, Alberto. 1966. *The Liberation of the Jew.* New York: Orion.

Mendelsohn, Ezra. 1970. *Class Struggle in the Pale: The Formative Years of the Jewish Workers' Movement in Tsarist Russia.* Cambridge: Cambridge Univ. Press.

————. 1993. *On Modern Jewish Politics.* New York: Oxford Univ. Press.

————. 2003. "Jewish Universalism: Some Visual Texts and Subtexts." In *Key Texts in American Jewish Culture*, edited by Jack Kugelmass, 163–84. New Brunswick, NJ: Rutgers Univ. Press.

————. 2004. "Jews, Communism, and Art in Interwar America." In *Dark Times, Dire Decisions: Jews and Communism*, edited by Jonathan Frankel, 99–132. Studies in Contemporary Jewry, vol. 20. New York: Oxford Univ. Press.

Menninger, Karl. [1937] 1959. "The Genius of the Jew in Psychiatry." Reprinted in *Karl Menninger: A Psychiatrist's World: Selected Papers*, edited by Barnard H. Hall, 415–24. New York: Viking.

Meyers, William. 2003. "Jews and Photography." *Commentary* 115 (Jan. 1): 45–48.

Michels, Tony. 2001. "Socialism with a Jewish Face: The Origins of the Yiddish-Speaking Communist Movement in the United States." In *Yiddish and the Left*, edited by Gennady Estraikh and Mikhail Krutikov, 24–55. Oxford: Legenda, Univ. of Oxford.

————. 2005. *A Fire in Their Hearts: Yiddish Speaking Socialists in New York*. Cambridge, MA: Harvard Univ. Press.

————. 2011. "Communism and the Problem of Ethnicity in the 1920s: The Case of Moissaye Olgin." In *Ethnicity and Beyond: Theories and Dilemmas of Jewish Group Demarcation*, edited by Eli Lederhendler, 26–48. Studies in Contemporary Jewry, vol. 25. New York: Oxford Univ. Press.

Mishkinsky, Moshe. 1994. "The Jewish Labor Movement in Modern Jewish History." In *Workers and Revolutionaries: The Jewish Labor Movement*, edited by Tamar Manor-Fridman, 16–25. Tel Aviv: Beth Hatefutsoth, Museum of the Jewish Diaspora.

Moore, James C. 1975. *Harry Sternberg: A Catalogue Raisonné of His Graphic Work*. Wichita, KS: Ulrich Museum of Art, Wichita State Univ.

Morawski, Stefan. 1973. "Introduction." In *Karl Marx & Frederick Engels on Literature and Art*, edited by Lee Baxandall and Stefan Morawski, 3–47. New York: I.G. Editions.

Morgan, David, and Sally M. Promey. 2000. *Exhibiting the Visual Culture of American Religions*. Valparaiso, IN: Brauer Museum of Art, Valparaiso Univ.

Morris, William. [1910–15] 1966. "Lectures on Socialism and Signs of Change." In *Collected Works of William Morris*, 23:81–97. New York: Russell and Russell.

————. 1979. "Art, Labor, and Socialism." In *Marxism and Art: Essays Classic and Contemporary*, edited by Maynard Solomon, 83–90. Detroit: Wayne State Univ. Press.

"The Moscow Trials." 1938. *New Masses* 20 (May 3): 19.

Moscowitz, Henry. 1912. "The East Side in Oil and Crayon." *The Survey* 28 (May 11): 273.

Novak, David. 2005. *The Jewish Social Contract: An Essay in Political Theology.* Princeton, NJ: Princeton Univ. Press.

Nusan, Jack, and Peter Dreier, eds. 1973. *Jewish Radicalism: A Selected Anthology.* New York: Grove Press.

Olgin, Moissaye J. 1936. "The Splendid Exhibition of the American Artists." In *Biro-Bidjan: Exhibition of Works of Art Presented by American Artists to the State Museum of Biro-Bidjan,* not paginated. New York: Association for Jewish Colonization in the Soviet Union.

Omer-Sherman, Ranen. 2002. *Diaspora and Zionism in American Literature: Lazarus, Syrkin, Reznikoff, and Roth.* Waltham, MA: Brandeis Univ. Press.

Park, Marlene. 1993. "Lynching and Anti-lynching: Art and Politics in the 1930s." *Prospects,* no. 18: 311–49.

Park, Marlene, and Gerald E. Markowitz. 1977. *New Deal for Art: The Government Art Projects of the 1930s with Examples from New York City and State.* Hamilton: Gallery Association of New York State.

———. 1984. *Democratic Vistas: Post Offices and Public Art in the New Deal.* Philadelphia: Temple Univ. Press.

Patai, Raphael. 1977. *The Jewish Mind.* New York: Scribner's.

Pearson, Norman Holmes. 1952. "The Nazi–Soviet Pact and the End of a Dream." In *America in Crisis,* edited by Daniel Aaron, 337–40. New York: Knopf.

Peeler, David. 1987. *Hope among Us Yet: Social Criticism and Social Solace in Depression America.* Athens: Univ. of Georgia Press.

Pells, Richard H. 1974. *Radical Visions and American Dreams: Culture and Social Thought in the Depression Years.* New York: Harper and Row.

Phagan, Patricia. 2000. "William Gropper and *Freiheit*: A Study of His Political Cartoons, 1924–1935." PhD diss., City Univ. of New York.

Phillips, William, and Philip Rahv. 1935. "Recent Problems in Revolutionary Literature." In *Proletarian Literature in the United States: An Anthology,* edited by Granville Hicks, Joseph North, Michael Gold, Paul Peters, Isidor Schneider, and Alan Calmer, 367–73. New York: International.

Pinchuk, Ben-Cion. 1978. "Jewish Refugees in Soviet Poland, 1939–1941." *Jewish Social Studies* 40 (Spring): 141–58.

Pirozhnikov, I. 1917. "Aesthetics in Jewish Life" (in Yiddish). *Der Fraynd,* Sept., 7–9.

Platt, Susan Noyes. 1995. "The Jersey Homesteads Mural: Ben Shahn, Bernarda Bryson, and History Painting in the 1930s." In *Redefining American History*

Painting, edited by Patricia M. Burnham and Lucretia Hoover Giese, 294–309. New York: Cambridge Univ. Press.

Pogrebin, Abigail. 2005. *Stars of David: Prominent Jews Talk about Being Jewish*. New York: Broadway Books.

Pohl, Francis K. 1987. "Constructing History: A Mural by Ben Shahn." *Arts Magazine* 62 (Sept.): 36–39.

Polonsky, Vyacheslav. 1934. "Lenin's View of Art." *Modern Monthly* 7 (Jan.): 738–43.

Portnoy, Edward A. 2008. "The Creation of a Jewish Cartoon Space in the New York and Warsaw Yiddish Press, 1884–1939." PhD diss., Jewish Theological Seminary of America.

Rabinovich, Anson. 2004. "Eichman in New York: The New York Intellectuals and the Hannah Arendt Controversy." *October* 108:97–111.

Raphael, Max. 1980. *Proudhon, Marx, and Picasso: Three Studies in the Sociology of Art*. Edited by Jon Tagg. Translated by Inge Marcuse. Atlantic Highlands, NJ: Humanities Press.

Raskin, Saul. 1907. "The Proletariat and Art" (in Yiddish). *Der Tsayt Gayst* 2 (Mar. 1): 6.

———. 1911a. "An Exhibition by Jewish Artists" (in Yiddish). *Dos Naya Land* 10 (Nov. 24): cols. 30–31.

———. 1911b. "The Future of Jewish Art" (in Yiddish). *Dos Naya Land* 1 (Sept. 15): cols. 17–21.

———. 1938. *Paintings and Drawings*. New York: Academy Photograph and Offset.

———. 1940. *Pirke Aboth in Etchings*. New York: Academy Photo Offset.

———. 1942. *Tehililm: The Book of Psalms*. New York: Academy Photo Offset.

———. 1966. *Our Father, Our King*. New York: Genesis.

———. [1914] 1999. "Proletarian Art: On an Exhibition of Constantin Meunier's Work in New York." Reprinted in *Building the Future: Jewish Intellectuals and the Making of Tsukunft*, edited and translated by Steven Cassedy, 124–27. New York: Holmes and Meier.

"Retrospect." 1905. *American Hebrew and Jewish Messenger* 76 (Apr. 7): 741.

Revutsky, Abraham. 1929. "Bira-Bidzhan: A Jewish Eldorado?" *Menorah Journal* 16 (Feb.): 158–62.

Rischin, Moses. 1962. *The Promised City: New York's Jews, 1870–1914*. Cambridge, MA: Harvard Univ. Press.

————. 1963. "The Jewish Labor Movement in America: A Social Interpretation." *Labor History* 4 (Fall): 227–47.

Rodman, Seldon. 1961. *Conversations with Artists*. New York: Capricorn.

Rogoff, Harry. 1930. *An East Side Epic: The Life and Work of Meyer London*. New York: Vanguard.

Rose, Margaret A. 1984. *Marx's Lost Aesthetic: Karl Marx and the Visual Arts*. London: Cambridge Univ. Press.

Rosenberg, Harold. 1936. "The Wit of William Gropper." *Art Front* 2 (Mar.): 8.

————. 1948. "The Herd of Independent Minds: Has the Avant-Garde Its Own Mass Culture?" *Commentary* 6 (Sept.): 244–52.

————. 1949. "Does the Jew Exist? Sartre's Morality Play about Anti-Semitism." *Commentary* 8 (Jan.): 8–18.

————. 1950. "Jewish Identity in a Free Society: On Current Efforts to Enforce Total Commitment." *Commentary* 9 (June): 244–52.

————. [1952] 1961. "The American Action Painters." Reprinted in *The Tradition of the New*, 23–39. New York: Grove.

————. 1966. "Is There a Jewish Art?" *Commentary* 42 (July): 57–60.

————. 1973. *Discovering the Present: Three Decades of Art, Culture, and Politics*. Chicago: Univ. of Chicago Press.

Rosenblatt, Gary. 2012. "A Community Pulling Apart." *Jewish Week* 224 (June 25): 8.

Rosensaft, Jean Bloch, ed. 2006. *The Eye of the Collector: The Jewish Vision of Sigmund R. Balka*. New York: Hebrew Union College–Institute of Religion.

Rubin, Theodore Isaac. 1990. *Anti-Semitism: A Disease of the Mind*. New York: Continuum.

Ruchames, Louis. 1969. "Jewish Radicalism in the United States." In *The Ghetto and Beyond*, edited by Peter I. Rose, 228–52. New York: Random House.

Rukeyser, Muriel. 1944. "Under Forty: A Survey on America Literature and the Younger Generation of American Jews." *Contemporary Jewish Record* 7 (Feb.): 4–9.

Ruskin, John. 1872. *Fors Clavigera: Letters to the Workmen and Labourers*. New York: Wiley.

————. 1875. *"Unto the Last": Four Essays on the First Principles of Political Economy*. New York: Wiley.

Sacher, Howard M. Alexander. 1992. *A History of the Jews in America*. New York: Knopf.

Salpeter, Harry. 1942. "Ribak: Art the Hard Way." *Esquire*, Nov., 75, 154–56.

Sanders, Ronald. 1987. *The Downtown Jews: Portraits of an Immigrant Generation*. New York: Dover.

Sarna, Jonathan D. 2004. *American Judaism: A History*. New Haven, CT: Yale Univ. Press.

Schapiro, Meyer. 1936a. "Public Use of Art." *Art Front* 2 (Nov.): 4–6.

———. 1936b. "Race, Nationality, and Art." *Art Front* 2 (Mar.): 10–12.

———. [1936] 1986. "The Social Bases of Art." Reprinted in *Artists against War and Fascism: Papers of the First American Artists' Congress*, edited by Matthew Baigell and Julia Williams, 103–13. New Brunswick, NJ: Rutgers Univ. Press.

Schary, Saul. [1936] 1986. "Tendencies in American Art." Reprinted in *Artists against War and Fascism: Papers of the First American Artists' Congress*, edited by Matthew Baigell and Julia Williams, 148–52. New Brunswick, NJ: Rutgers Univ. Press.

Schoener, Alon, ed. 1967. *Portal to America: The Lower East Side, 1870–1915*. New York: Holt, Rinehart and Winston.

Shahn, Ben. 1963. *Love and Joy about Letters*. New York: Grossman.

Shapiro, Karl. 1952. *In Defense of Ignorance*. New York: Random House.

Shatz, David, Chaim I. Waxman, and Nathan J. Dramert. 1990. Introduction to *Tikkun Olam: Social Responsibility in Jewish Thought and Law*, edited by David Shatz, Chaim I. Waxman, and Nathan J. Dramert, 1–16. Northvale, NJ: Jason Aronson.

Shechner, Mark. 1987. *After the Revolution: Studies in Contemporary Jewish American Imagination*. Bloomington: Indiana Univ. Press.

Shinn, Everett. 1966. "On George Luks: An Unpublished Memoir." *Archives of American Art Journal* 6 (Apr.): 1–12.

Silver, Rabbi Abbe Hillel. 1932. "The Relation of the Depression to the Culture and Spiritual Values of American Jewry." *Jewish Social Service Quarterly* 9 (Dec.): 44–48.

Simmel, Ernst. 1946. *Anti-Semitism: A Social Disease*. New York: International Universities Press.

Smith, Ellen. 2001. "Greetings from Faith: Early-Twentieth Century American Jewish New Year Postcards." In *Visual Culture of American Religions*, edited by David Morgan and Sally M. Promey, 229–44. Berkeley: Univ. of California Press.

Sokolsky, George E. 1935. "We Jews." *New Masses* 14 (Feb. 12): 27.

Solomon, Maynard. 1979. "Vladimir Ilyich Lenin." In *Marxism and Art: Essays Classic and Contemporary*, edited by Maynard Solomon, 163–69. Detroit: Wayne State Univ. Press.

Sorin, Gerald. 1985. *The Prophetic Minority: American Jewish Immigrant Radicals, 1880–1920*. Bloomington: Indiana Univ. Press.

———. 1992. *A Time for Building: The Third Migration, 1880–1920*. Baltimore: Johns Hopkins Univ. Press.

Soyer, Daniel. 1997. *Jewish Immigrant Associations and American Identity in New York: 1880–1939*. Cambridge, MA: Harvard Univ. Press.

Soyer, Moses. 1935. "The Second Whitney Biennial." *Art Front* 1 (Feb.): 7–8.

Soyer, Raphael. 1969. *Self-Revealment: A Memoir*. New York: Random House.

———. 1979. *Diary of an Artist*. Washington, DC: New Republic Books.

———. 1983. "An Artist's Experiences in the 1930s." In *Social Concern and Urban Realism: American Painting of the 1930s*, edited by Patricia Hills, 27–30. Boston: Boston Univ. Art Gallery.

Steinberg, Milton. 1941. "First Principles for American Jews." *Contemporary Jewish Record* 4 (Dec.): 587–96.

Storr, Robert. 1990. "No Joy in Mudville: Greenberg's Modernism Then and Now." In *Modern Art and Popular Culture: Readings in High and Low*, edited by Kirk Varnedoe and Adam Gopnik, 160–90. New York: Harry N. Abrams.

Strauss, Lauren B. 2004. "Painting the Town Red: Jewish Visual Artists, Yiddish Culture, and Progressive Politics in New York, 1917–1939." PhD diss., Jewish Theological Seminary of America.

———. 2008. "Images with Teeth: The Political Influence of Artwork in American Yiddish Periodicals." In *Yiddish in America: Essays on Yiddish Culture in the Golden Land*, edited by Edward S. Shapiro, 23–54. Scranton, PA: Univ. of Scranton Press.

Strebrnik, Henry. 2001. "Diaspora, Ethnicity, and Dreams of Nationhood: American Communists and the Birobidzhan Project." In *Yiddish and the Left*, edited by Gennadi Estraikh and Mikhail Krutikov, 80–108. Oxford: Legenda, Univ. of Oxford.

Swing, Raymond Gram. 1935. *Forerunners of American Fascism*. New York: Julian Messner.

Taine, Hippolyte. 1872. *History of English Literature*. Translated by H. Van Laun. New York: Holt and Williams.

———. 1883. *Lectures on Art*. Translated by John Durand. New York: Henry Holt.

Taylor, Kendall. 1987. *Philip Evergood: Never Separate from the Heart*. Lewisburg, PA: Bucknell Univ. Press.

Tofel, Jennings. 1927. "Jewish Art Center" (in Yiddish). *Der Hamer* 11 (Mar. 3): 53–56.

Trotsky, Leon. 1925. *Literature and Revolution*. Translated by Rose Strunsky. New York: International.

Tyler, Francine. 1990. "*Art Front* (1934–1937), the Magazine of the Artists' Union." PhD diss., New York Univ.

Vital, David. 1999. *A People Apart: A Political History of the Jews in Europe, 1789–1939*. New York: Oxford Univ. Press.

Vorspan, Albert, and Eugene J. Lipman. 1959. *Justice and Judaism: The Work of Social Action*. 4th ed. rev. New York: Union of American Hebrew Congregations.

Wald, Alan M. 1976. "The Menorah Group Moves Left." *Jewish Social Studies* 38 (Summer–Fall): 289–320.

———. 2004. "Between Insularity and Internationalism: The Lost World of the Jewish Communist Cultural Workers in America." In *Dark Times, Dire Decisions: Jews and Communism*, edited by Jonathan Frankel, 133–47. Studies in Contemporary Jewry, vol. 20. New York: Oxford Univ. Press.

Waldman, Morris D. 1932. "The International Scene in Jewish Life." *Jewish Social Service Quarterly* 9 (Dec.): 19–25.

Wallace, Henry. 1940. "Judaism and Americanism." *Menorah Journal* 28 (July–Sept.): 127–37.

Ward, Lynd. [1936] 1986. "Race, Nationality, and Art." Reprinted in *Artists against War and Fascism: Papers of the First American Artists' Congress*, edited by Matthew Baigell and Julia Williams, 114–20. New Brunswick, NJ: Rutgers Univ. Press.

Warshow, Robert. 1947. "The Legacy of the 1930s: Middle-Class Mass Culture and the Intellectuals' Problem." *Commentary* 4 (1947): 538–45.

Weber, Max. [1936] 1986. "The Artist, His Audience, and Outlook." Reprinted in *Artists against War and Fascism: Papers of the First American Artists' Congress*, edited by Matthew Baigell and Julia Williams, 121–29. New Brunswick, NJ: Rutgers Univ. Press.

Wechsler, James. 2002. "From World War I to the Popular Front; The Art and Activism of Hugo Gellert." *Journal of Decoration and Propaganda Arts* 24:199–228.

Weichsel, Dr. John. 1913. "The Painter from the Jewish Street" (in Yiddish). *Di Tsukunft* 18 (Feb.): 143–51.

———. 1915a. "Eli Nadelman." *East and West* 1 (Aug.): 145–48.

———. 1915b. "Jewish Workers and Jewish Artists" (in Yiddish). *Di Tsukunft* 20 (Sept.): 262–69.

———. 1916. "Samuel Halpert." *East and West* 1 (Jan.): 310.

Weinberg, Robert. 1998. *Stalin's Forgotten Zion: Birobidzhan and the Making of a Soviet Jewish Homeland.* Berkeley: Univ. of California Press.

Weiner, Rickie, ed. *Past Perfect: The Jewish Experience in Early 20th Century Postcards.* 1997. New York: Library of the Jewish Theological Seminary of America.

Weinstein, Andrew. 2001. "From International Socialism to Jewish Nationalism: The John Reed Club Gift to Birobidzhan." In *Complex Identities: Jewish Consciousness and Modern Art*, edited by Matthew Baigell and Milly Heyd, 142–61. New Brunswick, NJ: Rutgers Univ. Press.

Wenger, Beth S. 1996. *New York Jews and the Great Depression: Uncertain Promise.* New Haven, CT: Yale Univ. Press.

———. 2010. *History Lessons: The Creation of American Jewish Heritage.* Princeton, NJ: Princeton Univ. Press.

Werner, Alfred. 1948. "Soutine: 'Dedicated Traditionalist.'" *Commentary* 5 (May): 435–39.

———. n.d. *Ben Shahn: Artist, Passionate Prophet.* Readings on Jewish Art, vol. 4. New York: National Council on Art in Jewish Life.

Wheatley, Robert. 1892. "The Jews of New York." *Century Magazine* 43 (Jan.): 323–42, and 43 (Feb.): 512–32.

Whitfield, Stephen J. 1980. "The Imagination of Disaster: The Response of American Jewish Intellectuals to Totalitarianism." *Jewish Social Studies* 42 (Winter): 1–20.

"Who Patronizes Jewish Art?" 1905. *American Hebrew and Jewish Messinger* 17 (Aug. 5): 162.

Winkenweder, Brian. 1998. "Art History, Sartre, and Identity in Rosenberg's America." *Art Criticism* 13, no. 2: 83–102.

Wise, Isaac Meyer. 1854. "The Fourth of July: An Address Delivered in the Synagogue of K. K. Benei Yeshurun." *Israelite*, July 15.

Wisse, Ruth R. 1987. "The New York (Jewish) Intellectuals." *Commentary* 84 (Nov.): 28–38.

Wolf, Arnold Jacob. 2001. "Repairing Tikkun Olam." *Judaism* 50 (Fall): 479–82.

Wolf, Simon. [1888] 1926. "The Influence of the Jews on the Progress of the World." In *Selected Address and Papers of Simon Wolf*, not paginated. Cincinnati: n.p.

Wolfe, Bertram. 1935. "'What Will I Do When America Goes to War?' Symposium." *Modern Monthly* 9 (Sept.): 297.

Woocher, Jonathan. 2005. "'Sacred Survival' Revisited: American Jewish Civil Religion in the New Millennium." In *The Cambridge Companion to American Judaism*, edited by Dana Evan Kaplan, 283–98. New York: Cambridge Univ. Press.

Zagat, Ida, ed. 1972. *Zagat Drawings and Paintings: Jewish Life on New York's Lower East Side*. New York: Rogers Book Service.

Zetkin, Clara. 1934. *Reminiscences of Lenin*. New York: International.

Zucker, Bat-Ami. 1994. "American Jewish Communists and Jewish Culture in the 1930s." *Modern Judaism* 14 (May): 175–85.

Zukerman, William. 1937. "Under the Whip of Fascism." *Menorah Journal* 25 (Jan.–Mar.): 2–19.

———. 1942. "The Jewish Spirit in Crisis." *Menorah Journal* 30 (July–Sept.): 105–15.

Index

Italic page number denotes illustration.